T0376197

Digital Immersive Art in China

Digital Immersive Art in China

Rejuvenation and Cultural Presence

Xinyang Zhao

ANTHEM PRESS

Anthem Press
An imprint of Wimbledon Publishing Company
www.anthempress.com

This edition first published in UK and USA 2025
by ANTHEM PRESS
75–76 Blackfriars Road, London SE1 8HA, UK
or PO Box 9779, London SW19 7ZG, UK
and
244 Madison Ave #116, New York, NY 10016, USA

British Library Cataloguing-in-Publication Data
A catalogue record for this book is available from the British Library.

Library of Congress Cataloging-in-Publication Data
A catalog record for this book has been requested.
2024944094

ISBN-13: 978-1-83999-303-9 (Hbk)
ISBN-10: 1-83999-303-0 (Hbk)

Cover credit: AI generated

This title is also available as an e-book.

CONTENTS

LIST OF FIGURES

LIST OF TABLES

Chapter 1

INTRODUCTION: THE DIGITAL SUBLIME

On an otherwise ordinary weekend afternoon in October 2016, I was out with some friends at a shopping plaza in the southern city of Shenzhen when an art exhibition attracted our attention. It surprised us to come across a spacious art gallery in a commercial retail environment. More surprising, however, was the subject itself. The exhibition featured the work of Pierre-Auguste Renoir, the renowned French impressionist painter. The exhibition presented Renoir's masterpieces together with the photography-based artwork of his descendants. At one end of the gallery, a 3D-modelled interactive project displayed stories about the artist's life via a virtual reality (VR) headset. The interactive video was cartoonish and low resolution with occasionally dizzying moments. Afterwards, the viewing staff informed me that the immersive project was created by a Chinese team; they had hoped that VR would help viewers learn more about the artist and attract younger visitors.

Later, I realised that this awkward immersive experience was an example of an emerging trend. Policymakers were encouraging immersive art, entrepreneurs were joining in, and enthusiastic spectators were growing in numbers. In the course of my research, I came across many similar digital and immersive art projects under the aegis of 'Digital China', a large-scale government initiative that has generated capital inflows which have in turn advantaged innovation in the manufacturing sector.

Like many other countries and territories in recent years, the Chinese state uses policy models to direct innovation in the cultural and creative industries. The *2016 China Government Work Report* (2016 年中国政府报告) (Li, 2016) highlighted the significance of digital technology for China. The central government subsequently proposed the concept of 'digital creative industries' (数字创意产业) (later amended in April 2017 to digital cultural industries). In December 2016, the State Council, China's primary administrative organ, listed digital creative industries—including equipment manufacturing and software development, digital and creative content creation, new media services, and services for content application—as one of five 'Strategic

Emerging Industries' in the 13th Five-Year Plan for the nation's technological revolution and industrial transformation. The 14th Five-Year National Development Plan, which commenced in 2021, subsequently highlighted a program called 'Building Digital China' (建设数字中国). Under this vision, the central government maintains that digitalisation is an effective strategy to boost economic development and improve people's lifestyles (i.e. retail consumption, domestic life, tourism and leisure and transportation) (Xinhua, 2021a).

Building Digital China has already received another policy boost. In 2015, the concept of 'Made in China 2025' was introduced in the 13th Five-Year National Development Plan (2016–2020) (State Council, 2016). Then Premier Li Keqiang said, 'We still have to do the traditional MADE IN CHINA but the core of 'Made in China 2025' should be Chinese equipment' (Li, 2015). While augmented reality (AR) and VR are often regarded as media for producing or delivering digital content, the hardware components require advanced manufacturing. The central government emphasised how the flagship digital technologies of VR and AR will upgrade China's manufacturing industries. They link with other critically significant digital technologies, such as 5G and artificial intelligence (AI), which are dependent on advanced manufacturing. By 2018, China had become the world's second-largest VR headsets market with revenue amounting to US$364 million; it also had the world's highest ownership of VR devices (PwC, 2019). Big technological corporations in China have rushed to invest in VR businesses. In 2019, Huawei released its first VR headset – Huawei VR Glass. In 2021, ByteDance (the parent company of TikTok) acquired and wholly owned PICO, a VR manufacturer based in Beijing.

The emphasis on the 'digital' in the cultural and creative industries reflects the technological transformation of the cultural system. The 'cultural system' refers to a regulatory system mandated by the government and advanced by entrepreneurship. As a significant part of the cultural system, the creative industries seek a balance between public support for culture and the entrepreneurial spirit of the market (Keane & Zhao, 2014; Shan, 2014) The digital cultural industries receive government support. Tourism, leisure and entertainment companies, as well as the museum sector, can benefit from tax deductions and special funding support. Digital China thus becomes a set of strategies to enhance the nation's 'cultural power' (文化强国) (Keane & Chen, 2017).

In 2019, a report entitled *Opinions on Further Inspiring the Potential of Culture and Tourism Consumption*, issued by China's State Council, highlighted that the new style of immersive experience-based content is located at the intersection of culture, tourism and advanced digital technology (State Council, 2019).

The application of VR to cultural projects has become central to cultural rejuvenation (文化复兴). Cultural institutions have begun to explore the digitalisation of cultural heritage. Digital art projects about the Mogao Grottos in north-western Dunhuang are displayed in museums and on online VR platforms. The Mogao Grottos were listed as a World Cultural Heritage site by the United Nations Educational, Scientific and Cultural Organization (UNESCO) in 1987, and are now a popular tourism destination. However, like many other cultural heritage sites, they face the problem of preservation. To protect this heritage, the Dunhuang Academy digitalised the site. High-resolution pictures of the Mogao Grottoes were created and licensed to technology companies, cultural institutions and creative studios to produce immersive content. An example is the 2017 immersive art exhibition *Mysterious Dunhuang* at the OCT Creative Exhibition Centre in Shenzhen. In 2018, the Dunhuang Academy cooperated with the National Taiwan University to develop the virtual heritage project *Shenyou Dunhuang* (神游敦煌, lit. trans. *Wandering in Dunhuang*) on Steam VR, an online VR content platform.

The Palace Museum in the Forbidden City in Beijing has digitalised its museum collections. In 2016, it curated a series of artistic projects with the use of digital technology in order to rejuvenate its old image. The Duanmen Digital Hall (数字端门馆) comprised several immersive multimedia displays and allows visitors to interact with cultural relics in the Forbidden City. The Palace Museum also merged digital content with popular cultural elements in China, such as *meng* (萌, lit. trans. 'sprout') which connotes 'cuteness', and *guochao* (国潮, lit. trans. 'national trend'). Such a modern marketing strategy has attracted more younger visitors to the museum. According to 2018 statistics from the Palace Museum, 40% of the visitors were under 30 years old; 24% were between 30 and 40 years old; and 17.5% were in the 40–50 years old age group, data which implies that younger audiences, especially those born post-1980s and 1990s, have now become the main visitors to the Palace Museum (Shi, 2018).

Cultural content consumed in China tends to be ever more digital (Li & Zhao, 2017). Advanced technologies are increasingly used in creative content industries (Abbasi et al., 2017) and there is a growing appreciation of this new medium. In 2018, the immersive art exhibition *GameBox*, which integrated elements of video games, popular culture, and fashion brands, was launched at a Shanghai shopping plaza. The art exhibition included the digital media art of David O'Reilly and Fernando Ramallo; one of the works allowed visitors to play the popular mobile game *Monument Valley 2* through a VR device (Artron, 2018). This exhibition not only partnered with branded retail products, such as smartphones, smart speakers, and wine but also invited internet influencers and fashion magazines. Unlike conventional art

exhibitions in museums, *GameBox* was more like a mass-consumption cultural product. These cultural or entertainment products have, to some extent, exposed Chinese audiences to immersive digital media.

Finally, the description of Digital China is related to China's reputation, visibility and acceptance in the world. At the international level, Digital China is modifying China's image in the world: from a 'copycat' nation to a digital superpower. The copycat image initially associated with *shanzhai* (山寨, lit. trans. 'mountain fastness') culture, which connotes counterfeits, has been decried by authorities in China (de Kloet et al., 2019; Yang, 2015). In 2015, the city of Shenzhen, renowned equally for its *shanzhai* culture and complete hardware manufacturing industry, initiated a 'maker movement' to rebuild its brand as an innovative city (Wen, 2017). As Jing Wang (2016, p. 47) wrote, the 'triple shift' – from 'made in China' to 'created in China' and now to 'making in China' is a sign that innovation is now a societal concern.

But how can China harness innovation? Technology plays a key role in this triple shift. Globally, Chinese brands associated with digital technology are being recognised by consumers, such as TikTok (short-video social media), Huawei (smartphone brand) and HTC VIVE (VR headset brand).

The changes in China's brand image are evident in international mass events. Unlike the closing ceremony of the 2004 Athens Olympics, which focused on displaying Chinese history using traditional elements like red lanterns and jasmine, China's handover performance art presentation at the 2018 PyeongChang Winter Olympic Games, entitled *Beijing 8-Minute Show* (北京8分钟) (2018), offered a contemporary landscape in which Chinese people are welcoming a world of advanced technology. The director of the show, Zhang Yimou, said, 'We made every second count during the eight short minutes to showcase a confident China not only for its profound 5,000-year-old history but also the remarkable technological achievements the country has made today' (Sun, 2018).

Orientalism, Cultural Presence and Techno-cultural Imaginaries

This book considers the role that digital technology is playing in China's rejuvenation, especially in relation to cultural displays, performances and exhibitions; it examines how audiences, both in China and globally, are responding to Digital China. In the 2008 Beijing Olympics opening ceremony, the renowned Chinese film director, Zhang Yimou, utilised elements of advanced technology to highlight China's 5,000-year-old culture. The opening ceremony apparently changed many viewers' minds about Chinese culture (Gong, 2012), and the use of digital technology is said to

have played a significant role (Chen et al., 2012). Since then, China has continued to highlight digital technology as a way to increase its people's confidence in Chinese culture and demonstrate China's cultural presence on the international stage.

The term cultural presence underpins this research. The twenty-first century has been a transitional period for China in terms of culture, economy and image. Yet, many still hold on to outdated views and see China as backwards, a Communist dictatorship that is in stark contrast to the 'free' West (Hartley, 2022; Vukovich, 2013). As Edward Said argued in his seminal work *Orientalism* (1978), the West constructed the non-West as timeless, exotic and backwards. Said demonstrated how the idea of the Middle East as an exotic land full of scoundrels and terrorists is deeply rooted in the Western imagination. He argued that this caricature of cultural heritage consistently confuses many Europeans and Americans about the complexity and variety of the region. In this vein, views about China or/and even Chinese people are often imagined through similar lenses and images represented in art and literature of their respective periods precisely. For example, from 1920s to 2000s, Hollywood produced a series of motion pictures about Dr. Fu Manchu, a supervillain. Fu Manchu is the representative of 'yellow peril', whose image constructs the stereotype of Chinese men who are ugly, sinister and cunning (Mayer, 2013). Although things have changed over time, a disconnect remains as to how the West imagines the East compared with the reality in the East. As Gregory Lee (2018, p. 3), a France-based scholar, argues, 'the "China" we have created, that we have imagined, that we have dreamt up and of which we have dreamt – the China that frightened us as well as fascinated us – has slipped our grasp'.

This book draws on a modern iteration of orientalism in the current historical conjuncture wherein a resurgence of xenophobia targeted those who look 'Asian' during the COVID-19 global pandemic (Siu & Chun, 2020). The contemporary term soft power is often applied to Asia in relation to cultural ascendency, for instance, the Korean Wave (Nye & Kim, 2019). As I have alluded to above, the use of A/VR in the arts to represent Digital China presents an updated image of China's soft power to the rest of the world, one that can be constantly refreshed in real-time. One of the goals of this book is to investigate whether this use of digital technology has the potential to combat orientalist views of Chinese representations in art and, thus, even persistent stereotypes of Chinese people in the diaspora.

The other theoretical framework that I will apply to the discussion that follows is the imaginary, a concept derived from Charles Taylor's idea of the 'social imaginary' and subsequently developed by a number of scholars as the socio-technical imaginary. In science and technology studies (STS),

the socio-technical imaginary pertains to a cluster of disciples ranging from computing to genomics, and the positioning of science and technology within nation-building projects (Jasanoff, 2015, p. 459; McNeil et al., 2016). In order to establish a link between national building through cultural outreach and technological development within China I use a hybrid concept, the techno-cultural imaginary (Zhao & Keane, 2023), which I discuss in more detail in Chapter 3.

As many authors have noted, China's presence as a technological power is rising (Cheney, 2019; Keane et al., 2020; Shambaugh, 2020; Xu & Yu, 2022). In fact, the broader Asian region is recognised as an emerging powerhouse of digital technology in terms of its significant internet population and its diversity of cultures and geopolitics (Lim & Soriano, 2016). While there are artworks curated in the West that acknowledge the technological prowess of China, the discourse of these representations is not straightforward. Sometimes they tap into the fear of the other as per the framework of techno-orientalism. Morley and Robins (2002) applied techno-orientalism to describe techno-racist stereotypes of Japan, and Japanese people in the 1980s in the context of Western fear and anxiety about Japan's rise as a global technological power. In this study, I will draw on a contemporary framework known as Sino-futurism, a belief in a technological society, which some critics might construe as technocratic. As Virginia Conn (2020, p. 66), a researcher on science fiction, argues the concept of Sino-futurism is usually applied 'externally to China', that is, by 'Western observers.' Conn posits a connection between Sino-futurism and Orientalism (Said, 1978), an argument developed at some length by the digital anthropologist Gabriele de Seta (2020), who notes that narratives of techno-orientalism often position China as last in a series of East Asian countries to invest in accelerated industrialisation and informatisation.

The research questions focus on how digital technology enables cultural presence. In this regard, I offer two perspectives. The first perspective is from the viewpoint of the nation, specifically questioning China's cultural presence in the world, which is related to discourses about cultural soft power (Chen et al., 2009; Nye, 2004; Repnikova, 2022; Wang, 2023; Zhu et al., 2019). We can see a significant global presence of Chinese products and services today compared with a decade ago; for instance, electrical goods (i.e. Huawei and Lenovo), online platforms (i.e. TikTok and WeChat), Chinese art exhibitions, and ownership of cinema distribution (Curtin, 2007; Flew, 2016; Zhu & Rosen, 2010) Regarding China's cultural soft power ambitions, a key problem is that the viewer situated outside China already has an existing preconception of China, positive or negative, and sometimes neutral; as the art critic John Berger (2008) argued, viewers stand at a distance and observe.

Berger argued that seeing is a political act, a historically constructed process. The reality of China for people living outside China is largely constructed by Western media (Sun, 2002). As noted by Lee (2018), it is an imaginary that is at odds with the reality of China in the twenty-first century.

The second use of cultural presence is specific to digital immersive art, which refers to twenty-first-century media art facilitated by digital technology. This use of cultural presence here refers to how technology can create the impression that the viewer is immersed in the artwork, thus allowing the viewer a unique kind of virtual experience. Ideally, the distance between the viewer and the artist is collapsed. Art can act as a kind of illusion (Wolf, 2013). In VR, viewers are temporally and spatially removed from their normal world of preconceptions (Grau, 2003).

The central question, then, is this: Can the cultural presence that is manifest through digital immersive art overcome preconceived ideas that may exist amongst its audience and influence their perception of (the culture or politics of) China? Answering this question involves identifying and examining the context of Digital China: specifically, factors that influence the uses of digital technology within China's cultural system, for instance, the power of China's digital platforms seeking to go global; and the aspirations for asserting China's cultural presence that are manifest in digital immersive artworks. This, in turn, leads to the following question: Can digital immersive art be used as a means of augmenting China's cultural soft power? Can this change existing perceptions of China?

As a way of responding to these questions, I analyse Chinese practitioners' perceptions regarding the functions of digital immersive art facilitated by VR/AR and the implications of those views. More broadly, the book engages with understanding how domestic and international audiences perceive Digital China through digital immersive artworks.

Why Digital Immersive Art and China

Digital immersive art is a form of art mediated by digital technology such as AR and VR. Art has traditionally had many roles and functions. The anthropologist Ellen Dissanayake (2002) lists the functions of art, ranging from ceremonial to attracting mates. Art has been used as a display, adornment, and even a spectacle. It is also the carrier of culture and ideological values (Acciaioli, 1985; Egbert, 1967). For the last 170 or so years, art has also had a specific social and political avant-garde function; that is, it raises questions about the nature of society in the hope of critiquing and potentially changing it. This function of art is addressed in international contemporary artworks found in major art events such as the Venice Biennale and Manifesta

(European Nomadic Biennial). For instance, the work by Jordan Wolfson, *Real Violence*, in the 2017 Whitney Biennial of American Art is a VR piece that depicts the artist beating a man to death with a baseball bat. The work considers the seductive spectacle of violence in digital immersive technologies (Kuo & Wolfson, 2017).

Art had revolutionary aims in early modernist times, but this was erased by the market in the West and by the state control of art in the socialist bloc (Groys, 2008). It cannot be ignored that the functions of art are regulated by commercial and political mechanisms – as a commodity and as a tool of political propaganda (Groys, 2008). Digital immersive art is widely used and sponsored by commercial spheres and politics, especially in China. VR and AR technologies are being used in commercial art exhibitions by entrepreneurs to attract more visitors, and by the government at the Olympics to display China's new cultural image. digital immersive art is no different in terms of being produced as a commodity and used as a tool of political propaganda. Hence, this project not only focuses on art itself but also on how digital technology augments the functions of art and how the mechanisms of production and reception regulate them.

AR and VR are highlighted in digital immersive artworks. The newness of technology is considered in this project as the means to upgrade China's industrial structure, rejuvenate China's culture, and influence audience perceptions. However, newness is a temporal concept. This is because 'newness' is a process of change, whereby new ideas (and new technology) are taken up socially and used (Hartley, 2021). A population will tweak, amend and apply any given invention to suit their own horizons and purposes (Hutter, 2015; Mokyr, 2011), as seen in China's rapid and ubiquitous use of online mobile payments. Therefore, evaluating the legitimacy of newness is required when considering the application of the given new technology or innovation. To this end, I critically examine the functions of digital immersive technology (including its newness) in both cultural and social terms within the context of Digital China. More specifically, drawing on empirical data, I provide an empirical analysis of how digital immersive technology (AR and VR) influences the audiences' perceptions and China's cultural rejuvenation through digital immersive art.

I argue that digital immersive art has the potential to transform human perception by bridging cognitive distance in the experience of artworks and that AR/VR technology enables the realisation of this objective. As Merlin Donald (2006) has argued, art is both created in the context of distributed cognition (i.e. art involves the linking of many minds); and art is a technology-driven aspect of cognition (the medium is important; see McLuhan, 1964). In other words, digital technology plays a substantial role in shaping cognition

or perception through art, but the functioning of technology is conditioned by social systems. In China, the so-called 'cultural system' acts as a gateway. The cultural system is embedded in the state's modernisation project, which includes massive investment in new and emerging technologies. The upgrading or 'reform of the cultural system' over the past two decades in turn has fostered a techno-cultural imaginary mixed with the pride of Chinese culture (civilisation) and advanced by digital technology and entrepreneurs. Such a hybrid imaginary influences how people view and consume digital immersive art. Much digital immersive art within China is thus viewed within the framework of modernisation, as the case studies in this book will show. Outside China, however, the dominant narrative of techno-orientalism prevails, constructing a different image of Digital China,[1] a technocratic state.

Other Contextual Perspectives

Before proceeding to address issues around cultural presence, digital immersive art or the techno-cultural imaginary in depth, there are some basic features of this research which are important to note, in particular regarding the specificity of the data provided, the terminology used, the nature of the technologies being studied, and the position I adopt.

In relation to the exploratory aims of the project, it is worth stating that critically investigating the experiences of digital immersive art viewers was one of the driving forces behind my research. The analysis I conducted was entirely qualitative. For example, the data about participants' experiences of the digital immersive artworks collected in the focus group discussions were not in any way interpreted like content analysis. I did not count examples of any particular phenomenon occurring in the case studies but, in the vein of textual analysts, simply sought out dominant themes and patterns occurring in the experience of viewers.

It is worth considering the usage of the terms 'audience' and 'viewer.' I tried to identify generalisable patterns within the sample groups and use viewers' individual experiences to evidence these patterns. 'Audience' refers to a group of people, whereas 'spectator' or 'viewer' refers to a single person. Some of my case studies that use a VR headset apply to a single viewer or spectator. To further complicate matters, many people refer to a VR 'user', rather than a 'viewer', because the interactive feature of the media allows people to not just passively view the work (Candy & Ferguson, 2014). However, the subject of this

1 The use of the term 'Digital China' in this paragraph refers to the representation and perception of China's digital transformation, rather than an official designation.

study is art, which is not simply used as such but addresses the nature of seeing and looking, for example, from a historical or political view (Berger, 2008). Hence, the term 'viewer', referring to a person who is looking, seeing, and understanding artworks, is used when addressing the individual experience of the case studies. Conversely, the term 'audience' is used when the people are considered as a group who have collective features or behaviours. For instance, in Chapter 5, audiences are regarded as Chinese mass consumers of digital immersive art in a commercialised context. In Chapter 8, the term 'audience' is used to address a different group of people who have other collective ideas. For example, Western audiences and Chinese audiences may have different perceptions of China.

It is also critical to remember digital technology is consistently developing. Indeed, in focusing on AR and VR, this project takes as its subject of inquiry a form of technology that is constantly in flux. This also means that while both AR and VR were very much alive and increasingly popular at the time of writing, this will inevitably not be the case at some point in the future. In this sense, VR and AR are considered the media of art driven by technological development and as a strategy that generates the immersive experience of art to influence people's perception. Immersive strategies have been used for centuries in art, for example, in the form of panoramas and domes in a cathedral (Grau, 2003). Nevertheless, readers might consider when engaging with this study that, while it can take some time for gaps in our knowledge among different technologies and their functions in cultural or societal contexts to be appropriately filled by academic work, the time it takes for technology to progress is much shorter.

Finally, I should reiterate my own position and subjectivity. As was apparent in the anecdote that began this book, I am subjectively close to the culture being considered. I was born in China in the 1990s, and there does not exist for me a time when China was not going through great changes. I certainly can place myself in the position of my audience participants in relation to the ubiquity of digital technology and the importance of cultural preservation. In saying this, I am, therefore, aware of my own preconceptions. To remove my own 'self' from this research would not only limit my ability to reach some of the conclusions that I have drawn about domestic audience perceptions, but it would also diminish my level of access to the study's participants. The word 'I' also runs through this document as a corollary. This study, however, is based on much more than a collection of anecdotes and personal reflections. In addition, it is not a description by an inside observer of Digital China who is seeking to avoid hard questions of power. I use keywords such as 'Digital China' and 'cultural soft power', which many outside China might read as state propaganda. To some extent, this is a valid

critique, considering the limited knowledge in the West of the 'real' China. The term 'Digital China' is associated with the collective idea of how people in China feel about the positive changes that have come with technology. Additionally, it is associated with a growing belief within China that Chinese culture is worthy of preservation and should be appreciated and understood by domestic audiences – with confidence. In relation to soft power, China's culture is currently being extended outside China. I personally feel that China should 'tell its stories well', but I am not echoing state propaganda in saying this. Explaining these keywords is a form of critique since critique is usually presented in a way that encourages rebuttal or expansion of the ideas expressed (Wood, 1991).

Chapter Outlines

Chapter 2, 'Understanding Digital Immersive Art', focuses on the definition of digital immersive art and how digital technologies such as VR and AR enhance digital art. It explains the sense of presence and cultural presence in virtual environments, which refer to how technology can help create the impression that the spectator is immersed in the artwork, in this way allowing the user a unique virtual experience of culture.

Chapter 3, 'Cultural Presence and the Rise of Digital China', provides a theoretical context for understanding China's soft power/new images in art. It introduces the concepts of digital soft power, techno-cultural imaginary and relevant scholarship. The chapter examines imaginaries, both within China and outside China and how digital technology might change the orientalist imagination of China. The chapter also explores the idea of China's new 'cultural confidence' within the framework of techno-utopianism.

Chapter 4, 'A Multi-Perspectival Approach', outlines the methodological approach and reasoning behind the selected research methods. It also looks at how the research design operated during the data collection and data analysis stages of the research. A multi-perspectival approach is applied to explore how cultural presence is generated through digital immersive art and its implications for viewers' perception of China. The chapter introduces the approach in three layers: the production and political economy of culture drawing on the practitioner interview, the text analysis of digital immersive art drawing on the close reading of the content and the examination of audience effects based on focus group discussion.

Chapter 5, 'Economic and Cultural Dynamics of Digital Immersive Art in China's Creative Industries', examines the cultural and economic roles of digital immersive art in the cultural & creative industries of China. It discusses the ambivalence of digital immersive art with respect to perceptions

of increased access to cultural artefacts versus the commercialisation and mass acceptance of VR and AR. The access to advanced digital technology has the potential to provide life-changing experiences to those who may never before had such material opportunities or experiences. The younger generation has embraced the convenience of digital devices. The government sees digital platforms as a way to curate and disseminate Chinese heritage. On the other hand, there is also some uncertainty amongst domestic practitioners about whether these advanced digital technologies (VR/AR) are actually delivering better cultural experiences than non-virtual ones.

Chapter 6, 'Generating Cultural Presence in Digital Immersive Art', examines the three case studies: *Boost Your Art Energy: 8-Minute Guided Session* (2019), *Shenyou Dunhuang* (神游敦煌) (2018) and *The Worlds of Splendors* (瑰丽) (2019), drawing on empirical data from the viewers' focus group discussions. It explores two questions: how does VR impact the viewer's cultural presence? Second, how do Chinese audiences react to the way VR presenting Chinese culture? *Boost Your Art Energy* by Wang Xin, offers a 6 degrees of freedom (DoF) VR experience, featuring pop-cultural elements. It is targeted at young consumers in K11, a museum-retail in Hong Kong. *Shenyou Dunhuang* is a free downloadable VR program from Steam featuring the 3D simulation of the Mogao Caves, a famous cultural heritage site in China. *The Worlds of Splendors* is a collection of immersive art installations that aims to use digital immersive technology to elucidate Chinese aesthetics and philosophy, such as Zhuangzi (庄子)'s Daoism and Wang Ximeng's landscape painting in the Song Dynasty.

Chapter 7, 'Playfulness as the Illusionary Experience of Cultural Presence', continues to examine the above-mentioned three case studies drawing on the viewers' reactions. It applies the concept of *playfulness* (play) to consider viewers' illusionary experience of digital immersive art and question the *authenticity* of digital immersive art through the ambivalence of viewers' perception of Chinese culture in terms of real artefacts and virtual works of art. The case studies demonstrate how techno-cultural imaginary in China influences the audience's appreciation and understanding of digital immersive art.

Chapter 8, 'Digital Immersive Art and the Problem of China's Soft Power', examines digital immersive art in two high-profile international case studies. It considers China's cultural presence on a global stage and analyses the creators' views and audiences' reactions outside China by locating the cases within a matrix of global power relations. *Beijing 8-Minute Show* (2018) is a multimedia performance work at the closing ceremony of the PyeongChang Winter Olympic Games. It was hailed by China's leadership as a great success, an example of China's emerging technological development showcasing Chinese enterprises. *Blueprints* (2020) is Cao Fei's multimedia installation exhibition in the UK based on the artist's research on Chinese

modernisation. This case study provides a more critical perspective on the impact of digital technology in contemporary society.

Chapter 9, 'Chinese Modernisation and the Futurist Arts' concludes the study. It considers the tension between art axotomy and digital propaganda in relation to digital immersive art. The Chinese government's recent plans and policy on 'metaverse' and Digital China 2023 have clearly shown a future vision of 'Chinese style modernisation'. The chapter provides a discussion of the potential downside of digital immersive art blending with propaganda and regulations around state-sanctioned digital immersive art projects. Finally, the chapter points out the cultural power of technology like non-fungible tokens (NFTs) and AI in shaping imaginaries of Digital China through futurist art and its potential engagement with the broader concept of digital Asia.

Chapter 2

UNDERSTANDING DIGITAL IMMERSIVE ART

In its most baseline understanding, digital immersive art is artistic work mediated by digital technology. Digital immersive art plays a role in disseminating cultural value. Digitisation facilitates the consumption of art products, often in new ways. In other words, art plus (digital) technology provides novel experiences and new ways of imagining the world. China now wants to 'tell its stories well'. The interface of culture and technology has changed the production, consumption and speed of distribution of Chinese culture. If Chinese art is mediated successfully, this may potentially change the image of China globally. Digital immersive art thus provides an exemplary example. In this chapter, I offer an interdisciplinary approach to critique the intersection of digital technology and art.

In the first three sections, I focus on definitions of digital immersive art and how digital technologies such as virtual reality (VR) and augmented reality (AR) enhance digital art. Following this, I consider the concept of 'cultural presence'. I provide two ways of understanding cultural presence. The first refers to how technology can help create the impression that the viewer is immersed in the artwork, in this way allowing the user a unique virtual experience of culture. The second, which I will introduce in this chapter and further discuss in the following chapter is from the viewpoint of the nation and references China's cultural influence outside the People's Republic of China (PRC). I will show how these two kinds of cultural presence are interconnected.

In a philosophical sense, the term 'presence' originates from the German philosopher Martin Heidegger's (1962) ontology of 'being'. Cultural presence, thus, reflects the ontology of culture: an individual 'being' in a cultural environment. This study argues that VR and AR have the potential to generate a cultural presence in digital immersive art. The use of digital technology, especially VR, can accelerate how artworks connect with the public, and vice versa. Art is a statement in public space. In the present day, the intervention of immersive technology, the internet and art museums are changing the

conventional definition of public space for art viewers. On the other hand, VR has helped museums make culture accessible to a mass audience by extending the museum's boundaries to the modern entertainment industry (Carrozzino & Bergamasco, 2010). The institutionalisation of cultural meaning is a defining characteristic of cultural consumption, allowing cultural meanings in art to be received by mass audiences as acceptance or norms (Dolfsma, 2004; Jackson, 2009). In the next chapter, I will focus on the institutionalisation of digital immersive art. The increasing intersection of creative practice and technological innovation has led to new market segments and consumer groups (Abbasi et al., 2017). It has accelerated cultural consumption of, and toward, the immaterial and virtual (Denegri-Knott & Molesworth, 2010).

Digital Immersive Art: Definition, Digitalisation and Distribution

Media researcher Janet Murray (2017, as cited in Banis, 2017) notes that immersion is a pleasant experience encountered through centring to a carefully simulated space. The pleasure comes from the feeling of being surrounded by a completely different reality. Another digital media researcher, Marie-Laure Ryan (2015), believes that immersion is a process of recentring whereby recipients consciously locate themselves into another world. In the process of recentring, recipients not only convert their attention to the simulated world but also temporarily believe in the reality of the simulated world. According to the explanations by these researchers, immersion is the strategy used to generate the illusionary experience of being in another world.

The idea of immersion as an art strategy goes back as far as the classical world. In art historian and media theoretician Oliver Grau's book *Virtual Art* (2003), he notes that the feeling of immersion generates an illusion. For example, the *Battle of Sedan* (1883) by Anton von Werner is a painting measuring 115 metres long and 15 metres high. Standing on a panoramic viewing platform, which had a diameter of eleven metres and corresponded geographically to a plateau near the village of Floing, the viewer was completely surrounded by the circular painting depicting the battlefield. The experience was described by viewers as the first deep impression of feeling personally involved in what was taking place (Grau, 2003). The immersive strategy is still in use in contemporary art. For example, Japanese artist Yayoi Kusama's static art installation *Infinity Mirror Room – Phalli's Field* (1965) uses LED lights and mirrored optical illusions to create seemingly endless rooms.

More recently, digital technology has mediated the immersive strategy in art, thus allowing digital immersive art to become a subcategory of digital art. 'Digital art is an artistic work or practice that uses digital technology as part

of the creative or presentation process' (Paul, 2003, p. 7). From this definition, the creation of digital art can be traced to two approaches. The first is to use digital media to present art, such as digitalising an existing artefact. Following this approach, the immersive strategy mediated by digital technology allows viewers to feel like they are being surrounded by or immersed in an artefact which has already existed (either in the past or in the present). For instance, L'Atelier des Lumières opened in 2018 in Paris, where projection mapping produced a large-scale space with digitally stimulated paintings of Antoni Gaudí and Salvador Dali. The second approach is to use digital technology to create new art. In this approach, digital technology allows viewers to feel they are in a newly created world. For instance, *Rain Room* (2012) is an experiential artwork by Hannes Koch and Florian Ortkrass. The site-specific sound, light installation, and three-dimensional tracking cameras create an immersive space where visitors walk through a downpour without getting wet.

Digital technology has changed how art is distributed. Even during the pre-digital era, people sought to publicise 'high art' through its reproduction in prints, photos and videos. In 1968, Gerry Schum executed the first television gallery 'Fernseh-Galerie Gerry Schum' in Germany. This project allowed public members to see artworks in the gallery from their homes (Bismarck et al., 2004). Artists at that time had hoped to use the television to enable artistic creation and democratise distribution. In this way, they attempted to establish a distribution system for the public on a mass scale. This experimental form of presentation broke down the barriers of traditional art institutions, allowing artworks to enter thousands of households. Today, due to the internet, digital technology allows more possibilities for the public to engage with art through the particular way digital art is presented to and interacts with its mass audiences. The Palace Museum in Beijing has used such technology to offer live-streamed guided tours in the comfort of the user's home. The guided tours offered virtual insight into the 600-year-old site and allowed users to experience traditional Chinese culture using online platforms (Xinhua, 2020). Live streaming, when done well, can be a step up from immersive art tours that the public can experience online.

The Use of VR and AR in Digital Immersive Art

As a twenty-first-century digital technology, VR has become a significant means to accomplish immersive strategies in art. In the late twentieth century, scholars predicted that VR would soon be used for everything from arcade games to architectural and interior design, to new kinds of exercise equipment (Lombard & Ditton, 1997) and art (Negroponte, 1995). Immersion in art practice is achieved through immersive environments

and immersive aesthetics generated by immersive media (Burke, 2006). In the most compelling VR experiences, the senses are immersed in the virtual world; the body is entrusted to a 'reality engine' (Biocca & Levy, 2013). Other scholars (Carrozzino & Bergamasco, 2010) have calculated the levels of immersion generated by different VR devices. They believe that the cave automatic virtual environment (CAVE) provides the highest immersive and head-mounted display (HMD); this wearable VR device generates considerably high immersion. CAVE is a cube and all six surfaces can be used as projection screens, surrounding the user within an image environment (Cruz-Neira et al., 1993). HMD is a helmet with binocular displays in which the images on two monitors provide a three-dimensional perspective (Grau, 2003).

However, the quality of the digital experience depends on the rendering of the digital visualisation, including the quality of the specific hardware, server, software, browser and more. Although we may think that VR will bring a better viewing experience, its technological limitations are the main hurdle to VR access in the public domain. For example: VR HMD is expensive, at least is not cheap; there is a screen door effect[1] (Cho et al., 2017) because of low resolution which cannot be adequately avoided; while some headsets are still awkward to wear. Focusing on a screen a few inches in front of your face for an extended period causes eye strain. Some people experience motion sickness during use (Kim et al., 2018). However, Jeremy Bailenson (2018), a researcher on the psychology of VR and AR, is optimistic about the technology because of the technical improvements that have been made in recent years.

The gallery, library, archive and museum (GLAM) sector has adopted VR in cultural and art projects. VR constitutes a means to reconstruct artworks or artistic/historical environments that may have been destroyed or damaged, or a way that preserves and safeguards the originals. Film and media arts researcher Maggie Stogner (2011, p. 117) argues that 'the new immersive techniques can attract more diverse and younger audiences, increase accessibility to cultural experience, enrich visitor engagement, lengthen memory retention and inspire new ways to tell and share cultural stories.' As the information in VR is not mediated by language but conveyed mostly by sensorial feedback (i.e. images and sounds), it is easier to engage with and educate non-specialised users. As a result, the relationship between VR and cultural heritage is more consolidated and cultural institutions,

1 The screen door effect is a mesh-like appearance that occurs where visible gaps between pixels are seen on an electronic screen, usually when viewed close up.

primarily museums, can exploit the potential of this technology (Carrozzino & Bergamasco, 2010). For instance, as I have mentioned in Chapter 1, the Palace Museum in Beijing created a virtual heritage project in 2017 named 'Duanmen Digital Hall'. This virtual heritage project includes several immersive multi-media displays (i.e. VR HMD), allowing visitors to interact with simulated cultural relics.

With the interface of digital technology and contemporary art, VR has also become a means for artists to create new forms of art. In the 1990s, Australian media artist Simon Penny et al. (2001) first linked the concepts of telepresence and immersion in their art project *Traces* (1999). *Traces* is a project for networked CAVE installations. The first public presentation of *Traces* was at Ars Electronica in 1999 in Linz, Austria. The work not only provided an immersive experience but also allowed interaction among users in different places. *Traces* marks a critical stage in developing telepresence art. Users enter the virtual spaces to interact with traces of light that represent the dynamics and volumes of human bodies. Interactions take the form of real-time collaborative sculpting with light, generated through dancing with telematic partners (Grau, 2003). Instead of mirroring or simulating an existing artefact, contemporary artists can use VR to create a virtual world beyond the real and facilitate real-time interactions between people who are physically far apart. Human–computer interaction (HCI) researcher Nicholas Negroponte (1995, p. 116) suggests that VR 'can make the artificial as realistic as, and even more realistic than, the real'. Such creative practices like *Traces* have broken down the restrictions of the real world. Wages et al. (2004, p. 223) even suggest that VR art should not be restricted by real-world constraints. AR is also being used to generate immersive experiences. Höllerer and Feiner (2004, p. 2) define an AR system as 'one that combines real and computer-generated information in a real environment, interactively and in real-time and aligns virtual objects with physical ones.' Immersion can be applied to AR in a way that builds reality on the basis of the actual space nearby but adds virtual objects to that real space. For instance, Moment Factory, a Canadian multimedia studio, orchestrated an immersive and epic experience for visitors to the Notre Dame Basilica by projecting computer-generated images on the internal surface of the basilica. AR technology is often used in mass events to present spectaculars to audiences in front of a screen. For example, on the opening day of the 2019 Korea Baseball Organization season, SK Telecom used its self-developed AR hologram technologies to present a fire-breathing mythical dragon called a wyvern in the stadium to the audiences watching the event on TV, while those in the stadium using their smartphones could also see this high-tech spectacular (Hwaya, 2019).

Today, VR and AR technologies are growing rapidly, and they are being cross-fertilised (Jung et al., 2016) and together are regarded as extended reality (XR) (Chuah, 2018). XR technology blurs the boundaries between the real and virtual worlds, enhancing the realism of virtual experiences and creating a space where the boundary between the two becomes indistinct. This makes the application of VR and AR within digital immersive art more complex. VR and AR offer different interactions with reality: VR isolates viewers from the real world, and AR overlays computer-generated information with the real world. However, in the practice of digital immersive art, these two technologies are used in negotiated ways. For instance, *Flesh and Sand (Carne y Arena)* (2017), an American short VR art project, places the viewer among a group of illegal aliens moving across the Mexican border into America until the border patrol stops them. When viewers put on the VR headset, they can still feel that there is sand on the physical ground and that they are wearing a backpack, which enhances the virtual experience. The virtual experience of border crossing is thus augmented by the actual experience of stepping on the sand. Transformation is a dimension of creativity in art (Boden, 1994). VR and AR are digital forms, so their digital capacity enables them to transform from one to another. Visual artist and scholar Desmond Hui (2019, p. 18) believes that the transferability between AR and VR provides an interesting direction for artists to explore since the variability between the augmented real world and the virtual world may enable the creation of unexpected sensory effects. Accordingly, this study does not aim to isolate the different uses of AR and VR but rather considers how these two advanced digital technologies contribute to immersive art strategies.

The Digitalisation of Art for the Public

Driven by digital technology, particularly VR and AR, digitalisation has become an important way to restore and protect artefacts in galleries and museums (Jones, 2007). In line with Walter Benjamin's idea of mechanical reproduction, digitalisation seems to create the illusion that there is no longer any difference between original and copy (Groys, 2008). Moreover, it is now possible for multiple copies of these works to circulate within information networks. Museum arts should be made more accessible to the public. So, why should we just exhibit these artworks in galleries or museums? Why not just let them circulate freely through information networks or be experienced through VR headsets?

The museum is to some extent the guarantor of the authenticity of the artefact. 'Its [the museum's] anonymous and indirect validation enhances the aura of specific and fallible authorship' (Hein, 2006, p. xix). Historically,

the museum and gallery were spaces for collecting, preserving and displaying artefacts, and for the private contemplation of these artefacts. However, nowadays, they have become gathering places that publicly generate private experiences for people; they also have the function of educating and shaping the public's ideology (Hein, 2006). Art historian Cher Krause Knight (2011) argues that the art museum has increasingly paid attention to its role and issues of civic engagement, especially during the 1990s and 2000s. She believes that the public's agency at museums — like the populist intent in public art — is on the rise and gathering critical attention (Knight, 2011, p. 50). Moreover, in its annual conference in 2003, the Australian Society of Archivists (2003) introduced the concept of GLAM, the unity of different cultural institutions with a mission to gather public support and interest in their collections and activities, and to provide access to knowledge. Therefore, the GLAM sector, or the galleries and museums in this particular case, have an obligation to safeguard the authenticity of the artefacts, which cannot be achieved by anonymous circulation through the internet.

Groys (2008) believes that digital art loses its authenticity and 'aura' through its digital copies. Authenticity is the specific and mysterious attribute that only the original art object has. 'Aura' is the invisible value of authenticity in art. Walter Benjamin argued that only the original artefact has this 'aura'. In his 1935 essay, Benjamin (2008) notes that traditional artwork loses its aura when it is reproduced in the age of mechanical reproduction. Digital art itself is the invisible data that is stored on a computer and can be copied, so the availability of the copies dissolves the authenticity of digital art. As Groys (2008) argues, the visualisation of image data causes the loss of 'aura'; the aura is invisible, and nothing is more disruptive to the 'aura' than visualising the invisible:

> [...] the loss of aura is especially significant in the case of the visualisation of an image file. If a traditional 'analogue' original is moved from one place to another, it remains a part of the same space, the same topography – the same visible world. By contrast, the digital original – the file of digital data – is moved by its visualisation from the space of invisibility, from the status of 'non-image' to the space of visibility, to the status of 'image'. (Groys, 2008, p. 85)

Although different from mechanical reproduction, digital art is nonetheless easy to copy. The original artwork is first digitised as a data file stored on a computer and then visualised as the image we see. Digitalisation is not only a process of copying but also the visualisation of the invisible. A digital image, which is to be seen, should therefore not be merely exhibited but staged and performed (Groys, 2008, p. 84).

Virtual heritage aims to recreate navigable worlds of three-dimensional images while also providing something much less tangible, including historical, artistic, religious and cultural significance (Stone & Ojika, 2000). HCI and VR researcher Maria Roussou (2007) believes that virtual heritage is a representation that disseminates knowledge concerning the past and history. In the exhibition and staging process, museums play a significant role since curation modifies the performed image in a substantial way. VR and AR have the potential to demonstrate beyond the visible world, which means that contemporary curatorial practice can possibly do something that the traditional exhibition could do only metaphorically, that is, exhibit the invisible (Groys, 2008, p. 91). In other words, the digital reproduction of a 'real' non-digital artwork can capture some invisible 'aura' of the original work or site through curation. For example, the art museum L'Atelier des Lumières, which I introduced previously, digitalised artists Gaudi's and Dali's works by projecting massive digital images on the interior of the exhibition space. The invisible 'aura' of Gaudi's and Dali's works is exhibited in the museum, which allows visitors to explore the limitless 'inner' worlds of the works.

The intersection of immersive technology (AR and VR) and the internet creates a hybrid public space in the digital age which further fosters the experience of digital immersive art to the public. As Teigland and Power (2013, p. 2) have discussed, in the 'immersive internet' people can share and create information with others, as well as with virtual and augmented spaces and sites. Nevertheless, before the concept of the 'immersive internet' was promoted, users had already built up various two-dimensional virtual worlds on the internet. The idea of the virtual world is originally derived from the term 'metaverse' in Neal Stephenson's science fiction novel *Snow Crash* (1992). Some scholars in media and games interpret this term as a virtual world, as a computer-simulated environment in which users can simultaneously and independently explore the virtual world, participate in its activities, and communicate with others (Aichner & Jacob, 2015). More recently, the idea of the virtual world has been integrated with immersive experiences. For example, VRChat, the VR social media, allows users to create their own spaces, and through networking, users can communicate and interact in real-time in these virtual spaces (Alexander, 2017). Moreover, with the launch of the online VR platform, Rec Room is trying to build a 'metaverse' of gaming where users can create and play games together across different platforms, including smartphones and VR HMD (Takahashi, 2021).

The intersection of VR and digital networks as a public space has been readily adopted in digital immersive art by artists. 'Public space can take the form of archiving and filtering public contributions, merging physical and virtual spaces, and augmenting physical sites and architectures' (Paul,

2008, p. 163). For digital immersive art, such creative contexts are not only display channels but also the means to provide immersive interaction among audiences, objects and virtual spaces. Artists in the late 1960s and 1970s had already experimented with live networked performances that anticipated the interactions now taking place on the internet and through the use of streaming media (Paul, 2008, p. 165). For example, in Max Neuhaus' art project *Public Supply* (1966), he established a connection between a radio station and a telephone network whereby participants could intervene in the performance by making a phone call. 'Metaverse' and the intersection of VR and public space can potentially promote the popularisation and accessibility of digital immersive art to wider audiences. AR and VR are helping make culture and art accessible to the mass audience. These technologies have already started a process, referred to as the 'desacralisation' of art institutions (i.e. museums) (Carrozzino & Bergamasco, 2010). This extends the boundaries of digital immersive art across the modern entertainment industry.

Cultural Presence in Two Theoretical Contexts

I explore the concept of cultural presence from two perspectives. In this section, I will focus on teasing out the dual definitions. The first usage of presence is specific to digital immersive art, a twenty-first-century cultural technology. This usage refers to how technology can help create the impression that the spectator is immersed in the artwork, in this way allowing the user a unique kind of virtual experience. Ideally, the distance between the viewer and the artist is collapsed. The arts can act as a kind of illusion (Wolf, 2013). In VR, for instance, viewers are temporally and spatially removed from their normal world of preconceptions. Grau (2003) believes presence is the sense of centring in another world. He explains the aesthetic paradox of presence in VR art in terms of how this presence 'enables access to virtual spaces globally that seem to be experienced physically while at the same time, it is possible to zap from space to space at the speed of light and be present simultaneously at completely different places' (Grau, 2003, p. 271).

The second usage of presence is from the viewpoint of the nation, namely 'cultural soft power' (文化软实力), a term now used by the PRC government to refer to the influence of Chinese culture in the world. David Shambaugh (2013), an American researcher on contemporary China and international relations, argues that China is a partial power, with a 'greater presence' but not necessarily greater influence. As mentioned in the introductory chapter, China has achieved a global presence of digital products and services compared with a decade ago. However, a key problem for the cultural soft power project is that the viewer situated outside China has an existing

preconception of China, positive or negative, and sometimes neutral; they stand at a distance and observe. This distancing exists in most public artwork, as discussed in John Berger's *Ways of Seeing*, first published in 1972. Berger (2008) argues that seeing is a political act, a historically constructed process. The Western media have largely constructed the image of China for people living outside of China (Keane et al., 2020; Sautman & Hairong, 2009), and it sometimes structures an imaginary that is at odds with the reality of China in the twenty-first century (Lee, 2018).

Presence and Cultural Presence in VR

People are usually considered 'present' in an immersive VR experience when they report a sensation of being in the virtual world (Schuemie et al., 2001). Presence is a general and multi-dimensional concept which can be easily understood as an individual's feeling of being there (Minsky, 1980). In fact, scholars have defined the special experience of VR as presence (Lombard & Ditton, 1997; Steuer, 1992; Witmer & Singer, 1998). Presence is related to two kinds of experience: 'first-order' and 'second-order' mediated experience (ISPR, 2000). First-order mediated experience is the 'normal' or 'natural' way we perceive the physical world and provides a subjective sensation of being present in our environment (i.e. being in a forest or at a concert). The second-order mediated experience of presence is mediation by technology. The feeling of presence varies in different degrees (i.e. presence does not occur, presence is greater, or presence is maximised) depending on the different mediation of technologies. The viewer in an advanced VR experience can have a real sense of presence and partially acknowledges the role of technology in generating their experience. When an audience member's perception of VR cannot accurately acknowledge any role of technology in the experience, presence reaches its maximum (ISPR, 2000).

With the proliferation of terms across different disciplines, there are various definitions of specific aspects of presence. For example, the terms 'spatial presence' and 'physical presence' refer to the experience of individuals feeling they are in a physical location and environment different from the actual location and environment in the real world while partly neglecting the meditation of technology (ISPR, 2000). For example, in a VR experience that occurs via an HMD, spatial presence is achieved when the virtual space reacts to the user's body in the same way as in the real world. Moreover, when viewers devote all of their mental effort to processing what the technology creates rather than concentrating on the technology itself, they will feel 'psychological immersion' (ISPR, 2000). For instance, VR can arouse a sensation of nervousness when people play horror games in VR (Bender, 2021).

With the appearance of these newly coined concepts relating to presence, some researchers have started to realise that presence in the context of VR not only relates to the user's physical feeling of 'being there', but also to functional perspectives, such as interaction, virtual environments (VEs), and social construction (Flach & Holden, 1998). From an ecological view, psychologist James J. Gibson (2014) explains affordance as the possibilities or opportunities that the environment offers or affords animals (humans). At the same time, a particular affordance is dependent on both environment and animals (humans). For example, for a human, the ground affords walking; the surface of the water in a ditch does not afford support or walking for humans, but it does for water bugs. In a VE, affordance provides usefulness and allows users to act on VEs. Some works try to enhance the presence in VE by providing the user with a realistic experience. However, presence is not just the user feeling how real the VE is but also how logical the allowed actions are in a specific context (i.e. cultural framework).

Since this study concerns cultural aspects of VR, I will identify the term 'presence' in the context of culture. However, before moving on to a discussion of this, it is necessary to address social presence, the concept with which cultural presence is associated. In order to improve the sense of presence in VR, Giuseppe Riva and Giuseppe Mantovani (2000) propose the concept of social presence. Social presence can be understood as users feeling they are communicating with one or more other people or entities in VEs (ISPR, 2000). More recently, Riva et al. (2014) explained the concept of social presence by considering VR as communication media: social presence is regarded as an interactive experience that allows the self to identify and interact with others by understanding their intentions. There are three layers of social presence: other's presence – the ability to imitate a human being; interactive presence – the ability to identify a human being who is intimating me; and shared presence – the capacity to see oneself in another person, to get inside another's thought and state of mind (Riva et al., 2014). These layers emphasise the social attributes of presence, which is significant for multi-user VR (Riva et al., 2014). In this context, culture is considered to be a social construction. In addition, Riva and Mantovani (2000) note that two elements should be considered: a cultural framework, and the possibility of negotiation for both actions and their meaning; based on this understanding, the two researchers link the idea of culture and presence and provide a socio-cultural approach incorporating three key concepts, namely presence, communication, and cooperation, which link to the experience in VR. Riva and Mantovani (2000) believe that it is necessary for communication to build up a common ground in VE, namely via a cultural framework. The concept of social presence shows the importance of symbolic references in

a cultural framework and the user's understanding of them for the sense of presence in VEs. To this end, the cultural framework influences the user's expectations and interpretation of a VE (Pujol-Tost, 2018). For instance, users from different cultural backgrounds may have different understandings of the cultural elements in a virtual heritage experience.

Nevertheless, the significance of cultural presence and social presence is not the same. The archaeologist Laia Pujol-Tost and media technology researcher Erik Champion (2007) argue that cultural presence and social presence should be separated since social presence does not necessarily lead to cultural presence even though culture is a projection of society. They assert that the value of culture lies in learning and inheritance. Social presence and cultural presence are both relevant to collaboration, communication, or sharing, but the aim of cultural presence is not just communicative. In fact, over-communication in presence may negatively impact the quality of learning in virtual heritage (Pujol-Tost & Champion, 2007). Cultural presence refers to the feeling that people belonging to a specific culture occupied, or had occupied in the past, within a (virtual) environment (Pujol-Tost, 2018). Champion (2011, p. 179) defines cultural presence as 'the feeling of being in the presence of a similar or distinctly different cultural belief system'. Cultural presence also can be generated in a cultural context which is proximate to the viewers. Alternatively, it can be generated in an alien cultural context. Champion and Pujol-Tost use cultural presence as the criteria for evaluating virtual heritage projects. The aim of digital media is to facilitate understanding and appreciation, and communicate, safeguard, and respect the authenticity of cultural heritage (ICOMOS, 2008). To this end, the value of cultural presence in virtual heritage should involve not only physical immersion but also the cognitive and emotional aspects of digitally mediated learning (Pujol-Tost & Champion, 2007). Hence, it requires understanding how viewers interpret or receive the representations in the VEs rationally and emotionally.

The cultural presence of digital immersive art requires viewers to exercise their imagination from the emotional side and their understanding from the rational side. Aesthetician Werner Wolf (2013, p. 51) notes that when people appreciate artworks, there are two poles in the process of art reception: one is the emotional pole – immersion which triggers recipients' imagination that the aesthetic experience is a similar kind of experience to that in real life, and the other pole is the rational pole – distance – when people experience aesthetic illusions, they are still in their 'right minds' and able to 'read' a representation (Wolf, 2013). Immersive technology aims at eliminating the distance between viewers and artworks. Presence in virtual art is indeed a mediated perspective that surmounts great distances (Grau, 2003) because

of the more interactive and immersive designs in VEs. When the user is immersed in a high-resolution 360-degree immersive space, VR dissolves the interface of artworks to achieve more naturalistic and intuitive designs (Grau, 2003, p. 202). Moreover, the presence of interactive experience that VR generates, in turn, allows viewers to become the art – to be part of a world, even to be a character (Rubin, 2018). Some scholars have focused on users' emotional or sensational reactions to VR. For example, immersive media researcher Stuart Bender (2021) examines users' emotional responses in VR by monitoring their heart rates or facial expressions and using eye-tracking.

The other aspect of art reception, when the distance is dissolved, is equally significant, that is, whether viewers of digital immersive art are still in their 'right minds' and able to 'read' a representation. Wolf (2013) believes that in art reception, distance as the rational side contradicts immersion. According to the theory of the horizon of expectation, a person comprehends, decodes and evaluates any text (including visual content of art) based on cultural codes and conventions particular to their time in history (Jauss & Benzinger, 1970). Art is self-reflective or, to use another word, 'metacognitive', as defined by Canadian psychologist Merlin Donald (Donald, 2006). 'The artistic object compels reflection on the very process that created it – that is, on the mind of the artist, and the society where the artist emerged' (Donald, 2006, p. 5) (i.e. in a historical context or a cultural framework), so a cognitive distance is required for viewers when decoding the artworks (Berger, 2008). Distance always comprises the possibility of attaining an overall view; understanding organisation, structure, and function; and achieving a critical appraisal (Grau, 2003). The philosophers Hans Jonas (1973) and Hartmut Böhme (2014) advance arguments against aesthetic experience where distance is absent, and both believe in the significance of the subject-constitutive, epistemological quality of distance in aesthetics. Presence in VR is not only an index for audience evaluation by measuring the embodied experience of immersion; it also helps to refine and improve theories related to the intersection of culture and technology (Grau, 2003; Jeon & Fishwick, 2017). Therefore, this study not only aims to explore whether the concept of cultural presence in VR contributes to digital immersive art as an art strategy that creates immersive feelings; more importantly, it aims to examine whether this cultural presence impacts viewers' perceptions (cognitive distance) in digital immersive art.

Conclusion

In this chapter, I have defined digital immersive art as the new form of digital art which had adopted the strategy of immersion, one that is mediated by digital technology. In line with Grau (2003), digital immersive art recognises

immersion as an art strategy to generate an illusionary experience of being in another world for viewers. As advanced digital technologies, VR and AR are used to create immersive experiences that simulate existing artefacts (Bailenson, 2018) but in a way that represents the world beyond the actual world (Negroponte, 1995; Rubin, 2018). In line with Benjamin's (2008) idea of mechanical reproduction, digital technology seems to create the illusion that there is no longer any difference between the original and the copy. Moreover, it is now possible for immersive multiple copies of these works to circulate within information networks, which makes the arts even more accessible to public audiences. However, some researchers are concerned that the use of digital technology in art has started a process of desacralising art institutions (i.e. museums) (Carrozzino & Bergamasco, 2010) and eliminating the authenticity of art in the digital age. Essentially, this is the first modality of cultural presence: I will now turn to its broader usage.

Chapter 3

CULTURAL PRESENCE AND THE RISE OF DIGITAL CHINA

While the first modality of cultural presence is digital immersion, the second modality of cultural presence is related to the target audience more broadly and to cultural exports; that is, it pertains to national influence or reputation. In academic literature, the concept of soft power, coined by a US political scientist, Joseph Nye in 1990, is widely used and has recently entered the popular lexicon. Soft power, however, is somewhat problematic, as I will explain below. Yet despite definitional inconsistencies, China seeks to build on its soft power, together with economic and military hard power (Wang, 2008). With increasing global presence in economic and security areas, for instance, massive investment in the Belt and Road Initiative, China is a key player in geopolitics. The political scientist David Shambaugh (2013) argues that China remains a partial power, an idea disputed by many Chinese scholars. China's material presence is however undisputed. The nation has achieved widespread recognition in manufacturing. People in many countries are aware of made-in-China goods. Yet China's cultural reputation has failed to ascend to the global stage and this has been a cause for concern within government circles.

In this chapter, I extend the idea of cultural presence and introduce the concepts of digital soft power and techno-cultural imaginary. I examine imaginaries, both within China and outside China and speculate how digital technology might change orientalist perceptions of China. I then explore the idea of China's new 'cultural confidence' within the framework of techno-utopianism. The chapter also explores some of the themes raised in Chapter 2, namely, the cross-fertilisation of culture and technology, and the consumption of art. In order to take a critical look at the function of digital immersive art in institutionalising cultural meanings, the chapter reviews the concept of digital virtual art (Denegri-Knott & Molesworth, 2010) and the political mechanism of art (Groys, 2008). In his book *Art Power*, the art critic Boris Groys (2008, p. 12) argues that art can be produced and distributed to the public in two ways: as a commodity or political propaganda tool.

In line with Groys, this study takes a critical view to show how commerce and politics regulate the functions of digital technology and the consumption of digital immersive art. By referencing the theories of these scholars, I examine the implication of aesthetic and cultural values contained in digital immersive art for audience perceptions of China, and the influence of the convergence of digital technology and culture on a nation's cultural presence in the world.

Digital Soft Power

China's cultural presence is not only mediated by conventional soft power strategies, for instance, overseas delegations, performances and festivals but also is remediated in real-time through online communication. This simultaneous transmission allows cultural images to be presented and represented globally. In this respect, the medium is the message, to paraphrase Marshall McLuhan (1964).

Cultural presence is comparable to national cultural branding; more specifically in the context of Digital China, it relates to cultural assets that are created and disseminated online. In China, the term 'cultural soft power' (文化软实力) (Hu, 2007) has been used since the mid-2000s and as I will argue, it represents a kind of proxy for cultural presence. Having cultural presence does not necessarily translate to cultural soft power but the presence of Chinese culture internationally is a prerequisite for the former. The term soft power was originally coined by the American political scientist Joseph Nye (1990). Florian Schneider notes: 'In public diplomacy, the term usually describes a government's ability to influence foreign public opinion in its favour, and to generate goodwill among the citizens of other countries for its foreign policy' (Schneider, 2019, p. 205). Soft power refers to the attractiveness of a nation's culture and values – the ability to 'attract' followers rather than using force (hard power) (Keane & Chen, 2017). In many global soft power rankings, China is evaluated as exhibiting weak soft power. Keane et al. (2020) note that the metrics used by Western agencies are heavily based on liberal norms like democracy and human rights. For example, in the US-based Portland Soft Power 30 Index, China ranked 27th (fourth from last) in 2019. The problem of soft power therefore is how to measure it. A number of different approaches are used. However, most evaluations are based on subjective assessments, and evidently, a liberal bias is built into the Western model.

In order to emphasise its cultural assets, especially traditional culture, Chinese scholars and policymakers have favoured cultural soft power to refer to the nation's cultural image outside the PRC. The Chinese government monitors the output of its cultural products, such as films, TV programs, artworks and science fiction, to the rest of the world. This approach reflects

China's foreign policy, which also draws heavily on cultural values. Tim Winter (2019), a researcher on the geopolitics of culture, believes that China uses cultural heritage as an instrument of spatial and social governance; he calls this 'heritage diplomacy'. For instance, China's new Silk Road policy (the Belt and Road Initiative) is not just the bundling up of geopolitical power and geography but also the bundling of material objects (the heritage of the Silk Road) from the past into a grand narrative of connectivity, past and present (Winter, 2019, p. 24). China has a large digital footprint through its outreach, which we might call a digital cultural presence. The Chinese government is building a new digital Silk Road; and digital infrastructure and network applications have been granted a central position in the Belt and Road Initiative (BRI) (Fung et al., 2018; Shen, 2018).

Keane et al. (2020) argue that this digital cultural presence has the potential to transform China's international reputation from the stereotype of a copycat nation to that of an innovative nation. For example, the Internet+ strategy launched in 2015 contributed to the rise of China as a global power and has also motivated Chinese internet companies, such as social media and video-sharing platforms (i.e. TikTok), to be classified as cultural exporters.

The evaluation of China's soft power has until recently been predicated on its non-digital media, that is, older tangible art forms, including heritage, art and performance (Kang, 2012; Shambaugh, 2015; Winter, 2016). As digital immersive art is positioned at the intersection of advanced digital technology and art, the question is: Can digital immersive art thus be used to augment China's cultural soft power and, in this way, change global perceptions of China? To answer this, it is necessary to understand how foreign audiences view China's cultural presence. The Singaporean sociologist Chua Beng-Huat (2009) has identified three levels of understanding of China according to where viewers are geographically situated: first, the Chinese native living in China; second, overseas Chinese seeing China through a distant lens; and third, so-called 'foreigners', for example, the imagined Western audience. Lenses differ. People outside China may be 'dragon slayers' (someone who thinks the situation in China is terrible) or 'panda huggers' (someone who believes that almost everything going on in China is good) (Gifford, 2007).

People living in China currently identify with a resurgent China. The Chinese Dream legitimises how the government operates (Wang, 2014). The concept of the Chinese Dream, which is manifested in cultural products (e.g. exhibitions, TV programs and movies), is understood by many Chinese audiences as the shared identity of a rejuvenated nation in terms of technological advances, economic security and improvement in people's daily lives (Keane, 2016; Pow & Kong, 2007). As I have discussed in Chapter 1, advanced digital technology (i.e. VR and AR) is widely used

in the production and distribution of China's cultural products. Technology is an instrument to enhance 'national cultural power'; in other words, to make China a strong cultural power (文化强国). Within China, this term is suggestive of how many people feel about the changes that have come with digital technology. The Chinese Dream and the more recent idea of 'cultural confidence' (文化自信) are associated with a growing belief among elites and policymakers that Chinese culture should be accepted and appreciated by other nations (Xi, 2017, as cited in CGTN, 2020).

The understandings of China mentioned above are based on what scholars in political science, sociology and communication refer to as imaginaries. The philosopher Charles Taylor (2003) uses the term 'social imaginaries' to illustrate how people collectively come to see themselves. The origins of imaginaries can also be traced to Benedict Anderson's work on the 'imagined community'; Anderson (2020) showed how the print media advanced political movements, and democracy, in south-east Asia. In Taylor's work, imaginaries legitimise democracy. Taylor was writing about Western liberal democracies.

At the end of the nineteenth century, intellectuals and writers in China looked to the West, translating ideas across cultures, often via Japan, a nation that had experienced significant political and institutional reforms during the Meiji Restoration period. Japan's reformers had opened the nation's doors to Western technology. The key period was called the New Culture Movement (1915–1930). According to Chen Duxiu, one of the founders of the Chinese Communist Party, China should assimilate Western values, expressed as Mr Democracy and Mr Science (Wang, 1995, p. 53). Western ideas were new and seemed to offer solutions. Evolution, for example, allowed people to think about the future rather than be caught up in a traditional Chinese model of recurrence, that is, the dynastical model (Pusey, 1983, p. 238). In effect, a new cultural movement led to the birth of a social imaginary, a collective aspiration for change. This 'social imaginary', while largely confined to urban knowledge centres, aimed to bring about a broader renewal of social consciousness.

The social imaginary of the times was eventually subsumed into a political imaginary, underpinned by Marxism and Mao Zedong Thought. Mr Democracy was unnecessary although Mr Science was deemed useful. This political imaginary anchored society until the 1980s, when China opened its doors to the world. The philosopher Cornelius Castoriadis (1987) developed an idea called the 'collective imaginary'. He argues that when the collective imaginary, also called the 'instituting' imaginary, breaks down, it is necessary to create a new one. Hence, there have been revolutions and coups in many societies. It is important, therefore, to note that an imaginary in this sense does not belong to an individual: it is something a group of people collectively identify with.

The France-based cultural theorist Gregory Lee (2018, p. 3) says that an imaginary is a 'clutch of phrases, images and beliefs which make up the commonly held understanding we have of a group or community (be it an ethnicity or a nation, our own or someone else's), and which dictates the way we perceive it or them'. Hartley and Potts (2014) believe that a culture-made group or association forms a 'we-community' built around culturally made meaningful identities. Groups can occur at many different scales; for example, a family or a nation.

In the past, European and American sinologists and novelists have imagined versions of China, often based on crude stereotypes (Lee, 2018). This kind of imaginary evolved from orientalism (Said, 1978), for instance, Western stereotypes that relegated China to a space of backwardness, or weakness. Of course, China was backwards compared with the developed West during the period when Western technology advanced. However, there is significant cultural dissonance in how the world imagines China compared with how China and its people imagine China. Lee (2018) argues that in the twenty-first century, 'China', whose shape and form and categories those in the West invented and maintained, is starting to escape from these categorial limitations. In the present day, China is arguably a 'digital power', and its 'digital power' has been diffused through the production of culture and artworks both within and outside China.

The Techno-cultural Imaginary and Cultural Confidence

By 1996, China had plugged into the world wide web. The development of technology since that time has culminated in a platform society, similar to but different from the West. China's internet population by 2023 had reached one billion, China Internet Network Information Center (CNNIC, 2023); people use digital payment systems; and universities now churn out large numbers of tech-savvy graduates. The Taiwanese tech entrepreneur Kai-Fu Lee (2019) has conjured up the futurist idea of China as an AI Superpower according to which Chinese dreams of prosperity will be manifested in the cloud. Meanwhile, many Chinese people have embraced a 'sociotechnical imaginary', a collective vision of desirable futures created by science and technology (Jasanoff & Kim, 2009; Kim, 2018). In science and technology studies (STS), the sociotechnical imaginary refers to a cluster of disciples ranging from computing to genomics; it also reflects the positioning of science and technology within nation-building projects (Jasanoff, 2015, p. 459; McNeil et al., 2016). In China, the 863 Program (National High-Tech Research and Development Plan) initiated in 1983 raised technological projects to the forefront of national planning. In 1988, the status of science

and technology was further elevated in China when Deng Xiaoping proposed that science and technology were the primary productive forces, igniting a heightened enthusiasm for technological development.

The term sociotechnical, while useful, draws the focus away from culture, an ever-present and dominant theme in narratives of Chinese-style modernisation, in which the modernisation of China must align with its own civilisation, culture and national conditions, and of course, political ideology. A similar explanatory weakness applies to the term social imaginary. McNeill et al. (2016, p. 438) note that all imaginaries are 'necessarily social in some way'. In order to explain the systems that regulate social life in China, it is necessary to understand the importance of culture, particularly its Confucian elements. During the reform period, from the 1980s to the end of the millennium, debates about the role of technology were somewhat separated from the cultural field as China sought to build its technological capacity by learning from the West.

A change in perspective started to emerge within the Chinese Academy of Social Science (CASS), as the concept of blending technological innovation and cultural creativity gained traction. This shift was driven by the widespread adoption of mobile devices, which provided people with the opportunity to explore new realms of imagination. Li Wuwei (2009), an economist at the Shanghai Academy of Social Sciences and a vice-chair of the Chinese People's Political Consultative Congress (CPPCC), played a prominent role in promoting collaboration between science and technology scholars and cultural scholars, emphasising the importance of mutual understanding and exchange of ideas.

More recently, in the eyes of many progressive thinkers in China, the integration of technological innovation and cultural creativity would allow the former to upgrade culture (Jin & Ziye, 2023; Li & Zhao, 2017). Tech companies have capitalised on this trend by applying technologies and platforms to promote Chinese traditional culture, thereby expanding reach and attracting new audiences for Chinese narratives. This in turn reinforces the concept of 'discourse power', a combination of technological and economic influence that is central to the goals of national cultural rejuvenation. Through digital channels, it enables the effective dissemination of an idealised vision of China's future, often referred to as a 'community of shared future' (Y. Zhao, 2018), to the global audience, while reminding people within China of 'shared prosperity' and civilised online conduct. This Sino-futuristic narrative is characterised by impressive demonstrations of advanced technologies like virtual reality (VR), robotics, and artificial intelligence (AI), alongside depictions of harmonious cultural interactions. Thus, the dominant imaginary is a hybrid concept, a 'techno-cultural imaginary' (Zhao & Keane, 2023). Chinese tech giants such as Alibaba, Tencent and ByteDance are enthusiastic about helping Chinese cultural content reach global audiences.

Cultural confidence ('文化自信') is a message that resonates with national rejuvenation. The term was mentioned frequently in speeches from the 20th National Congress in October 2022. The newly elected Politburo member Li Shulei (2022) asserted that a key challenge is 'accelerating the construction of Chinese discourse and Chinese narrative system, telling Chinese stories well, spreading Chinese voices well, and presenting a credible, loveable and respectable image of China [...].'

In this political understanding, the digital reach of platforms can effectively add to Chinese people's cultural confidence. However, outside China, there is another picture. For centuries, discourses with an ethnocentric perspective have shaped the Western perception of China. As pointed out by Edward Said (1978), Western scholarship constructed the non-Western world as timeless, exotic and culturally backward. More recently, these ethnocentric narratives have collided with a techno-centric vision of digital China, where China's image is shaped through digital media, accompanied by concerns over its technological advancements (Keane & Yu, 2020).

The expansion of Chinese digital technologies and platforms globally indicates that the Chinese government considers the Internet as a means to showcase its status as a powerful nation (Xu & Yu, 2022) and promote its ideas on the global stage. However, the image of China portrayed by Western media, which largely influences perceptions of China among non-Chinese populations (Sautman & Hairong, 2009), often constructs an imaginary that does not align with the reality of China in the twenty-first century (Lee, 2018).

The collision between these ethnocentric perspectives and the techno-centric vision of digital China highlights the complex dynamics in shaping China's image. The Chinese government utilises digital platforms to assert its national power. While Western media often constructs an image of China that may not align with the reality of the country in the modern era. As I have discussed, China is creating a cultural image along with the nation's rejuvenation. However, does the cultural confidence in Chinese people's minds really need justification from outsiders? To answer this, it is essential to understand how the techno-cultural imaginary is generated and fostered within the political mechanisms of China's creative industries.

Creative Economy, Virtual Consumption and Mass Audiences

As I have discussed in the previous chapter, art is metacognitive. In this respect, art is an instrument of defining cultural periods and providing tribes, of whatever size and complexity, with their self-identifying symbols (Donald, 2006). The fundamental nature of art is its contribution to the

collective processes of thought, memory and perception in society, even in the chaotic and fluid imagery of modern secular society which conveys many different worldviews. Therefore, to examine how digital technology can play a role in China's rejuvenation, it is necessary to 'see' the fluidity of China's cultural presence in the twenty-first century and the gap (disconnect) of the imaginaries between audiences inside and outside China. To do this, we need to 'see' how the creative industries have adopted digital technologies.

In this section, I review theories in relation to the mechanisms which regulate the use of digital immersive art. As I have discussed in Chapter 1, 'Digital China' reinforces the significance of digital technology. The creative industries (or the creative economy) are a collective policy concept related to creative practice, such as advertising, entertainment and gaming, which contribute to the economy (Hartley, 2005; Howkins, 2002). The sociologist John Hannigan (2005) argues that the increasing development of megaplex cinemas, themed restaurants, simulation theatres and VR arcades constitutes a 'new urban economy' dominated by tourism, sports and entertainment. From Hannigan's discussion, it is not difficult to see the importance of digital technology to the creative industries. This momentum has been evident since the early 2000s. According to research by the US National Research Council, digital technology (or information technology) is the glue that links scientific practices, cultural practices and business practices in the creative industries (Mitchell et al., 2003). The increased interaction of digital technology with creative practice has not only led to new forms of artistic expression (Abbasi et al., 2017) but also brought about new industrial formats, such as digital immersive art and immersive entertainment. The increasing intersection of creative practice and technological innovation has created new marketplaces and consumer groups. Meanwhile, the lowering of the threshold of perceived accessibility to cultural content is resulting in new population segments of consumption demand (Casarin & Moretti, 2011). Following Max Weber's thesis on rationalisation and disenchantment, the sociologist George Ritzer (2005) believes that these 'new means of consumption' are rationally designed with an 'enchanted' character to maximise consumption.

In the art world, VR and new digital technologies are making culture accessible to a mass audience by extending their boundaries across the modern entertainment industry (Carrozzino & Bergamasco, 2010). Using visual technology, curators can make images the central focal point of communication and engage mass audiences through different forms of interactive technology. However, curators also face challenges. The use of digital technology in museum arts has been criticised. Some accuse technology of desacralising museum institutions by engaging with entertainment and popularisation rather than with what has been considered more serious and

traditional art practice. In another context, Groys (2008) argues that the art world is not entirely occupied by commercial interests but is also regulated by political mechanisms. Hence, to explore mechanisms that regulate the use of digital immersive art in the context of 'Digital China', the following sections focus on literature concerning how art facilitated by digital technology can be produced and consumed by the public.

Immaterial and Virtual Consumption

As I have discussed in the previous chapter, the intersection of art and digital technology is lowering the threshold of accessibility to cultural content, resulting in new forms of cultural consumption. Cultural consumption here refers to the consumption of goods and services with primarily aesthetic functions and only secondarily instrumental uses (Rössel et al., 2017). Cultural consumption can be immaterial, for example, a kind of service, or watching a film. Moreover, the definition of cultural consumption emphasises the aesthetic value of cultural products. For instance, the cultural consumption of a vase may be its decorative function.

Cultural consumption is a significant aspect of the diffusion of cultural value to the public. Through creating new content, producers embed the subjective meaning they want to deliver via cultural products and services; consumers then form their subjective meanings of the cultural products when experiencing or interpreting the cultural content (Chang et al., 2021). The symbolic value in cultural products becomes the intersubjective experience shared by people in a common societal context when symbolic meanings are embedded in collective cultural consumption. Institutionalisation, a defining characteristic of cultural consumption, establishes the cultural element in the artefact as an icon or norm in a culture (Benzecry, 2014; Dolfsma, 2004). Chang et al. (2021) argue that the Korean popular music industry (K-pop) is an example of cultural institutionalisation since K-pop has become a kind of cultural icon that is not only accepted by the people of South Korea but also by global audiences. The aforementioned 'Chinese Dream' is an instance of cultural institutionalisation in China; it may even be called a political imaginary.

As I have discussed, even though cultural presence in VR is an individual experience, it is also a shared experience when cultural consumption happens in a societal context (i.e. 'Digital China') and on a group scale. Hence, to know how VR and AR contribute to the diffusion of cultural value in the context of Digital China, it is important to understand how changes in cultural consumption are mediated by digital technology. Digital media researchers Mike Molesworth and Janice Denegri-Knott (2007) note that

digital technologies produce a new style of consumption – digital virtual consumption (DVC), which is seen as a consumption model that involves hybridisation of the material and the virtual-as-imagination through the use of digital technology. They highlight the ontological properties of DVC. DVC is a kind of digitally and virtually immaterial consumption. For example, in the online mobile game *Honor of Kings* (王者荣耀), players can buy a magical epigraph to aid them in attack and defence. Such immaterial consumption does not improve players' fighting skills in the real world but enhances the gameplay capacity. Moreover, such consumption behaviour in the game differs from psychological (or spiritual) cultural consumption since in the virtual world, the magical epigraph could be consumed for instrumental use rather than aesthetic function. Hence, Denegri-Knott and Molesworth (2010, p. 109) believe that DVC is linked to the 'theorisation of the digital virtual as a liminal space – somewhere between the imagination and the material' – which is staging a virtual and experiential consumption spectacle for audiences.

In line with Denegri-Knott and Molesworth, Jaesuk Jung et al. (2021) examine the DVC experience of luxury brand fashion shows in VR. They find VR can democratise and commodify consumption experiences and fulfil consumer desires to relieve themselves from the mental burdens and anxieties of their ordinary lives. In their research, DVC is a kind of cultural consumption since viewing fashion shows either in VR or in the real world is primarily for aesthetic purposes. In this study, I also consider appreciating digital immersive art as a form of cultural consumption to fulfil spiritual or cultural demands through DVC.

Molesworth and Denegri-Knott (2007, p. 117) list four key factors of DVC. The first is 'stimulation of consumer desire', for example, experiences in digital virtual spaces that stimulate consumer desire for both material and digital virtual possessions. In some museums or online platforms, virtual heritage can stimulate some viewers' desire to visit the physical tourism site (Guttentag, 2010). The second key factor of DVC is the 'actualisation of consumer daydreams', which means consumers may actualise daydreams through ownership of digital virtual goods. In addition, through immersive art exhibitions, audiences can actualise daydreams through acting out their wishes in an imaginary virtual world. The third is the 'actualisation of consumer fantasy', such as the example of *Honor of Kings* (王者荣耀) that I previously used. The fourth factor is the actualisation of consumer experimentation, for example, performing anti-normative subjectivities, like committing a serious crime in a video game. DVC is intrinsically a kind of spiritual behaviour. *Boost Your Art Energy: 8-Minute Guided Session* (2019), one of the case studies of digital immersive art in this study, also allows audiences

to try anti-normative subjectivities, like destroying the virtual room. Accordingly, this study considers that the cultural consumption of digital immersive art is a particular form of DVC (as will be detailed in Chapter 5). The explanation of DVC by Denegri-Knott and Molesworth is primarily related to the consumption of virtual commodities, such as purchasing equipment in a video game. Purchasing equipment in the virtual world is immaterial, but such behaviour may be defined as material consumption in the actual world. The consumption behaviour of art is immaterial both in the virtual world and the actual world.

Political Education and the Mass Audience

Commodification has gained unlimited access to the art world. Art is sponsored by retail brands. For instance, *Carne y Arena (Flesh and Sand)* (2017), a VR art installation exhibited at the Los Angeles County Museum of Art (LACMA), was sponsored by a film company and a luxury brand charity foundation. Moreover, art itself has also become a kind of experience economy. As a new form of art, immersive cinema is produced within the commercial context of the experience screen economy (Pett, 2021). In visual culture, the images of art become entertainment content consumed by mass audiences. With the application of digital technology such as VR and AR, commerce is driving the development of blockbusters, computer games and simulation rides with the addition of advanced visual experiences (Darley, 2002; King, 2005). However, according to this type of analysis, the art world has become entirely occupied by various commercial interests that dominate the criteria of inclusion and exclusion that shape the art world. 'In this way, the balance of power between economy and politics in art has become distorted', as Groys (2008) argues.

> one cannot, that is, avoid the suspicion that the exclusion of art that was not produced under the standard art market conditions has only one ground: the dominating art discourse identifies art with the art market and remains blind to any art that is produced and distributed by any mechanism other than the market. (Groys, 2008, p. 6)

Art functions in the context of the art market or, more broadly, in the creative industries, and that every artwork and its derivatives are commodities is beyond doubt. However, 'art is not just a commodity but also a statement in public space; art is also made and exhibited for those who do not wish to purchase it – indeed, they constitute the overwhelming majority of the audience for art' (Groys, 2008, p. 108). Especially today,

the intervention of immersive technology, the internet and art museums are changing the conventional definition of public space for art viewers, which means there are more ways for people to encounter a work of art. Art is not the same as a commodity, the value of which is to contribute to the economy and influence the audience's mind ideologically and cognitively (Donald, 2006).

In his book *Art Power*, Groys (2008) uses Socialist Realism as an example to demonstrate how political ideology was institutionalised through art. Socialist Realism was based on the Leninist theory of reflection and the theory of Andrei Zhdanov (1950) that art should realistically reflect reality (the superstructure should reflect the base). Socialist Realism was not supposed to narrate life as it was because life was interpreted by Socialist Realist theory as being constantly in development. 'Socialist Realism was oriented toward what had not yet come into being but what it saw should be created and was destined to become a part of the Communist future' (Groys, 2008, p. 144). By contrast, the commercial world is less concerned with the truth of work and more with its commodity form as previously discussed. In 1934, Socialist Realism was expanded in the Soviet Union to encompass all the arts, including the visual arts. The introduction of Socialist Realism coincided with the massive abandonment of the market economy in the socialist bloc, including the art market. Hence,

> the Socialist State became the only remaining consumer of art. And the Socialist State was interested only in one kind of art – socially useful art that appealed to the masses, that educated them, inspired them, directed them. Consequently, Socialist Realist art was made ultimately for mass reproduction, distribution, and consumption – and not for concentrated, individual contemplation. (Groys, 2008, p. 145)

The Soviet theorist Zhdanov argues that literature must become 'a small cog' in the social-democratic mechanism (Wang, 1988, p. 716). Once cultural policy had been formulated, it became absorbed into theories of propaganda and a legacy inherited by the socialist bloc. In the 1940s, art in China was part of ideology and art was used in propaganda successfully. As David Holm (1991, p. 152) points out in his study of the Chinese communist base camps in what is known as the Yan'an period, in determining what cultural forms were appropriate for the task of revolutionary class struggle, the Chinese leadership determined the cultural forms that were 'pleasing to the masses' while at the same time educating and arousing the masses. Socialist ideology was put into existing popular art forms to educate the public, which could be interpreted as Socialist Realism. Similar to Socialist Realism in the Soviet Union, the

directive to 'tell China's stories well' ('讲好中国故事') is an example in China of how art becomes 'a small cog' in the political mechanism.

In 2015, the Chairman of the PRC, Xi Jinping, announced that China's artists, writers, and journalists should 'tell China's stories well' (China Media Group, 2019). One function of political art in China is to preserve memory (i.e. revolution); the other function is to promise a better future (i.e. 'Chinese Dream'). TV dramas in China used to have these functions (Keane, 2015). In the context of 'Digital China', as I have discussed in Chapter 1, VR and AR connect with science and technology, which are key elements of the 'Chinese Dream' for the future. The immersive performance *Beijing 8-Minute Show* featuring AR and AI at the 2018 PyeongChang Olympics closing ceremony was described as 'telling the story of China in the new era' and 'what people's lives will be like in the future' by China's state-owned media, China Central Television (CCTV, 2018). Schneider (2019) argues that high-profile art events like the Beijing Olympics opening ceremony in 2008 and the Shanghai Expo in 2010 can shed light on the meanings that inform politics in the PRC to understand China's revival, China's new branding, and the manifestation of the 'Chinese Dream' in complex modern societies. I will further analyse the mechanisms of the *Beijing 8-Minute Show* (2018) as a case study in Chapter 8.

Conclusion

The literature reviewed in this chapter, and the previous one, not only provides the theoretical frames for this study but also directs the choice of methodology for this project. By discussing theories about political and commercial mechanisms in relation to cultural products, this chapter suggests a political economy perspective of digital immersive art, especially in the context of 'Digital China'. China operates on the top-down model of governance, and this fits a political model (the power of the state to determine). Increasingly, however, there are also more digital options oriented towards the power of audiences. Many companies are trying to enter the market; and to help understand this phenomenon, a creative industries approach is required. Therefore, as I will discuss in the next chapter, a 'multi-perspectival' approach, or a methodology that is situated between these fields in terms of the production, cultural content and audience reception of digital immersive art, is applied in this study.

Chapter 4

A MULTI-PERSPECTIVAL APPROACH

This chapter outlines the project's overarching research approach and the methods undertaken to facilitate this approach. It explains the data collection and data analysis stages as part of the research design. To explore the implications of digital technology for China's rejuvenation and global cultural presence through art, I employed a multi-perspectival approach using an entirely qualitative methodology. As I have mentioned in the previous chapter, Digital China lends itself to viewing digital immersive art as a cultural product via a political economy lens. An approach combining political economy and cultural studies is therefore appropriate. This multi-perspectival approach, which is often used in studies regarding media studies, cultural studies and creative industries, has three levels of analysis: the production and political economy of culture; the cultural text; and audience reception and effects (Kellner, 2011). This approach provides a reasonable and multiple analytical perspective for cross-checking claims against observational data in qualitative methodologies (Livingstone et al., 2008).

The digital world we live in challenges the foundations of political economy since digital technology accelerates the convergence of products and services as well as audiences and labour (Jenkins, 2004). Cultural studies scholars Scott Lash and Celia Lury (2007) point out that cultural objects are diffused everywhere, including information, communications, branded products, financial services, media products, transport and leisure services. Their argument is that it is hard to differentiate between products and services as everything is digitalised. The rapid move to online on-demand content enables audiences to have more opportunities to choose cultural content and be involved in the production, so there is a tendency in research scholarship to focus on audience studies of culture. Nevertheless, some scholars (Croteau & Hoynes, 2013; Kellner, 2003) in the area of media culture and political economy studies have expressed concerns that the focus on audiences can lead to neglecting discussions of production in cultural studies.

A series of ongoing debates have ensued among scholars; those that focus on the control of production (political economy) (Fuchs, 2014) and those

that identify the agency of the audience (cultural studies) (Hartley et al., 2015). According to the mass communication researcher Vincent Mosco (2009), cultural studies exaggerate the importance of subjectivity, as well as the inclination to reject thinking in terms of historical practices and social totalities, whereas political economy departs from such tendencies through exploring the social mechanism of how a cultural product moves through a chain of producers and, finally, to consumers. Alternatively, the 'production of culture' approach brings in other aspects in the chain of production and consumption; it focuses on 'the content of symbolic elements of culture [that] are significantly shaped by the systems within which they are created, distributed, evaluated, taught, and preserved' (Peterson & Anand, 2004, p. 311). The approach I used is situated between these fields because China's production of culture is generally viewed as top-down and fits a political economy model (the power of the state to determine). In recent years, however, more choices and more digital options are available, underscoring the power of the audience. Further complicating the political economy approach, many smaller cultural companies are trying to enter the market in China. The creative industries model undercuts both the political economy and cultural studies models. It shows that audiences and producers are closer than ever.

In line with the multi-perspectival approach, I conducted in-depth interviews with practitioners, first, to understand the production and political economy of culture in the context of Digital China. Then, I decided on the case studies of digital immersive art and analysed them as cultural texts. Lastly, I conducted focus group discussions based on the selected case studies to examine audience effects. In this chapter, I demonstrate the application of each research method as part of the overall research design. In the first section, in order to investigate how cultural products of digital immersive art are produced and distributed, I show how I interviewed three different kinds of practitioners, namely creators, curators and entrepreneurs. The second section focuses on cultural content analysis. I applied close readings of the text (i.e. literary text, audio and cultural elements) from the digital immersive artworks/exhibitions, didactic panels and other supporting documents. The third section demonstrates the use of audience studies in the research design. To explore Chinese domestic audiences' responses to Chinese cultural presence in digital immersive art, I organised three focus groups to discuss three VR works: *Boost Your Art Energy: 8-Minute Guided Session* (2019), *Shenyou Dunhuang* (神游敦煌) (2018) and *The Worlds of Splendors* (瑰丽) (2019). Finally, I collected some additional documents (i.e. online comments, news coverage and art criticisms) to understand international audiences' views about China through digital immersive art and to supplement the data collected using the above methods.

Critics often point to a tendency to romanticise the 'active audience' in cultural studies by neglecting the fact that media have a direct influence on audiences. The strong 'effects tradition' has come in for criticism over time but it should not be dispensed with. Douglas Kellner (2011) notes that audiences are diverse and can interpret texts in various ways, including sometimes in conflicting ways, which can complicate investigations on the whole picture of culture. Hence, the first level of my approach focuses on the political economy of cultural production. More specifically, dialogue between political economy and cultural production (i.e. how the cultural product is being produced and distributed) helps to reveal the social and economic reasons for the tension among producers, distributors and audiences in the field of digital immersive art. Due to the exploratory and interpretive nature of the project, it is not enough to simply look into secondary data or published materials. Interviews with practitioners are included because the interview data serve to identify the dynamics of the production of culture through digital immersive art in China's creative industries.

Interview as Method of Data Collection

The approach demonstrated in this section draws on analysing the data from in-depth interviews with different practitioners in relation to the production and distribution of digital immersive art. The key roles of cultural producers and intermediaries, which, respectively, correlate with the production and distribution components in the chain of creative industries (Chang et al., 2021), determined the selection of the types of interviewees. Digital creative industries in China are changing fast, and it is important to consider the specific nature of cultural production; as I have discussed in the introductory chapter, digital immersive art is impacted by commerce, culture as well as politics and policies, which is, in turn, brings new intermediaries into the art world. Moreover, obtaining data from interviewees allows us to unveil further their creative motivations and examine the convergence of immersive technology in art.

From March to December 2019, I conducted interviews in Shenzhen, Beijing, Nanjing, Qingdao and Hong Kong. The fieldwork helped me not only find potential interviewees but also the potential case studies for close reading and audience study. During the fieldwork in China, I located interviewees at conferences like the Sandbox Immersive Festival (SIF) 2019, which is an annual event gathering artists and their immersive works, and the Future Business Ecolink Conference (FBEC) 2019, which is a commercially oriented conference aimed at connecting the different fields of the immersive

industry in China. I also visited immersive art exhibitions to find potential interviewees. Some of the interviewees were introduced by acquaintances or by other practitioners. Additionally, some of the interviewees introduced other practitioners in relevant fields, which gave me more options for selecting potential interviewees. Twenty practitioners were contacted through WeChat or email for my research, and seventeen agreed to participate. The chosen interviewees included digital immersive art creators (i.e. artists, producers and technicians), curators from art and cultural institutions (i.e. galleries and art museums) and entrepreneurs (i.e. founders of start-ups and investors) from digital creative industries.

In order to examine the context of Digital China and factors influencing the functions of digital immersive technology as well as the production of culture through digital immersive art, I designed my interview schedules accordingly. The questions in the interview schedules included but were not limited to the following: What is your opinion about the development of VR/ AR and digital immersive art in China? What is your role and aim in terms of the showcases? Why were you involved in such business or projects? What kinds of audience effects were you looking for? More extended questions were asked according to participants' answers. To make sure that each interview would be fully developed and aligned with the perspective of this study, semi-structured interviews were carefully planned before the scheduled interviews. I recorded the interviews using a recording pen, and then I transcribed the interviews.

Data Analysis

In order to pursue the research questions in greater depth and contextualise the findings with particular reference to Digital China, I applied textual analysis techniques to the interview materials. To identify the influence of different practitioner roles on the production and distribution of digital immersive art, I coded the transcript text into three categories according to the three key roles (creators, curators and entrepreneurs) and then compared their responses to the same questions. Through this first step of analysis, I found that different actors have different functions during the process of production. Then, I further analysed how their functions were generated (motivations and conditions) and how their practice in the field had an effect on the audiences' reception. Moreover, in order to summarise or compare selected interviewees' ideas, I coded the interviewees' names according to the roles they played and the chronological order in which they were interviewed (Table 4.1). For example, interviewee Cr-1 represents the creator whom the researcher first interviewed.

Table 4.1. Summary of interviewees

Role	Position of Affiliation	Name	Code
Creator	Founder of YCVR	CAI Songyan	Cr-1
	Lecturer at The Hang Seng University of Hong Kong	Patrick MOK	Cr-2
	Director of Configreality Space	LIU Liquan	Cr-3
	Founder of Jes Studio and Configreality Space	HUANG Jiasheng	Cr-4
	Founder of LumiereVR	GUO Qinya	Cr-5
	Veer staff/VR artist	HUANG Ruogu	Cr-6
Entrepreneur	Founder of Blooming Investment	YANG Juze	E-1
	Veer staff	REN Qing	E-2
	Founder of Eyemax	Wu Zhanxiong	E-3
	President of Shenzhen VR Industry Association	TAN Yiguo	E-4
	Founder of Configreality Space	PENG Junxi	E-5
	Manager of Cultural and Technological Promotion Association for Nanshan District, Shenzhen	LIU Xi	E-6
	Officer at Cultural and Technological Promotion Association for Nanshan District, Shenzhen	HE Xi	E-7
Curator	Owner of Horizon Art Space	ZHANG Taiyong	C-1
	Staff at K11 Art Museum	NG Pui Lok	C-2
	Staff at Deji Art Museum	N/A	C-3
	Curator at Red Brick Art Museum	WANG Liping	C-4

Research Approach from the Perspective of Cultural Texts

Textual analysis was useful for close reading, in-depth exploration and analysis of the technological affordance and cultural text that constitute the selected digital immersive artworks. Textual analysis is often used as the method for analysing various forms of discourse, ideological positions, narrative strategies, image constructions and effects. Traditionally, textual analysis is mainly used in the analysis of written language and literature.

With the intervention of semiotics, which originates from linguist Ferdinand De Saussure's (1960) concepts of signifier (the form) and signified (the idea or concept), textual analysis is also used in the analysis of various non-verbal cultural products.

This method is appropriate for studies of digital immersive art. Curators and artists often use cultural text, including literary text and non-verbal text, such as voice, images and music, to convey meanings and ideas in artworks and exhibitions. Close reading of this cultural text needs to connect the context of the production and the audiences' reception. 'It is important to stress the importance of analysing cultural text within their system of production and distribution' (Kellner, 2011, p. 10). Hence, through a close reading of the selected digital immersive artworks, I try to find out how the production and political economy of culture influence the use of immersive technology and cultural elements in digital immersive art, and how technological affordance [in virtual environments (VEs)] and the cultural text of digital immersive art are received by audiences.

The Selection of the Case Studies

The case studies are examples of Chinese VR and AR works that advance the context of Digital China, either in terms of advancing the digital technology itself or as representative of Chinese culture or culture within China. Thus, I focused on two factors, namely the type of immersive technology and the cultural elements of the work, when selecting the case studies. VR and AR are considered 'flagship' technologies in the context of Digital China. As I have discussed in the previous chapters, VR/AR technologies are complex and include different types of applications. For example, head-mounted display (HMD) and cave automatic virtual environment (CAVE), which is a cube-shaped device, in which all six or four surfaces can be used as projection screens (Cruz-Neira et al., 1993), are two different types of VR technology. Furthermore, China has multiple cultures (traditional and modern), and the development of Digital China makes the question of culture more complex. Therefore, I used diversified criteria in the selection of case studies to indicate this complexity. First, it was important that the case studies should include different types of VR technology. Second, the selection of cases should represent different perspectives of Chinese culture to examine the interface of technology and culture. Moreover, as the research also concerns how the work has been received by international audiences, the selection of case studies needed to consider their availability to audiences within China as well as internationally. For this reason, I selected two relatively high-profile examples in the field that have been presented to international audiences.

Table 4.2. Summary of the main case studies

No.	Name (Year)	Author	Location/Platform
1	*Boost Your Art Energy: 8-Minute Guided Session* (2019)	Produced by Wang Xin and LumiereVR	K11 art space in Hong Kong (China)
2	*Shenyou Dunhuang VR* (2018)	Produced by imLab at National Taiwan University and Dunhuang Academy	Steam VR (online platform)
3	*The Worlds of Splendors* (2019)	Produced by GLA (格兰莫颐) Art Group and BlackBow (黑弓)	Deji Art Museum in Nanjing (China)
4	*Beijing 8-Minute Show* (2018)	Produced by Zhang Yimou	PyeongChang Winter Olympic Games (Korea)
5	*Blueprints* (2020)	Cao Fei	Serpentine Galleries (UK)

However, when commencing the fieldwork, I realised there were restrictions in terms of where and when the cases were exhibited. Due to the popularity of digital immersive art in China, many works and exhibitions were located in different cities and exhibited at the same time, so it was difficult for me to view all the exhibitions in person before I made sure which work qualified as a case study. Before visiting the case studies, I collected information about the potential cases from official websites, WeChat and online ticketing platforms to schedule the travel agenda. It was sometimes not easy to select the cases according to the online information without visiting them in person to gauge the quality of the works. Therefore, during the interview process, I would ask practitioners in this field to introduce some typical cases and explain their views in relation to the cases, which was helpful to me in narrowing down the selection. Hence, in this sense and light of my fieldwork practice, the multiple-perspectival approach is appropriate for my research.

After taking into consideration these issues as well as previous hurdles and criteria, I ultimately selected five case studies (see Table 4.2). In the next section, I will briefly introduce these case studies based on my observations and publicly available resources.

The Case Studies

Case Study 1, ***Boost Your Art Energy: 8-Minute Guided Session*** **(2019)**, is one of the VR artworks in Wang Xin's *Maybe it's Time to Refresh the Art World a Little Bit* (2019), the artist's ticketed exhibition at K11 art space

Figure 4.1. Photo of a participant experiencing *Boost Your Art Energy*

located in a shopping mall in Hong Kong. Wang's *Boost Your Art Energy* is a spiritual, mystic and immersive VR artwork that aims to recharge one's 'art energy' (Wang, 2019). When viewers put on the VR headset, they are thrust into a dream-like virtual environment (VE) freed from conventional space, time and reality. In the VE, viewers choose to activate one of the four guided sessions separately in four virtual rooms, each with a different approach to revitalisation. Throughout the exhibition, viewers can see many elements of pop art (Figure 4.1), such as Wang's signature pink colour and the use of wave dots (which refer to the mass of replicated dots or dot patterns). The bold colour and wave dots are widely used in pop art, opposite to 'high art' (Grenfell & Hardy, 2007). Such elements are considered part of popular culture among younger Chinese audiences.

Case Study 2, *Shenyou Dunhuang* (神游敦煌) **(2018)**, is presented by imLab at National Taiwan University and Dunhuang Academy (Han et al., 2019). It is a virtual heritage (VH) project and is free to download from Steam's online store. *Shenyou Dunhuang* intends to contribute to its viewers' cultural understanding of Mogao Caves (莫高窟) through an interactive experience of the virtual artefacts and displays in the VE. The Mogao Caves, found in the Western city of Dunhuang, is one of the China's World Cultural Heritage sites and was listed by UNESCO in 1987 as a relic of Buddhist culture in China (UNESCO, 1987). Dunhuang is also a public tourist destination in Western China. Like many other cultural heritage sites, it is facing problems with protection and preservation. This VH project allows viewers to explore

Figure 4.2. Photo of *Shenyou Dunhuang* experience site

Mogao Cave No. 61. Viewers can see a digital restoration of the deteriorated murals and ruined statues. For example, the Manjushri statue in Mogao Cave No. 61 is missing but it has now been digitally reconstructed and reappears vividly in the virtual cave. Viewers can also see animations on the walls, which illustrate the stories behind the murals (Figure 4.2).

Case Study 3, *The Worlds of Splendors* (瑰丽) **(2019)**, at Deji Art Museum is a ticketed immersive exhibition of Chinese traditional artefacts and aesthetics. The works in this exhibition are a CAVE installation, which allows viewers access to the VE by means of surrounding projected images. This exhibition includes four CAVE works. The first work, *Accessing the Realm through Cloud Reel* (云轴入境) (2019), creates the dynamic spectacle of a Chinese landscape painting inspired by Zhuangzi, a renowned philosopher of ancient China, specifically his aesthetic thought in the Warring States period (476 BC–221 BC). According to the didactic panels in the exhibition, this immersive artwork presents a light circle that intersects with the 'digital image' and 'stereo laser projection' to express Zhuangzi's aesthetic philosophy of infinite time and space from his notable work *Zhuangzi: A Happy Excursion* (庄子·逍遥游). The interactive effects are presented under the viewers' feet as they walk through the real water mist and virtual laser projection. The second work is *A Thousand Miles of Rivers and Mountains* (千里江山) (2019). This immersive work is based on the Chinese fine artwork of the same name, which the 18-year-old Wang Ximeng created during the Song Dynasty. The third work is *Goddess of the Luo River and Neon Dream* (洛神霓梦), inspired by the tragic love story of Luoshen (Goddess of the Luo River) (Figure 4.3) .The love story and the image of Luoshen are represented in many ancient artefacts, such as the *Ode of the Luo River Goddess* (洛神赋) by Cao Zhi and *Picture of*

Figure 4.3. Photos of *Goddess of the Luo River and Neon Dream* in *The Worlds of Splendors*

the Ode of the Luo River Goddess (洛神赋图) by Gu Kaizhi. Through projection mapping, this artwork shows images and calligraphy about Luoshen on long white strips of translucent paper hanging from the ceiling to generate a mist-like experience for visitors. The fourth work, *At the Deepest Part of the Blossom* (百花深处) (2019), is inspired by the Chinese painting *Scroll Painting of Blossom* (百花图卷) from the Song Dynasty. This immersive work aims to evoke viewers' imagination about blossoming, fading and withering through interaction with the flowers projected on the walls. Visitors can touch the walls to see the flowers completing their life cycles

Case Study 4, *Beijing 8-Minute Show* (北京8分钟) (2018), directed by Zhang Yimou, is a performance with multi-media works at the closing ceremony of the 2018 PyeongChang Winter Olympic Games. As one of the several performances foreshadowing the 2022 Beijing Winter Olympics, this show was hailed by China's leadership as a great success and lauded as an example of China's emerging technological leadership, showcasing Chinese enterprises. Typical Chinese cultural motifs like the panda and phoenix, along with technological achievement, were displayed. Twenty-four roller-skating actors led by two skaters in panda costumes performed along with twenty-four moving transparent screens on the immersive stage accompanied by projected images. In order to create a sense of immersion for the live audiences, AR and relevant digital technologies were also used. As reported by CGTN (2018), 'images were projected to the icy floor while dancers skated across it, creating a sense of augmented reality (AR)'.

Case Study 5, *Blueprints* (2020), is artist Cao Fei's ticketed exhibition at Serpentine Galleries in the UK. *Blueprints* (2020) includes five multimedia pieces: *The Eternal Wave* (2020), *Nova* (2019), *Whose Utopia* (2006), *Asia One* (2018) and *La Town* (2014). In this study, I mainly focus on *The Eternal Wave*, a VR piece. This work creates the illusionary experience of being in a virtual

world extracted from science fiction and the real world and is based on the artist's memory and research. The experience in VR begins with viewers standing in a stimulated kitchen in Cao's studio located in Beijing before being subsequently led into another virtual space (Cao, 2020a). The work features animated images and cultural backgrounds depicting the Sino–Soviet relationship in the 1950s and 1960s.

Data Collection and Analysis

The data for the close reading of the five case studies mainly draw on my observations. During the fieldwork, I visited some of the cases in person and recorded them by taking photographs, video recordings and screenshots. I was not able to see the *Beijing 8-Minute Show* and *Blueprints* in person due to restrictions of time and location. Therefore, I collected additional data about them in the form of trailers, online footage, media coverage, didactic materials and exhibition catalogues.

Close reading of an artefact of media culture involves interpreting the forms and meanings of elements in a music video or television advertisement as one might read and interpret a book (Kellner, 2011). This is the chosen method for analysing the various forms of discourses, ideological positions, narrative strategies, image construction and effects of the case studies. To better understand the viewers' reactions to the cultural context in VR, how the cultural elements are represented in the affordance of VE, and how the context of Digital China involves cultural production, the close reading involved applying questions to frame the data. Adopting the textual analysis approach, the following questions were included: What is the primary meaning of this artwork or exhibition? What kinds of cultural elements are used, for example, Chinese traditional culture elements or pop culture elements, and what do these elements represent? How does the digital technology used in the artworks mediate the representation of these cultural elements? How does the context of Digital China influence the selection and representation of cultural elements of digital immersive art?

Research Approach from the Perspective of the Audience's Reception

In line with the qualitative approach, I used focus group discussions drawing on the aforementioned case studies to understand how the cultural presence of digital immersive art is generated, and how it has impacted on cultural experience among Chinese audiences. Due to the scheduling constraints previously mentioned, I selected the following case studies for the audience study:

Boost Your Art Energy: 8-Minute Guided Session (2019), *Shenyou Dunhuang* (2018) and *The Worlds of Splendors* (2019).

Audience studies of immersive media can be traced back and separated into the active media perspective (i.e., the media has an effect) and the active audience perspective (i.e., users make meanings). The active media perspective mostly starts from behaviourism and experimental psychology, which measures attitudes and behavioural change among the audiences by using quantitative methods, such as surveys, questionnaires (Schuemie et al., 2001), and more recently, bodily response by monitoring heart rate or eye-tracking (Bender, 2019). By contrast, studies on the active audience come from the fields of anthropology, ethnography and cultural studies (Iser, 1980). Such studies emphasise the audience's subjective initiative and artistic experience rather than the text of the artwork or the artist's intention. The active audience perspective has been widely used in the research of presence and VR. Jonathan Freeman and Steve E. Avons (2000) use focus groups to discuss people's experiences while watching stereoscopic TV. Their results show that audiences can describe sensations of presence and relate presence to involvement, realism and naturalness. Carrie Heeter (1992) applies a similar approach, questioning users after they had used immersive VEs, and examining the personal, social and environmental elements related to users' sense of presence in VR.

Following the chosen multi-perspectival approach, I moved between the two approaches. In other words, this study takes the perspective that affordance in VE has an effect on viewers and that viewers also make meanings. Through the textual analysis of case studies and audience responses, the audience study allows me to answer how the sense of cultural presence is generated in digital immersive art. Unlike quantitative audience studies of immersive media, the approach applied in this study is a qualitative means to examine the audiences' introspection and their subjective understanding of digital immersive artworks. The immersive media researcher Mel Slater (2004, p. 3) questions approaches to the research of 'presence' that heavily rely on the questionnaire-based methodology, which 'draws on respondents being able to reasonably compare a given situation with a number of other situations, and then (usually) make a quantitative assessment'. Slater (2004) argues that in the quantitative approach, there can be no evidence that presence in VR played any role in the audiences' actual mental activity or behaviour at the time of the experience. He further points out that, to some extent, questionnaire-based studies may be 'thought of as hypothesis generators rather than as reaching conclusions' (Slater, 2004, p. 10). Thus, while Laia Pujol-Tost and Erik Champion (2007) attempt to verify the validity of the concept of cultural presence in VH in a quantitative questionnaire-based way, they point out

that a qualitative framework is also needed. Furthermore, Pujol-Tost (2018) believes that cultural presence refers to the feeling that people belonging to a specific culture occupy or had occupied in the past (virtual) environment. This is different to spatial or psychological presence requiring examination or observation of one's own mental and emotional processes. More research on audiences' introspection in relation to cultural context is needed to develop the concept of cultural presence.

Using Focus Group for Data Collection

To observe how cultural presence of digital immersive art is generated and how it has impacted on cultural experience among Chinese audiences, I chose focus groups to gather the reactions of the recruited participants to the selected works. Focus groups are one of the more established tools of social research that became popularised late in the twentieth century, notably in marketing, product development and public opinion or policy research (Barbour & Kitzinger, 1998; Bennett et al., 2009; Bloor, 2001). 'The group is focused in the sense that it involves some kind of collective activity – such as viewing a film, examining a single health education message or simply debating a particular set of questions' (Kitzinger, 1994, p. 103). So, it is an appropriate method to investigate participants engaged in a collective activity of experiencing an immersive art project or exhibition. Moreover, one of the strengths of focus groups is that they can reorder relationships of power between researchers and research participants. Sue Wilkinson and David Silverman (2004) outline the ability of group members to claim or reclaim the agenda of the discussion and to refuse or resist narratives imposed upon them by researchers. In a study such as mine, recognition of these types of reordering was important, and focus groups were at their most revealing when it came to learning about the participants' cultural and aesthetic experiences. Moreover, focus groups can encourage a great variety of communication from participants – tapping into a wide range of understandings (Kitzinger, 1994). In this study, during the discussion, participants could remind each other and express their in-depth understanding of the immersive art projects/exhibitions. Therefore, the focus groups were only conducted by the researcher after the participants had viewed the selected case studies (i.e. Case Studies 1, 2 and 3).

The recruitment of participants occurred in tandem with the selection of case studies. When each case study was confirmed, the recruitment process for its focus group was conducted. All the participants were recruited without incentives. The recruitment information was spread on WeChat moments (a social media platform in China) or WeChat group (an instant messaging service for group chats on WeChat).

To maintain the quality of the focus group discussion, the participants were opt-in participants. During the recruitment, I tried to select participants who were younger, around 18–28 years old. In the context of China, the younger generation is the mainstream consumer demographic for VR. According to a report by HTC VIVE (2017), most of China's VR users were born in the 1980s and 1990s; with China's market for VR expanding year by year, the younger people born in the 1990s are regarded as having a considerable market potential. Moreover, according to the interviews with the practitioners, many of the VR users and visitors of immersive art exhibitions are young people. To further help focalise the discussion about digital immersive art in the focus group, I skewed the selection of the participants to ensure they have a background in art or cultural or media studies. Finally, as a precondition of their recruitment, the participants need to have known about or used AR/VR devices, and that it was their first time viewing the work selected for their group.

For the audience study, each work was assigned a focus group for discussing the participants' experiences (see Table 4.3). In the first study, involving *Boost Your Art Energy*, each of the nine participants randomly chose one of the four virtual rooms to have an eight-minute virtual experience. During the viewing, participants were assisted by the art gallery staff. As part of the exhibition experience, the staff provided a brief introduction about the exhibition and the artist, and how to use the VR device. For the second study, each of the 11 participants had about 10 minutes to view *Shenyou Dunhuang*. This was enough time for participants to complete the whole audio-guided tour, with spare time for them to explore the exhibit by themselves. For this viewing session, the participants had input audio guidance with Chinese subtitles. In this way, I was trying not to influence the participants' viewing experience while providing necessary assistance on the use of the VR headset. For the third study, the on-site staff provided brief instructions to every participant before they experienced *The Worlds of Splendors*. Participants had around 40 minutes to take in the exhibition. The seven participants experienced the four immersive artworks together.

Table 4.3. Summary of the focus groups

Focus group	Name of case study	Date	No. of participants
1	*Boost Your Art Energy* (2019)	28 April 2019	9
2	*Shenyou Dunhuang* (2018)	14 May 2019	11
3	*The Worlds of Splendors* (2019)	24 May 2019	7

The researcher conducted a semi-structured focus group discussion with the participants after viewing the respective work. In order to focus on the factors influencing the art reception of digital immersive art, key topics were formulated to frame the semi-structured questions used in the three focus groups. These key topics include the following: 'the most liked and disliked parts of the work'; 'the understanding of the cultural elements in the work'; 'the understanding of the artistic meaning in the work'; 'the feeling of the immersive technology used in the work'. During the discussion around the key topics, participants were encouraged to expand on these topics and give their individual ideas about digital immersive art.

Data Analysis

The discussion in focus groups was recorded using a recording pen, and the transcripts were analysed using NVivo software. In order to summarise or compare a few participants' views, I coded their names in order. For example, participant 3-1 means the participant who is the first speaker in Case Study 3. Moreover, since the framework of cultural presence was not well developed in the field of digital immersive art, I applied open reading to separately examine the data in the three focus groups. Open coding pertains to the categorising of phenomena through close examination of the data. First, the data in the three case studies were coded using conceptual labels based on the word frequency facilitated by NVivo and on reoccurring themes identified through close reading. NVivo was favoured for its capacity to deal with large-scale qualitative materials like the focus group discussions and interviews in this study. Some concepts emerged from reoccurring themes in the focus group discussions, and accordingly, I categorised the concepts that pertain to each other or share similar meanings. Finally, based on the definition of cultural presence and the theoretical framework of aesthetic illusions, I chose 'illusion', 'playfulness' and 'authenticity' as the significant concepts which are the most likely to explain audiences' perception and the sense of cultural presence in digital immersive art. These concepts, as facilitated by NVivo analysis, not only framed the participant responses in the focus group data but also guided more open findings.

During the categorising process, I also drew on findings from other approaches in this study. For instance, when I analysed the concept of authenticity, which relates to viewers' admiration of specific cultural artefacts, I found out that the surrounding environment of art also influences viewers' perception of authenticity. According to the data obtained from the perspective of production and the political economy of culture, some entrepreneurs choose to exhibit digital immersive art for commercial purposes. Hence, I related commercial elements to viewers' perception of authenticity in digital immersive art to explain how exhibition venues influence viewers' cultural presence.

Additional Data Collection

Additional data were collected to reduce the limitations in the research design and to facilitate my study of audiences outside China. In his book *Documents of Life*, originally published in 1983, sociologist Ken Plummer (2001) uses a wide range of life documents as research tools, including diaries, letters, photographs, films, tombstones and suicide notes. However, British sociologist Clive Seale (2004) notes that there are more life documents beyond those identified by Plummer in the present day, which include websites, advertisements, minutes of meetings, newspaper reports, medical records and paper releases; the list is endless. 'All of these can be and have been used by researchers studying particular social and cultural processes' (Seale, 2004, p. 237).

As previously mentioned, I could not view the works in person due to scheduling constraints. Case Study 4, *Beijing 8-Minute Show* (2018), happened before this study started, while Case Study 5, *Blueprints* (2020), was exhibited during the COVID-19 lockdown. Therefore, I collected publicly available documents as the substitute data for the closing reading of these two case studies. The additional data include online footage, didactic materials, exhibition catalogues, trailers on the internet, and interviews in mainstream media coverage.

For the same reasons, the audience study was not able to be conducted as I had originally designed, so the additional data, such as art critiques from media reports and online reviews by internet users, were collected and used for analysing the disparity among Chinese and foreign audiences. There are two reasons for doing this. First, as high-profile events, the art critiques and online reviews for these two case studies are easy to collect. Second, media workers (e.g. reporters and art critics) and internet users are also considered audiences. Florian Schneider (2019) defines three orders of audiences for his study of international mass events. The 'first-order audience' is the spectator who witnesses the works first-hand. However, in terms of high-profile international events, such as the opening ceremony of the Olympics, most audiences do not have the chance to see them in person. The 'second-order audience' includes media workers and critics who filter, rework relay the event on the ground, create the mass media products, and provide semiotic signposts to understand the event (Rauer, 2006). They normally have the chance to view the work first-hand and make meaning to the 'third-order audience'. The 'third-order audience' consists of viewers and readers who experience the event through other media, especially through digital relay technologies associated with the internet; they are not passive audiences, since they experience the mediated events and leave comments for others on the internet (Schneider, 2019, p. 66).

Conclusion

Spending about nine months conducting fieldwork in China was a rewarding experience for me. It not only trained me as a researcher but also provided me with a complete view of the development of digital immersive art and the digital creative industries in China. Despite the rapid development of digital immersive art and digital creative industries driven by digital technology, especially in regard to VR and AR, there are still gaps between cultural production and audience reception.

The research design for this study is not without shortcomings. One shortcoming is that most of the focus group participants had similar backgrounds in the arts, media and design. This shortcoming points to more work that needs to be done through focus groups with different groups of audiences, such as foreign audiences outside China. In addition, some of the artists that I had planned to interview were difficult to reach, so alternative materials such as publicly available interviews from mainstream media and their keynote speeches from conferences were used to supplement the data. However, these documents would not have provided the same level of accurate answers as the interviews. Despite these shortcomings, the multi-perspectival approach is appropriate for conducting research in relation to digital immersive art and for my fieldwork research design and practice. As a kind of digital art, digital immersive art is more accessible to public audiences, compared to sculptures and paintings. For example, *Blueprints* (2020) encountered the COVID-19 pandemic in early March 2020. The VR installation *The Eternal Wave* (2020) at the exhibition was turned into an AR work – accessible on any mobile phone – in collaboration with Acute Art, enabling audiences to experience it despite lockdown restrictions. Hence, the data for the textual analysis of cultural products can be collected related to multiple versions of the work. Furthermore, Case Study 2, *Shenyou Dunhuang* (2018), is available online, and viewers can leave comments on the internet platform, which provides an alternative way to collect the audience data. With the popularity of VR HMD and the 'metaverse', more digital immersive artworks will appear on the internet, and users will leave more traces for future research.

Chapter 5

DYNAMICS OF DIGITAL IMMERSIVE ART IN CHINA'S CREATIVE INDUSTRIES

Art has many roles and functions. It is used as a display, adornment and even spectacle (Dissanayake, 2002). It has a non-commercial aspect, notably the gift economy, in which artworks are exchanged without requiring payment. In recent decades in China, art has become a business, and this brings new and different actors into the art world (Berger, 2008). Digital technology has offered opportunities to expand artists' horizons and reach new audiences. The 'value' of digital immersive art, therefore, can be analysed from an economic perspective (i.e. contribution to economic growth) and a cultural perspective (i.e. contribution to aesthetics and the diversification of cultural elements).

In order to explore the implications of digital immersive technology on audiences' cultural consumption of digital immersive art, I examine the role of different actors (creators, entrepreneurs and curators) in the production, drawing on practitioner interviews. In doing so, this chapter examines the factors motivating practitioners in their creative works, the messages they want to convey to audiences and how practitioners' intentions influence the effectiveness of digital immersive art in generating cultural meanings. Moreover, according to the interview data, the convergence of art and business in China's creative industries has led to both economic and cultural values. In this regard, I will investigate the collaborations and tensions between the business and art spheres.

The analysis in this chapter mainly draws on in-depth interviews with practitioners, including producers, entrepreneurs, curators and staff members who work in art institutions. I selected examples of digital immersive art to explore in order to contextualise the claims made by interviewees. I analyse the making and use of these works and the motivations of their creators.

The examples include works exhibited in China by teamLab, which is an art collective based in Japan; *The Worlds of Splendors* (瑰丽) (2019), an immersive art exhibition in Nanjing Deji Art Museum; *The Unspeakable Openness of Things*

(2018) at Red Brick Art Museum in Beijing; *Maybe it's Time to Refresh the Art World a Little Bit* (2019), Wang Xin's solo immersive art exhibition in Hong Kong K11 art space; and *Lost in Play: Find the Lost One Hour of Life* (2019) at CHAO art centre in Beijing.

The Cultural and Economic Dynamics of Digital Immersive Art

As I have shown, the Chinese government is investing in digital immersive art activities with the intention of using digital technology to promote China's national innovation. It uses public funding to not only support the sustainable development of art creation but also to guide cultural production. More importantly, private investors and enterprises have entered the field of digital immersive art. For example, according to my interview with Yang Juze, an investor in the immersive exhibition *teamLab: Dance! Art Exhibition, Learn & Play! Future Park* (2017) in Shenzhen, this project received 200,000 RMB (about US$30,000) funding from the local government. Yang's art investment company, Shenzhen Blooming Culture Investment Co., Ltd., invested 27 million RMB (about US$3.9 million). In this commercialised sense, digital immersive art becomes a cultural product following the rules of the market economy; however, it is also a vehicle for conveying cultural and artistic content. Cultural novelty is produced in the cultural sphere and, in turn, also becomes part of the production of economic novelty and value in the process.

From a political economy perspective, this process can be divided into three parts: production, distribution and consumption. According to Yu-Yu Chang et al. (2021), the central premise of the value chain is that creativity and culture are constructed and negotiated by three key actors: (1) cultural producers, (2) intermediaries and (3) cultural consumers. The product values are not only perceived by consumers simply in terms of the fulfilment of utilitarian or functional purposes but also the values associated with the symbolic meanings of culture and the arts. The production dynamics are complex, involving different actors in the value chain. The intentions of creators and intermediaries (entrepreneurs and curators) are reflected in the production, discovery, selection, testing and refining of cultural products. In order to explore how digital immersive art creates economic and cultural values, this section will use value chain analysis to examine the different aims of the creators, entrepreneurs, and curators drawing on a number of in-depth interviews.

Practitioners of digital immersive art use artistic creativity, existing cultural elements and the facilitation of digital technology to produce cultural

products. It is easy to discover that successful digital immersive art products have the capacity to integrate these three factors. teamLab's art projects are considered such examples. teamLab is an art collective based in Japan, and their work has attracted global audiences and promoted Japanese culture to the world. In 2015, the Japan Pavilion of Expo Milano exhibited two immersive artworks by teamLab. teamLab's immersive art exhibitions, which are inspired by nature and traditional Japanese aesthetics, are facilitated using immersive digital technology. Many of their artworks use a VR cave automatic virtual environment (CAVE) to represent Japanese culture. For example, in the Shenzhen exhibition, one of the works, titled *Crows are Chased and the Chasing Crows are Destined to be Chased as well, Transcending Space* (2017), is an interactive digital installation in which viewers can walk around in an immersive space surrounded by projections on all sides. In the immersive space, viewers can see crows, rendered in light, flying around the space, leaving trails of light in their paths, while creating cursive forms depicting Japanese calligraphy (teamLab, 2017).

In order to form new creative content, artists integrate existing cultural elements and contextual idiosyncrasies into cultural production (Chang et al., 2021). Cultural intellectual property (IP), which is derived from the concept of IP, is one such term used in China to describe the use of existing cultural elements in the creative industries. This term was frequently mentioned by the interviewees to express how an iconic cultural element is used in cultural products. The term refers to the cultural invention that connects and integrates different cultural products with high recognition value and the capacity for monetisation, similar to the IP of the Disney entertainment conglomerate. In China's creative industries, cultural IP became a buzzword after some successful cultural projects agglomerated famous Chinese cultural IP with cultural products. For instance, Tencent (a Chinese technological company) collaborated with and incorporated the cultural IP of the Mogao Caves in its mobile game *Honor of Kings* (王者荣耀), which increased the reputation and revenue of the game.

Start-ups and creative studios in creative industries related to VR and digital technology have received funding from the government. In the context of digital China, the policy formalised in 'Made in China 2025' and the 13th Five-Year National Development Plan (2016) (see Chapter 1) also support digital immersive art development. The emerging VR industry is considered an opportunity for changing China's national identity from 'Made in China' to an innovative country. In the policy document for the 13th Five-Year National Development Plan of Strategic Emerging Industries (2016), the development of the VR industry became China's national strategy in the new era. However, some creative studios have realised the difficulties in receiving

such financial support from the government. As interviewee Cai Songyan, the founder of YC Virtual Reality:

> Start-up companies like us don't know how to apply for government funding, and then the government can't find us [to give out the funding]. Yes, I think it's kind of nonsensical. However, virtual simulation is a big market in China. In the past, China was a country that used machines to make slippers and clothes, and now these industries have moved to South-east Asia, so China needs to find new types of industries that cannot be replaced by machines within a short time. I think digitalisation [like VR] is an opportunity.

Cai Songyan is not satisfied with the current policy in relation to VR industries, but on the other hand, he believes VR-related industries in China are promising. Interviewee, Peng Junxi, the founder of a VR technology company in Shenzhen, shared a similar opinion. He preferred looking for industrial investment rather than spending more money to hire additional staff to read the government policy and apply for funding.

The above-mentioned phenomenon reflects the ambivalent circumstance of Digital China: the government has set up digital technology as the national strategy, which likely promises a future for the field of VR, but the disconnect with the supporting policy has triggered an entrepreneurial spirit, which in turn results in the commercialisation of digital immersive art. Facing the difficulties of receiving government funding and the cost of research and development (R&D), creators also need to consider the economic value of digital immersive art in order to adapt to the substantial market in China.

Many digital immersive art exhibitions I examined were ticketed and exhibited to enhance the aesthetic experience of retail space. Art in the retail environment has a novel attraction factor, therefore increasing a shopping mall's traffic; 'it also promises to improve a mall's image and perceived value, thus helping to achieve differentiation and possibly reducing customers' price sensitivity' (Vukadin et al., 2018). Although this does not mean creators need to master all the skills in terms of cultural understanding, commercialisation and digitisation, the cultural production of digital immersive art is no longer a purely artistic creation. As producers of cultural value, artists have integrated their resources (i.e. creativity, artistic skills and technological skills) to infuse new subjective meanings into works, while at the same time considering or fostering the commercial value of digital immersive art as a new and high-cost art media to be accepted by more audiences.

In 2016, teamLab launched its first solo exhibition, *Living Digital Space and Future Parks*, in Silicon Valley. According to media reports (Davis, 2016), this

Figure 5.1. teamLab's *Crystal Universe* (2015) exhibited in Shenzhen

exhibition attracted 65,000 visitors in its first three and a half months (the gallery had initially projected 30,000 visitors for the run). Following this, some of China's cultural and art institutions invested in teamLab's art projects and brought them to China. teamLab has presented different immersive art exhibitions and art installations in different cities in China, including Shanghai, Beijing, Guangzhou, Shenzhen and Wuhan. Significantly, teamLab attempted to localise some of the exhibitions by assimilating Chinese cultural elements into the artworks. For instance, in the Guangzhou exhibition, the artwork *Born from the Darkness a Loving, and Beautiful World* (2019) allows viewers to touch Chinese characters projected on the walls, making dynamic images appear that embody the meaning of the characters; these images could eventually be recognised as representations of Chinese oracles.

In order to explore how teamLab's art engages with business and influences the diffusion of cultural value, I interviewed an investor of the Shenzhen exhibition, Yang Juze. He believes that immersive experiences have significant market value. After viewing the exhibition by teamLab at the Japan Pavilion of Expo Milano, he decided to invest and bring teamLab's digital arts to Shenzhen (Figure 5.1). He described his perception of teamLab's art exhibition at Expo Milano as follows:

> I don't know much about technology. But after I experienced the works,
> I think there is market potential, and everyone will like them because

I have been shocked by them. I have never seen such beautiful works presented with immersive digitalisation. When I went in, the lights dimmed, and the devices displayed the lotus [flowers].

Before teamLab's immersive exhibition was commissioned for Shenzhen, its commercial value had already been tested in Beijing. As Yang mentioned in the interview, teamLab's immersive exhibition in Beijing had achieved significant ticket revenue before he invested in the Shenzhen project. As the media reported (PIKAPIKA, 2019), teamLab's Shenzhen exhibition at the OCT Creative Exhibition Centre attracted more than 400,000 visitors. The entry ticket fee, which gave him a substantial profit from the exhibition, was the main revenue source and return on investment.

Even though this exhibition had received commercial investment, it is still considered a public cultural project. OCT Creative Exhibition Centre is located in a retail complex. It is a public exhibition centre that focuses on displaying projects in relation to commerce, culture and creative arts. Moreover, this exhibition received 200,000 RMB (about US$28,000) in funding from the local government as a cultural and art project for the public. However, Yang said the funding from the government was not enough for its initial investment, including renting the venue, acquiring copyright from teamLab Japan and purchasing the required equipment, so he invested 27 million RMB (about US$3.9 million) in total from his investment company.

Even though he agreed that the exhibition is a public project which has a cultural perspective, he expected the economic benefits of his commercial operation. Yang highlights the significance of commerce in this public project. For an investor or an entrepreneur, the principal function or motivation is to bring the cultural product to the market and then make a profit. Moreover, he believes that mature cultural IPs can expand cultural consumption and thus make more profits. He said that he prefers to invest in famous existing cultural IPs rather than creating new IPs. Successful IP would have already been tested by the market and can attract more audiences to the immersive art exhibition.

In fact, it is really difficult to develop an IP, like Disney's, teamLab's, or some artists, including Takashi Murakami and Yayoi Kusama. Yayoi Kusama also has a digital immersive exhibition. In the past, Yayoi Kusama's works were static works, but now her works are also digitalised. The reason why audiences want to visit or appreciate the immersive art exhibition is that they know Yayoi Kusama's work. If it [the exhibition] can't generate a kind of recognition based on the audiences' admiration of the artist or their works, it is not a successful cultural IP.

The cultural presence of digital immersive art therefore is not only about cultural recognition but also refers to familiarity, which means it is based on a specific cultural context. Following the idea of cultural proximity, people tend to gravitate towards information from their own culture or the culture that they are familiar with (Straubhaar, 2014). The reason that audiences visit Yayoi Kusama's immersive art is not only because of the immersive experience but also the familiarity with the iconic elements of her art that makes the work attractive to audiences. Yayoi Kusama has been acknowledged as one of the most important living artists to come out of Japan (Yamamura, 2015). Her works are primarily sculptures and installations, and they are based on conceptual art and show some attributes of feminism, minimalism, surrealism, pop art and abstract expressionism. In order to attract more audiences and generate sustainable economic profits, entrepreneurs are also incentivising famous cultural IP to be presented in digital immersive art exhibitions.

As considerable profit was achieved from teamLab's Shenzhen exhibition, some organisations believe this represents a successful business model for commercialising digital immersive art. In light of the successful implementation of teamLab's business model in Shenzhen, the Association of Culture and Technology Promotion in Nanshan District planned an immersive art exhibition in Shenzhen in 2019. Founded in Shenzhen in 2018, the association is a government-oriented organisation that includes member enterprises in cross-integrated fields of culture and technology. This association aims to integrate resources (i.e. funding and talents) for its member enterprises and seek projects from government and industrial fields for its members. The association agreed with the business model for the commercialisation of digital immersive art and highlighted the significance of the business value of digital immersive art. As one of the managers, interviewee Liu Xi said,

> teamLab represents foreign intellectual property imported from abroad. It was brought into China through the exhibition in a rented venue, selling tickets to audiences. The selling point was really about the shocking visual effects. However, we also want to do something more about [Shenzhen] culture, for example, the ocean culture could be a spotlight for the city of Shenzhen [in our upcoming exhibition].

The association connects local government and entrepreneur members, and in the process, entrepreneurs are directed to follow the government directive to promote Shenzhen's culture by using digital technology. Like other industrial associations, they also need to represent and seek benefits for their entrepreneur members. Hence, a digital immersive art exhibition

with the theme of Shenzhen culture is a way to connect the resources of their member companies in relation to digital technology and cultural creativity while following the government directive. Another interviewee, He Xi, notes that economic value is essential in connecting the art exhibition, entrepreneurs and government. As he said,

> The key to achieving these aims is to ensure that the returns to the businesses are essential. After all, who pays for this exhibition, and who receives profits from the exhibition?

The exhibition can be paid for by visitors, government funding and private investors. In the value chain, entrepreneurs are the actors who examine the economic value of the cultural product. As the profit generator, entrepreneurs need to inspect whether the exhibitions can make a return on the investment.

Success in the market brings more business opportunities to teamLab, which in turn allows digital immersive art to be more broadly accessed by mass audiences in China. Real estate companies use digital immersive art to add cultural value to their commercial projects. A Shenzhen real-estate company, Centralcon Group Co., Ltd., invited teamLab and its architect team to create a public space for the real estate project, C Future City, which has a total construction area of about five million square meters. The project includes office buildings, hotels, retail streets and apartments. In order to highlight the city of Shenzhen, which is to be characterised by digital technology, modernisation and creativity, this real estate project integrates art, nature, science and technology into the urban public space (C Future Lab, n.d.). In C Future City, teamLab has used digital technology to create a free public installation, *Crystal Forest*. This installation is developed from *Crystal Universe* (2015), one of the digital immersive art works in teamLab's Shenzhen exhibition.

Commercialisation is one of the significant reasons for teamLab's success in China. To some extent, the relationship between teamLab and business is a win–win situation. A high-quality art project can bring potential commercial profits to the investors. On the other hand, the sustainable collaboration of teamLab and business helps the value of digital immersive art to diffuse into broader areas such as city complexes, tourism destinations, and even restaurants, which is to say that local audiences can have more chances to experience digital immersive art. As a city complex, C Future City is not only considered a shopping mall but also a cultural destination and public space for people's daily lives. The fact that teamLab's digital installation is used as permanent public art in such a complex means digital immersive art

is beginning to be accepted and adopted by the public. The issue of whether cultural products can pass the test in the market economy to some extent influences the diffusion of their value in broader domains.

Curators as the Cultural Value Keepers of Digital Immersive Art

The analysis in the following section draws on interviews with two practitioners who work in art museums and refers to two digital immersive art exhibitions with which they were engaged. Maintaining cultural and aesthetic values is one of the curators' primary purposes since they want to use digital immersive art to enhance or maintain the reputation of the art institution. Interviewee C-3 (anonymised) works at Deji Art Museum, which has received investment from a retail company and is located in the shopping centre, Nanjing Deji Plaza. In 2019, the Deji Art Museum exhibited an immersive art project called *The Worlds of Splendors* (2019). Another interviewee is Wang Liping, the vice-curator of the Red Brick Art Museum in Beijing. In 2018, Wang curated an immersive art exhibition, *The Unspeakable Openness of Things*, which featured the work of the artist Olafur Eliasson. Curators expect digital immersive art to deliver cultural and aesthetic values to the public as a new form of art; they select and curate art products to safeguard or refine the cultural and aesthetic values of the exhibitions. At the same time, however, a well-attended art exhibition can enhance the recognition, acceptance, and visibility of the art museum.

To enhance the audience's understanding of China's culture, creators also make new meanings of the existing cultural elements in digital immersive art. As interviewee C-3, who works at Deji Art Museum, said, there are many Chinese cultural elements in Case Study 3, *The Worlds of Splendors* (2018). Case Study 3 tries to interpret traditional Chinese artworks in the context of contemporary China (Figure 5.2). The digital artwork 'shanshui' and 'jiayuan' ('山水'和 '家园', lit. trans. 'landscape' and 'homeland') is inspired by the seminal Chinese painting *Qianli Jiangshan* (千里江山, lit. trans. *Thousands of Miles of Rivers and Mountains*) by Wang Ximeng from the Song Dynasty. In the digital artwork, visitors can view digital installations featuring Wang's renowned 'qingshan lvshui' ('青山绿水', lit. trans. 'indigo mountain and green river') and experience the view of the mountain from *Qianli Jiangshan* under the water via the immersive projected images. *Qianli Jiangshan* is a famous cultural IP not only because it is cultural heritage but also because it has been represented in many films and television programs in China. For instance, in December 2017, *Qianli Jiangshan* was featured in National Treasure (国家宝藏), which is a culture and museum discovery television program in China.

Figure 5.2. A participant in front of *The Worlds of Splendors* at Deji Art Museum

The artwork also connects the traditional cultural elements in *Qianli Jiangshan* with China's contemporary mainstream values. The didactic panel (Figure 5.3) of the artwork states:

> Our traditional values are often linked with the concepts like *tianxia* [天下, lit. trans. "under the sky"], *jiangshan* [江山, lit. trans. "rivers and mountains"], and *jiayuan* [家园, lit. trans. "homeland"], which are different from the concept of state/regime in the Western world. These concepts are perhaps more about cultural belonging and awareness, worldviews, and spiritual existence. From babbling babies to elders, the Chinese people are bound together as a community through the shared ideas of "homeland" or "mountains and rivers".

While the concept of *jiangshan* connotes 'nation' and *tianxia* connotes 'the world', the equivalent contemporary term would be 'Community of Shared Future' (命运共同体). This concept was officially proposed as a Chinese ideological value in Xi Jinping's (2017, as cited in X. Zhao, 2018) work report to the 19th Communist Party of China (CPC) National Congress. Inspired by ancient Chinese wisdom (i.e. Confucius), this concept represents China's vision of a more justice, secure and prosperous world where China sees itself as a builder of world peace and contributor to global development (X. Zhao, 2018). According to the information in the didactic panel, through using both traditional Chinese culture and immersive technology, this artwork is an

《洛神赋图》

"山水"与"家国"

《千里江山图》

提起"国画"，眼前立刻浮现层峦迭起的山水映像，这是国人对于"国"与"家"最瑰丽的原生念想，家国与山水相融而生。

山水的静穆与博大契合了古人对自然的向往与神游，

从山水的自然到气韵的精神，中国山水画的文脉流转、意境追求与中国艺术推崇的"写意"一脉相承。山水画也成为了古人意境展现的最佳载体。

同时，云的交融、水雾的弥漫流荡、光的游移，使意境画中产生灵动诗意的画面。在山水中观察一种秩序，放弃了一味追求形似的执念，而在不断触及作者内心本质的过程中上升到了中国人文哲学的高度。

我们传统观念中常常提及的"天下"、"江山"、"家国"等概念，不同于西方人世界中准确的政权形态，也许更多的，是对文化、意识、生存价值的心灵依存与归属。从呀呀学语的婴儿到翛然回首的长者，"家"与"山河"是散落在中国人心目中永恒的共同体。

在获得甄后遗枕后，感改为《洛神赋》传世，愿与顾恺之相隔百年之遥

。这也解答了为什么隔

"无"处看到了"有"，在可能。

画中的"实"。这是我们

Figure 5.3. Part of a didactic panel at *The Worlds of Splendors* (2018)

interpretation of the significance of how China and the Chinese understand the 'Community of Shared Future' political slogan.

As recounted by interviewee C-3, Deji Art Museum had two reasons for choosing *The Worlds of Splendors*: the Chinese creation teams (BlackBow and GLA Art Group), and the installations' interpretation of Chinese traditional culture. As the interviewee said,

> In the beginning, we chose *The Worlds of Splendors* because we felt that it demonstrated the convergence between modern technologies and culture and thus deserved an opportunity for exhibition. Moreover, they [BlackBow and GLA] are Chinese teams whose works are an interpretation of Chinese traditional culture. What our art museum hopes to exhibit is not only their technical aspects but also the essence of Chinese culture.

The use of digital technology, especially VR, in artworks and exhibitions has become a substantial trend in China's art and cultural sphere. Some overseas teams (i.e. teamLab), as I have discussed, have achieved tremendous success in China. Interviewee C-3 believes that *The Worlds of Splendors* is a good opportunity to display the 'modern technologies' by a national company, BlackBow, to the audiences in China. Before *The Worlds*

of Splendors was exhibited, BlackBow had already been engaged in cultural events to present Chinese culture on the global stage through immersive technology. Notably, it orchestrated the immersive stage effects at the *Beijing 8-Minute Show* (2018) at the PyeongChang Winter Olympic Games closing ceremony.

Deji Art Museum believes *The Worlds of Splendors* should help audiences better understand Chinese culture. For example, in 2018, Deji Art Museum exhibited more than 200 prints and installation works by the Chinese artist Chen Qi that demonstrate his understanding of Chinese culture. The digital works in the exhibition attempt to create a virtual space surrounded by the immersive projected images of Chinese fine arts to elucidate Chinese humanistic philosophy. During the exhibition, visitors can see typical Chinese elements, such as Chinese landscape painting and calligraphy. Some renowned ancient Chinese artworks and aesthetic ideas are also represented in the exhibition, such as Wang Ximeng's Chinese painting *Qianli Jiangshan* (千里江山, lit. trans. *Thousands of Miles of Rivers and Mountains*) and Zhuangzi's philosophical thoughts about the 'infinite'. Zhuangzi's Taoist philosophical thoughts had deeply provoked traditional Chinese aesthetics. The Chinese aesthetician Xu Fuguan (2005) notes that the spirit of Chinese art is influenced by Taoism, especially the Taoist view on life and the universe.

To convey the cultural value of the artworks to the audiences, the curators test and refine the art products. According to interviewee C-3, Deji Art Museum conducted some surveys and questionnaires with the visitors. From their research, they found that the attraction of *The Worlds of Splendors* was more about the immersive experience for most visitors rather than Chinese culture. Many said they could not understand some specific cultural meanings in the artworks. As interviewee C-3 said,

> In the end, we found that few could understand the message and comprehend the cultural significance. As such, there is no way for audiences to immerse themselves in the cultural experience. They probably just acknowledged the advanced technologies through being immersed in the technological environment. They appreciated the artistic atmosphere created by laser light, light and shadow, and screen art, instead of Chinese culture.

The interviewee further explained that to ensure visitors have a more comprehensive experience of Chinese culture, the museum provided additional didactic panels and offered free guided exhibition services. In doing so, the

curator believes that the additional information will make visitors understand the cultural content well, and not just focus on the immersive experience of the exhibition. Interviewee C-3 justified the museum's approach in this way:

> This immersive exhibition actually only extracts elements from Chinese art. But for these works to be completely understood, the audience must understand the meaning of each element. For example, one of the works is not a literal interpretation of Wang Ximeng's *Qianli Jiangshan* because it only extracts some elements and some images from the original artefact. If the audience does not know Chinese painting very well, it is difficult for them to know what this immersive work wants to convey.

Therefore, one may argue that understanding the digital immersive art also depends on cultural capital, which relates to an individual's education, knowledge and intellectual skills. However, as the exhibitions are intended for mass audiences, digital immersive art should consider the mainstream cultural capital in China. C-3 noted:

> Everyone has their own field of expertise [...] I'm not talking about the cultural literacy of Chinese people, but in fact, most people have not achieved a very high degree of artistic attainments, including many young people nowadays. Although we Chinese are slowly improving ourselves, we have not achieved omniscience. I think this is impossible for anyone to achieve.

In this regard, the immersive art exhibition does help audiences to understand the cultural meaning, although it relies on the audience's knowledge of ancient China to deeply comprehend the work.

Unlike Deji Art Museum, Red Brick Art Museum in Beijing is dedicated to collecting and exhibiting contemporary art. In 2018, the art museum curated an immersive art exhibition of Olafur Eliasson's artworks, *The Unspeakable Openness of Things* (2018) (Figure 5.4). As interviewee Wang Liping, who is the vice-curator of Red Brick Art Museum, said,

> Because we are an international contemporary art museum, our curatorial decision is mainly based on academic, artistic, and cultural values. I would say that we decided to exhibit it not just because it is immersive art. Our first consideration was whether it fits our art museum, not whether it was immersive, when we finally made the decision about this artist's exhibition.

Figure 5.4. An immersive art installation by Olafur Eliasson at Red Brick Art Museum

Olafur Eliasson has a long record of creating significant contemporary art installations using light and shadow. Red Brick Art Museum had started contacting Olafur Eliasson since 2012, when immersive art was not yet a trend in China. The subdivided building structure of the Red Brick Art Museum lends itself to creating an immersive environment for each installation. As interviewee Wang further noted,

> Our exhibition space is very large, and each hall is quite independent. In his [Olafur Eliasson's] exhibition, each immersive work suited and also required a separate space. So, we intentionally designed the exhibition in that way, creating a separate, closed, and immersive environment for every work.

The principal reason for curation was that the artist's works were well suited to their art museum. The Red Brick Art Museum aimed to use the immersive exhibition to promote the art and cultural value of the institution.

According to audience feedback and the critical reviews, Wang believes *The Unspeakable Openness of Things* (2018) successfully promoted the museum's reputation. The exhibition was not only well discussed by professionals in the field of art, literature and architecture, but was appreciated by mass audiences. In order to further promote the exhibition, Red Brick Art Museum curated four stages of dance performance based on four of Eliasson's immersive

artworks in the exhibition halls. For the art museum, this was an attempt that integrated the concepts of body and immersive installation to engage with audiences. The addition of interactive performance enabled the curator to refine the delivery of cultural and aesthetic meanings in the digital immersive art works and foster the audiences' understanding of the body and immersive experience in the artworks. According to the interviewee C-3, the curators also refined the artworks in *The Worlds of Splendors*, such as conducting visitor surveys and adding didactic panels to reinforce the audiences' cultural understanding.

As Wang said, Red Brick Art Museum does not reject commercialisation since it can bring sustainable development (i.e. more sponsors and visitors) to the art museum. *The Worlds of Splendors*, for example, was also a ticketed and commercialised art project in a shopping centre. However, the curators of both exhibitions highlighted that the aesthetic quality and artistic significance of the exhibition are more important than commercialisation. The vice-curator of *The Unspeakable Openness of Things* (2018) believes that its aim is completely different from the immersive exhibitions in shopping malls, such as some teamLab's art exhibitions. Regardless of the choice of immersive experience or the use of interactive performance during the latter part of the exhibition, Red Brick Art Museum's aim was to bridge the artist and audiences. The principal function of curators in an art institution is not just to find a way to attract more audiences or make more profits, but to deliver symbolic cultural or artistic meanings to audiences.

Balancing Cultural and Economic Value in the Production of Culture

Entrepreneurs now hope that immersive experience projects can activate cultural consumption and fulfil the need to upgrade the entertainment industry. The involvement of digital immersive art in the commercial field has, to an extent, led to the rapid development of the immersive entertainment industry in China. According to the commercial report by Illuthion (2018), the association for China's immersive entertainment industry, the number of immersive entertainment projects has grown from zero in 2015 to two hundred in 2018, and different kinds of immersive art exhibitions are one of the significant growth segments. Moreover, retail and real estate companies are collaborating with digital immersive art for the purpose of advertising and refining the consumption scene. According to the statistics prepared by the commercial real estate service provider RET (2019), scenario-based activities drawn from famous cultural IP have accounted for the largest proportion (about 71.67%) of advertising activities in China's urban commercial

complexes; additionally, in order to obtain relatively high quality immersive art exhibitions with famous IP, real estate developers are also introducing preferential policies such as free rent and free advertising to the creators or investors. Therefore, real estate developers are incentivising art displays in commercial settings.

Compared with traditional forms of art production, digital immersive products require greater investment in equipment, creation and devices. Therefore, profitability is an important motivation. An interesting parallel can be drawn between the field of digital immersive art and the immersive entertainment industry in China in relation to the significance of profitability. Immersive experience became a consumption trend in China's location-based entertainment (LBE) after 2016, before contracting in 2018. Interviewee Wu Zhanxiong, the founder of Eyemax Co., Ltd., the first location-based VR entertainment company in Shenzhen, told me:

> 2016 was the peak of the VR industry in China with the acceptance by capital and consumers, but soon the entire market was saturated. Many counterparts plagiarised our company's VR LBE products. During that period, there were few new products because the entire VR LBE industry focused on how to get investment and profits rather than creating new content for the VR LBE.

Wu said that in order to survive in the competitive market after 2016, many companies focused on how to make profits rather than produce new content, which is one of the reasons why the industry was contracting. Although the Chinese government has a supportive policy for the VR industry as an emerging industry, the creators need to consider the profitability of the work to offset expenditure costs. However, compared with the entertainment and gaming industries that attract wider audiences, the profitability of digital immersive art is more difficult to achieve. As interviewee Huang Ruogu, a VR artist in Veer (a VR content platform based in Beijing), told me,

> 3D simulation is high-cost. Without enough funding, the quality of VR products is unstable, so users do not want to pay for the low-quality content.

In the creative industries, the arts are part of a dynamic system of economic activity with links to safeguarding and inheriting culture, fostering creativity, embracing new technologies and feeding innovation (Throsby, 2008). When infusing new ideas into works, creators of digital immersive art also foster commercial value. For example, *Andy's World* (2019), which is a large-scale

VR work presented by Configreality Space, was exhibited at K11 art space in 2019. The creative team invented a new algorithm in VR that allows viewers to feel the infinity of the virtual world in the body of a robot whose name is Andy. *Andy's World* applies the aesthetic elements of cyberpunk and combines these with unique imagination to explore the meaning of life in an immersive narrative. *Andy's World* won the best Chinese VR Work at the 2019 Sandbox Immersive Festival in Qingdao. After winning the prize, the creative team commercialised the work as a location-based entertainment project in a shopping mall. According to the interview with the creators Liu Liquan and Huang Jiasheng, they did not consider their works to be authentic artworks since they would finally be used as entertainment projects. But even then, as both interviewees clarified, they still consciously distinguish their works from purely commercial projects that are only used for entertainment. They try to add some aesthetic elements and artistic ideas to their works.

However, once the value of arts gravitates towards profit margins, digital immersive art may become a gimmick to attract more audiences and make more profits. When the gimmicks outweigh the artwork, then it is a problem. In light of the peak of China's immersive entertainment industry in 2016, the immersive experience only created short-term profits instead of fostering sustainable value for the industry. In some respects, it was initially seen as a gimmick. Hence, creators need to balance the commercial value and artistic value in their works. Interviewee Guo Qinya, who is the producer of *Maybe it's Time to Refresh the Art World a Little Bit* (2019), described Wang Xin (the artist of the work) as a good example of this balance:

> Wang Xin's advantage is that her artworks have some commercial value, and they can be commercialised. But the content of her artwork is quite interesting. There are some creative uses of hypnosis in the artworks, as well as the artist's own unique ideas and worldview. I think the combination of these two [art and commercialisation] in her artworks is pretty good.

The pop art features in the artist's works lent themselves to being exhibited at the K11 art space, an art museum at the K11 shopping centre in Hong Kong. K11 art space belongs to the K11 Art Foundation (n.d.), and is a retail corporation-owned art museum dedicated to fostering the development of Chinese contemporary art. As Guo said,

> This digital work has a pop art style. K11 likes this style because it can attract more visitor views; if a commercial exhibition is presented in a shopping centre, it cannot be too '*gaoleng*' ['高冷', lit. trans. 'high and

cold', which connotes 'highbrow']. Pop art has its own audience that is normally very young, so the artist can put some bold ideas and new technologies in the artworks, which not only caters to the preferences of young people but can also lead more people to accept new art forms like VR.

In the interview, Guo highlighted the significant role of creators in diffusing the value of digital immersive art and VR to more audiences. In the exhibition, viewers can see many elements of pop art (Figure 5.5), such as the artist's signature pink colour, neon light and wave dots. The bold colour and wave dots are widely used in pop art, which is opposite to 'high art' (Grenfell & Hardy, 2007), such as the aforementioned Japanese artist Yayoi Kusama's works, for example, *Infinity Mirror Room* in 1965 and *Dots Obsession* in 1997. The symbolic pop art elements fit the aim of K11 as a museum-retail space not only attracting young visitors to the shopping centre, but also allow the artist (Wang Xin) to use the opportunities to deliver her specific art ideas.

As a complex mechanism of production, the cultural sphere has allowed some commercialised digital immersive art exhibitions to be shown at art museums or cultural centres. Digital immersive art works attract consumers and create value in a cultural market by embedding the symbolic meanings that

Figure 5.5. The pink colour and neon light in *Maybe it's Time to Refresh the Art World a Little Bit* (2019)

cultural producers want to convey, and provide novel experiences facilitated by digital technology. The positioning of digital immersive art in the intersection of cultural and commercial spheres not only delivers cultural value to the public but also enhances the mass acceptance of digital immersive media. Cultural institutions such as art museums and galleries play the role of guaranteeing that the digital immersive art works have their cultural or artistic value. Meanwhile, entrepreneurs transfer cultural value into economic value.

VR has become a creative media diffused in art and cultural institutions. Interviewee Guo Qinya said,

> I think VR will break a lot of traditional things [i.e., media and industries], so VR also needs to be accepted by all the industries, rather than just using it to make games. In the early stage, there were many large-scale VR projects presented in cooperation with museums. I think that after art museums cooperate with the more famous artists who are using VR, they will be able to pave the way for all kinds of industries to accept VR gradually. And even the next generation of artworks can be created using VR.

Gaming is one of the largest digital industry sectors globally that uses VR (PwC, 2019). Large VR companies like Oculus and HTC VIVE consider VR gaming and entertainment as their main business. Nevertheless, Guo believes that VR can be valued as a medium of art in its own right and this is something that should be accepted by more art organisations and other industries. In other words, art museums are perceived to be the gatekeepers for mainstream and broader acceptance of VR by audiences or for its wider adoption across other industries.

Interviewee Huang Jiasheng, a VR artist and the founder of Jes Studio in Shenzhen, shared Guo's opinion on this, and he used teamLab as an example. As Huang said,

> Artistic works have to enter a certain field [art field], be recognised by the experts [i.e., artists, curators, or art critics] and circulate in art museums and galleries. teamLab's works were not really a work of art at first. teamLab started its company with commerciality as its goal, and now it wants to cultivate itself as the image of public art through exhibitions in various cultural centres and art museums. However, it still has a strong commercial nature.

teamLab is not only an art studio but also a collective. Its main business is art design, commercial installation and architectural design. Immersive

art brings teamLab into the public art sphere through being exhibited in art museums and cultural centres. The investor in teamLab's Shenzhen exhibition, Yang Juze, also considered the question of whether teamLab's immersive exhibition is art. As he said in the interview,

> [In 2018] I went to Shenzhen University to speak at a forum when teamLab was just introduced to China. An audience member who studied art history asked me a few sharp questions at the forum. The audience questioned whether such a high-tech work [digital immersive art] is art.

In 2018, Shenzhen was the second Chinese city to host teamLab's immersive exhibition. Even though teamLab's exhibition already had received a good reputation in Beijing, many audiences in other cities were not familiar with immersive arts. Since then, teamLab has exhibited in many art centres and museums, such as Party Pier Culture and Art Zone in Guangzhou and Deji Art Museum in Nanjing. Additionally, in 2019, teamLab launched a permanent art museum, teamLab Borderless, in Shanghai, to exhibit its immersive arts. As Yang said,

> teamLab's exhibitions have turned into multidisciplinary art projects, given they were exhibited in art galleries and museums.

As evidence of the scope for further commercialisation, Yang uses the reputation of teamLab in the art and cultural sphere as a kind of cultural IP. For instance, he has used this IP in his Shenzhen catering business, where the customers can experience immersive arts while consuming meals. That is to say, he has applied elements from teamLab's works to commercialised arenas, such as his restaurants and tea rooms. He has invested and opened an immersive restaurant with artistic and nature-based themes drawn from teamLab's digital content shown at art exhibitions. According to Yang, the price per person for a meal at this restaurant is 2,688 RMB (about US$400). By using the digital content from teamLab's artworks, customers can experience the changing of the four seasons during the meal, and they can even interact with these elements.

GLA Art Group has taken a similar path in cultivating *The Worlds of Splendors* (2019) as a cultural IP in China. According to its official website, GLA Art Group (n.d.), established in 2017, 'specialises in modern aesthetics reengineering and exhibition on Chinese cultural IP (Intangible Property) [sic]'. In order to cultivate *The Worlds of Splendors* (2019) as Chinese cultural IP, GLA brought it to the art sphere, for example, by holding a seminar in

the National Palace Museum in 2019, and curating exhibitions at Deji Art Museum in 2019 and Guardian Art Centre, and more recently orchestrating a Chinese culture themed immersive show for a Chinese car retailer at Auto Shanghai 2021 (the 19th International Automobile Industry Exhibition). Even though the aims of the cultural and commercial spheres related to digital immersive art are different, it is the current trend for each side to collaborate with the other. As a cultural product, digital immersive art is present in China's cultural sphere with its adoption by cultural centres and art museums. The adoption by these cultural institutions reinforces digital immersive art as a new form of art and helps it to be accepted by the public and enables entrepreneurs to turn the cultural value to economic value and make more profits in the commercial sphere.

The founder of teamLab Toshiyuki Inoko (2019) states: 'Everyone is concerned about whether to make money or not, but the spread of culture is the most important thing'. However, cultural products that do not grasp ideas that can be turned into profitable content and marketable meanings will tend to fail (Throsby, 2008). In China, when retailers need to improve brand recognition and style, immersive art activities have become the preferred choice, replacing traditional advertising activities (RET, 2019). Compared with static window showcases, retailers in shopping malls tend to choose forms that are more experiential, interactive and immersive when advertising their products. According to an iResearch (2018) report, 69.4% of Chinese consumers believe VR and AR immersive technology can improve their entertainment experiences.

In November 2017, the immersive art project *Lost in Play: Find the Lost One Hour of Life*, curated by digital media artist Fei Jun and curator Jiang Jian, was held at CHAO art centre in Beijing. The exhibition was sponsored by a cosmetics corporation. The artists used multimedia installations, performance art, contemporary dance, music and modern drama, creating an immersive world that allowed viewers to pause for an hour in their busy urban life; like the fairy tale *Alice in Wonderland* they can be temporarily isolated from the real world. The exhibition is not only an immersive art project but also advertising for brand promotion. It attempts to link artistic experience with bodily experience while also creating an immersive makeup experience. Within the experience, audiences can view the brand logo and elegant models wearing delicate cosmetics.

The immersive arts allow audiences to actualise their daydreams and fantasy from the first-person view, which is difficult to achieve in traditional art media. The curatorial team JV communication (2018, as cited in JOYNVISCOM, 2018) believes *Lost in Play: Find the Lost One Hour of Life* has changed the relationship between audiences and traditional plays since

the audiences become the protagonist in the artwork. The intervention of digital technology in art turns the spectator's passive 'viewing' into an active 'experience'. The spectators do not view the works at a distance but experience the performances inside the works; thus, every spectator becomes the indispensable protagonist in the play. Through interactive multimedia installations, performance art, contemporary dance, music and modern drama, the artworks served to fulfil the audiences' spiritual and psychological demands. Moreover, the artists designed different immersive senses using a range of makeup and styles to match with the cosmetics brand. In the AR work *Twin Flower*, the digital images projected on to the dancers' faces illustrate different makeup effects. As another example, the work *The Red Queens' Banquet* adopted the elements of the rabbit from *Alice in Wonderland* into the makeup style. As part of the exhibition, a rabbit dressed in a black suit dance while the model applies makeup.

Immersive arts are not only used as advertising per se, but generate a virtual consumption experience where customers can be immersed in the art while they are consuming it through staged immersive scenarios of consumption. This is evidence of Law's (1993) claim that experience can be detached from the real world and sold as a commodity or service. 'Once an experience is taken out of the real world, it becomes a commodity. As a commodity, the spectacular is developed to the detriment of the real. It becomes a substitute for experience' (Law, 1993, p. 4). According to a 2021 research report, the immersive virtual experience can fulfil consumers' desires for luxury brands and relieve them from the mental burdens of their real lives (Jung et al., 2021). It demonstrates the similar function of immersive digital technology used in *Lost in Play: Find the Lost One Hour of Life*. One of the latter's aims is to actualise an artistic, petty-bourgeois and escapist lifestyle in the virtual environment through the digital immersive art. As a commodity, digital immersive art in a commercial circumstance not only fulfils audiences' spiritual demands but also promises to improve their consumption experience. As another example, the cultural elements in teamLab's immersive installations were selected and refined to fulfil aesthetic demands in a luxury hotel. teamLab's created the permanent art installation *Enso in the Qing Dynasty Wall, Beijing* (2017) in the Temple Hotel. The Temple Hotel is retrofitted from an ancient Buddhist temple located in a tourism precinct in Beijing. The art installation draws on philosophical thoughts from Zen (a major Chinese Buddhist sect) and the cultural element of traditional calligraphy to characterise the cultural image of the Temple Hotel in Buddhist terms.

Positioned at the intersection between art and retail, the immersive art experience becomes a means of directing consumers' consumption behaviour.

In the twentieth century, the situationist philosopher Henri Lefebvre (1991) asserted that art should be immersed into everyday life to destroy the barriers between art and life and deconstruct and criticise the false desires constructed by the spectacle of a positive and authentic living situation, to call for the return of the real nature of human beings. In this assertation, Lefebvre highlights the function of art to critique the consumption society constructed by the spectacle of the commodity. However, in the present day, VR/AR is not only the media that advances the critical function of art but also is the digital machine that facilitates the incorporation of art into the commercial sphere. Art in the retail circumstance constitutes a novel attraction factor for increasing a shopping mall's traffic and improving its image and perceived value; however, this is not a new strategy – famous examples include Beaugrenelle and the Polygone Riviera (France), Miami Aventura (USA), Aishti (Lebanon), Parkview Green and K11 (China) (Vukadin et al., 2018). Consumers not only need to spend their income to 'enjoy' the circumstance generated from artistic experience since some of the digital immersive art exhibitions are ticketed; they may use some of their surplus labour time to spend more or stay longer in the retail environment. There is therefore no difference between digital immersive art becoming part of the commercial mechanism either as a commodity or as a service. Thus, digital immersive art is produced through a complex mechanism that is regulated by the government policy, fostered by commercialisation and generates new cultural meanings for society in the context of Digital China.

'Ticking the Box': A New Mode of Cultural Consumption

Along with the intersection of digital immersive art and commerce, a new mode of cultural consumption is present on social media, particularly among younger audiences in China. *Daka* (打卡, lit. trans. 'check in') has become an internet buzzword in Chinese, connoting going to a popular place or owning something special and usually showing it to others on social media via photographs (or short videos). In these images, people are deliberately pictured with objects or exhibition props or located within a space in the gallery to prove that they are physically present with the objects or space. Any place that has been viewed and posted online many times can become an influential spot with specific characteristics, such as a restaurant famous for serving local cuisine. *Daka* has become a particular type of consumer behaviour in the digital economy. For example, tourists can check online whether they have visited the most important sites; if so, English-speaking people can say they have 'ticked that box'. As symbolic cultural elements appear more in people's daily lives in China, such as in museums, city complexes, shopping

malls and restaurants, the 'box that needs to be ticked' by younger audiences in first- and second-tier cities in China is digital immersive art.

Daka was frequently mentioned in the interviews and focus groups when participants talked about the popularity of digital immersive art. As interviewee Wang Liping, the deputy curator of Red Brick Art Museum, said,

> What the immersive experience exhibition brings to the museum is, in fact, more audiences. These audiences are younger, and more fashionable [...] This new audience may not be as professional as before. [Nonetheless] It has made our museum more popular with mass audiences.

Even though Wang notes that Red Brick Art Museum does not have a deliberate policy of curating immersive exhibitions, its curators may choose to exhibit immersive art because it is easier to generate publicity around this. Through *daka*, such immersive exhibitions tend to attract more mass audiences, especially younger audiences, to the art museum. Wang further stated,

> In fact, because this kind of immersive exhibition does not need to be promoted to audiences, the audiences will naturally take pictures and *daka* with the work when they come to view it. This is the innate advantage of immersive exhibitions, so I think this is the reason why an audience would like to visit immersive exhibitions. The exhibitions we did before were mostly discussed and seen by experts in the art-related fields. We found that the immersive experience exhibition is especially easy for interaction and communication on social media. Under the effect of communication [on the internet], this type of exhibition has become very popular. It aroused the enthusiasm of the public to come to the museum, so we ushered in a large wave of new audiences last year.

Before its immersive exhibitions, Red Brick Art Museum was normally visited and talked about by people from the art and the cultural sphere. Immersive art exhibitions have attracted broader audiences since the advent of *daka* and digital immersive art has become a way for museums to connect with mass audiences more broadly. Museums can use social media to boost their visibility on the internet and attract more attention and potential visitors (Lazaridou et al., 2017). Despite the fact that aesthetic qualities were conventionally seen as central in the communication of the museum experience (Weilenmann et al., 2013), *daka* has become the new trend for museums in communicating with younger Chinese audiences. Visitors can take pictures of the exhibition, using it as a kind of background, and post these images on their social media. This behaviour and its influence on

social networks have further promoted the current popularity of immersive exhibitions shown at art museums.

The distinctive colour and neon lights of the immersive works form aesthetic backgrounds for the pictures posted by the young audiences on social media. Documentation of traditional art forms, such as visual art and music, can be posted on social media and appreciated on mobile devices, but digital immersive art is a kind of bodily experience and spatial immersion that cannot be easily accomplished on two-dimensional screens.

While viewing the exhibition *Maybe it's Time to Refresh the Art World a Little Bit*, I conducted an on-site interview at K11 art space with staff. The majority of the visitors to this exhibition are young people in their 20s–30s. When visiting the exhibition, half of the visitor's aim is to *daka* instead of appreciating the artwork. As explained by interviewee NG Pui Lok:

> In addition to the pink, it also combines with neon lights which form a very noticeable background, so it is very suitable for *daka* and taking pictures [...] I think half of the people really wanted to appreciate the artworks and understand the content, but the others just came to *daka*.

Entrepreneurs also recognise *daka* as a form of consumer behaviour. The investor in teamLab's immersive exhibition in Shenzhen, Yang Juze, said,

> Then they would also take pictures [of the art exhibition]. Why do we have to appreciate art exhibitions in a religious way? Why can't we play like young people? It does not have to be very serious. Art can just be a very beautiful, very imaginative, or creative thing. So, when we invest in something, we think about the capacity of influence. When something is influential, it will attract people's attention. When a thing can gain attention, everyone wants to see it. If people want to see it, I have to charge money from the audience because we are doing business.

From the perspective of economic value, interviewee Yang Juze considers digital immersive art as a machine for profit, as a gimmick to attract the audience's attention through its novelty, creativity or immersive experience. The rise of the digital economy has made cultural suppliers increasingly inclined to deploy resources to the contents that have already attracted the market or are ready to be shared and liked on social media (George & Peukert, 2019; Potts et al., 2008). The type of content that is suitable for *daka*, thus, has become favoured by cultural suppliers. The content of digital immersive art received by audiences is selected, refined and tested by the intermediaries. Entrepreneurs are in the role of regulating what audiences see and how they see it.

Daka digital immersive art provides us with a unique example of digital virtual consumption (DVC) fulfilling audiences' spiritual or cultural demands through cultural products. DVC (as introduced in Chapter 3) accomplishes demand-fulfilment through virtual and digital activities (i.e. online shopping or mobile games) (Denegri-Knott & Molesworth, 2010). As discussed, *daka* is online behaviour, and digital immersive art is a form of virtual content. In China, WeChat moments and *Douyin* (抖音, the Chinese version of TikTok) have become popular online platforms to see and post the *daka* content. It is a way to construct a new self that exists both in physical and virtual worlds: 'I *daka*, therefore I exist' (Sun, 2020, p. 6). Social media create a co-presence of audience, which motivates people to project a self of who the user is as a being (Aguirre & Davies, 2015). *Daka* is the online evidence to show that the audience was physically present with the arts. For the self on the internet, digital immersive art thus becomes a background for taking pictures and an instrument for showing off on social media. If such a critical decision about *daka* is being made by Chinese mass audiences, then it can be surmised that digital immersive art paradoxically also has the capacity to engender the neglect of cultural or artistic value.

Conclusion

In the context of an emerging technology, it is evident that commercialisation plays a significant role in the mechanisms of cultural production. This has been a key finding of the research in this chapter. Creators bring new ideas, creativity and cultural meanings to digital immersive art, while also needing to consider the capacity of the works to be profitable so as to offset the expenditure on the creation costs. Entrepreneurs from the commercial sphere and curators from the cultural sphere collaborate with each other to deal with the commercialisation of digital immersive art.

However, products and services in cultural markets often provide symbolic content for achieving higher-order benefits, such as spiritual satisfaction, self-fulfilment and cultural identity (Venkatesh & Meamber, 2006). As my fieldwork has observed, the immersive experience on offer may attract many viewers at the early stage (e.g. many visitors go to buy tickets and even wait in long queues to view the exhibition), but in the end, viewers find that the experience of these exhibitions is not as good as non-digital exhibitions in terms of the delivery of cultural value. In the next two chapters, I will discuss this further from the perspective of the audiences. Hence, it is also a critical question for cultural suppliers in the future to either increase the artistic value of the content to fulfil audiences' cultural demands or generate another gimmick to attract new viewers – or seek a balance between the two options.

Chapter 6

GENERATING CULTURAL PRESENCE IN DIGITAL IMMERSIVE ART

One of the advantages of VR, according to its proponents, is how the experience can transcend time and place while allowing the viewer to recognise the interplay of familiar cultural elements. Cultural presence is the viewer's experience of being in a specific (familiar or unfamiliar) cultural context at a specific time (Champion, 2011); for example, a European viewer immersed in a VR work that simulates the Forbidden City of 200 years ago; ideally, the distance between the viewer and the work is collapsed when the viewer is immersed in the cultural context and this may change the viewer's preconceived perception about the Forbidden City.

In the previous chapter, I provided a critical perspective for looking at the production of digital immersive art and how viewers react to it as a cultural product. In many cases, there is a disparity between VR creators' intentions and the audience's reception. Chris Milk (2015), an entrepreneur and immersive art creator, has a much-discussed assertation about audience experience in VR; he claims that VR creates 'the ultimate empathy machine' since it allows a user to empathise with another person deeply. However, some scholars and art critics claim that what the user has experienced is not real empathy since 360-degree video of VR is sometimes just a first-person point of view without a 'phantom-subjective image' (Hassan, 2020; Messham-Muir, 2018), and empathy requires a permeable boundary between 'me and you' allowing two people to mingle in a shared mental space (Rifkin, 2009). As I have discussed in the previous chapters, China's government see digital technology as a way to rejuvenate Chinese culture; and cultural institutions in China hope VR can augment viewers' cultural experience. In light of the dynamics of digital immersive art production (as discussed in Chapter 5), I focus on whether there is a disparity between the cultural institutions' display intention and the viewer's actual experience of VR.

In this chapter, I explore two questions: first, how does VR impact the viewer's cultural presence? Second, how do Chinese audiences react to how VR presents Chinese culture? I draw on three case studies. Case Study 1 is *Boost*

Your Art Energy: 8-Minute Guided Session (2019); Case Study 2 is *Shenyou Dunhuang* (神游敦煌) (2018); and Case Study 3 is *The Worlds of Splendors* (瑰丽) (2019). These three case studies feature immersive experiences and engage different cultural elements (i.e. traditional Chinese culture and popular culture). I use empirical data from focus group discussions to support arguments and analyse the factors generating cultural presence. The arguments are based on recurring themes from the focus group data. I use the concept of *illusion* as an imaginary experience to examine how viewers perceive cultural meanings in digital immersive art works.

To present a better understanding of, and contextualise the participants' discussion in the focus groups, I introduce the contexts of display for the three case studies in the first section. I provide a brief description, including some of the cultural contexts of each work, the type of immersive experience, and how interaction is triggered. This also refers to the description of the information (e.g. flyers) that is presented to viewers before and after their experience.

Case Study 1: *Boost Your Art Energy: 8-Minute Guided Session* (2019)

Boost Your Art Energy: 8-Minute Guided Session (2019) was featured in Wang Xin's (2019) solo art exhibition *Maybe it's Time to Refresh the Art World a Little Bit* (2019) at K11 art space in Tsim Sha Tsui, Hong Kong. As mentioned in the previous chapter, K11 uses the art space to engage with consumers and collaborate with young artists. Case Study 1 is a spiritual, mystic and immersive VR artwork that aims to recharge one's 'art energy' (Wang, 2019).

The work employs a VR head-mounted display (HMD) which offers 6 degrees of freedom (DoF) experience to the users. The interaction in VR is triggered by hand controllers. Within the artwork, users are given a choice to activate one of four guided sessions separately in four virtual rooms. As the eight-minute guided session activates creativity within each user, it attempts to tell viewers that everyone has 'art energy' that can be depleted, recharged and utilised at will. This art energy is related to an individual's artistic creativity generated from human emotions. A female voice acts as a hypnotist in the VR experience, guiding viewers in the dream-like environment and leading them out at the end. According to a flyer about this artwork, the moment users put on the HMD, 'they are thrust into a dream-like state freed from conventional space, time, and reality'. Wang Xin is a certified hypnotist and uses her work to alter a viewer's perception and affect their subconscious (DeSarthe, 2019).

Before the VR experience, the participants have already inferred some basic ideas about the art exhibition from the flyers available at the exhibition venue. In the exhibition, the participants can see the artist's signature use of pink adding to the hypnotising effect and installations composed of art-related

slogans (e.g. 'we will change the art world', 'a museum lost in time'). The use of these bold colours and duplicated elements of dots and slogans in typographic font suggests a cultural context of pop art. As I have noted in the previous chapter, the cultural element of pop art attracts younger audiences more than 'high art' (Grenfell & Hardy, 2007), which conforms to K11 as a 'Museum-Retail', a convergent space of art and retail.

Case Study 2: *Shenyou Dunhuang* (神游敦煌) (2018)

Shenyou Dunhuang (2018), presented by the National Taiwan University imLab and Dunhuang Academy (Han et al., 2019), is a virtual heritage project. Like *Boost Your Art Energy: 8-Minute Guided Session,* this work is also a VR HMD offering 6 DoF experience. However, it is not a project exhibited in a physical place; it is a free downloadable program from Steam, a popular VR content platform. This project features the 3D simulation of the Mogao Caves, a cultural heritage site in China. Even though it is classified as a game on the VR platform, *Shenyou Dunhuang* attempts to evoke the cultural and artistic experience of the Mogao Caves. *Shenyou Dunhuang* intends to provide viewers with a better cultural understanding of the Mogao Caves through the interactive experience of virtual artefacts and displays.

The Mogao Caves, in the western Chinese city of Dunhuang, are an icon of Buddhist culture in China. As an iconic cultural heritage site in China, the Mogao Caves have been featured in many digitised projects such as *Digital Dunhuang Tales of Heaven and Earth* (2018) in the Hong Kong Heritage Museum and *Mysterious Dunhuang* (2017) in OCT Creative Exhibition Centre of Shenzhen. Owing to the popularity of the Mogao Caves in China, the viewers have some pre-existing knowledge of Dunhuang from different resources, such as exhibitions, documentaries, archives and textbooks before viewing the VR work; some viewers had even previously visited the Mogao Caves.

This virtual heritage project allows viewers to explore Mogao Cave No. 61. Viewers can see a digital restoration of the deteriorated murals and the ruined statues. For example, the Manjushri statue in Mogao Cave No. 61 is missing, but it is digitally reconstructed, reappearing vividly in the VR work. In addition, the viewer in the VR can watch some interactive videos which illustrate the stories behind the murals, such as Mount Wutai and *Avatamsaka Sutra.*

Case Study 3: *The Worlds of Splendors* (瑰丽) (2019)

The Worlds of Splendors (2019) at Deji Art Museum in Nanjing is a collection of immersive art installations attempting to elucidate aspects of Chinese aesthetics and philosophy with digital immersive technology. The main part

of this exhibition consists of four cave automatic virtual environment (CAVE) works with projected images on the walls. Visitors can view the four works via connected corridors. When visitors walk through specific areas, their interactions are triggered by tracking sensors. Moreover, to create a more aesthetic experience, some physical installations, such as mirrors and strips of translucent paper, are added to the virtual environment. As in conventional art exhibitions, visitors can read an introduction on the didactic panels. In addition, free guided tours are provided to give visitors a better understanding of the artworks.

This exhibition attempts to foster the cultural understanding of traditional Chinese artefacts and philosophical thoughts with immersive technology. The first artwork, *Accessing the Realm through Cloud Reel* (云轴入境), generates a dynamic spectacle in the style of Chinese landscape painting inspired by Zhuangzi's philosophical thought. Zhuangzi was a famous philosopher of ancient China in the Warring States period. The second work, *A Thousand Miles of Rivers and Mountains* (千里江山), uses some elements from the Chinese painting of the same name, which was created by Wang Ximeng when he was 18 years old during the Song Dynasty. The third work, *Goddess of the Luo River and Neon Dream* (洛神霓梦) is inspired by a tragic love story of the Goddess of the Luo River (洛神) and includes elements of the Chinese painting *The Ode of the River Goddess* by Gu Kaizhi in Eastern Jin Dynasty (317–420). The calligraphy of the same name produced by Cao Zhi in the Three Kingdoms period (220–280) is also represented in the work. The fourth work, *At the Deepest Part of the Blossom* (百花深处), is inspired by *Scroll Painting of Blossom* (百花图卷) from the Song Dynasty. This work allows visitors to experience the view from lying under the flower bush in an immersive environment.

Illusion as a 'reception contract' with Viewers

From the perspective of art reception, the illusion is the acceptance of a '*reception contract*' (Wolf, 2013, emphasis in original) – 'the willing suspension of disbelief for the moment' (Coleridge, 1950, p. 194). To create a sense of presence, artists use the immersive strategy to allow viewers to recentre themselves in a virtual environment (VE). Viewers temporarily have the illusion of believing the environment that they are immersed in is real. Long before virtual art, the strategy of using immersive images was utilised by artists to generate the illusion of 'being there'. For example, as discussed in Chapter 2, *The Battle of Sedan* (1883) by Anton von Werner is a painting 115-metres long and 15-metres high. Standing on a panoramic viewing platform, which has a diameter of 11 metres and corresponds geographically to a plateau near the

village of Floing, the spectator is surrounded by a circular painting depicting the battlefield (Grau, 2003). Moreover, there are many details in the work attempting to represent the real sense of the battle. 'One believes that one is standing in the surging midst of the terrible battle', and 'it is exactly as His Majesty the Kaiser is reported to have said: It does not look painted at all; it is reality' (Grau, 2003, p. 98). In this sense, the viewers accept the *'reception contract'* in relation to the illusion of presence on the battlefield.

Realism is one of the strategies used to generate the illusion of presence in immersive art. In realist works, the represented world is much the same as the real world. As per Walter Benjamin's (2008) assumption, advanced technology can guarantee the material relationship between the original and its reproduction. For example, 3D virtual simulation technology allows details of the objects to be accurately captured and constructed in VEs, thus enabling users the experience of being there as if in the real world (Chen & Sharma, 2021). However, presence is not only restricted by the rules of the actual world but also is capable of triggering the sense of being beyond the real world. As Richard Wages et al. (2004, p. 223) suggest, 'art and in particular, VR art should not routinely and self-evidently be restricted with real-world constraints'. With the affordance of digital technology, especially VR, immersive art can create a virtual world beyond the actual world, as Jean Baudrillard (1988, p. 173) says, this is where representation is replaced by simulation and reality shifts to hyperreality. Immersive art through VR can thus transport viewers into a hyperrealistic realm, where the line between the real and the simulated becomes blurred. It opens up possibilities for experiences that go beyond what is feasible in the physical world, allowing for imaginative and illusionary encounters.

Digital immersive art as mediated by VR and AR technology can both generate illusionary experiences both in realistic and hyperrealistic ways. In line with the two kinds of ways generating the illusion of presence, the following sections focus on examining viewers' experience of *Shenyou Dunhuang* (a mirroring and restoration of cultural heritage), *Boost Your Art Energy: 8-Minute Guided Session* (a virtual world beyond the actual world), and *The Worlds of Splendors* (how viewers use rationality to understand the culture in a VE).

Incongruities in Realist Virtual Environments

Realism is not only the mirroring of the real world, rather it refers to whether or not the VE provides the real experience expected by the user, both consciously and unconsciously (Gilbert, 2016). Realism proposes an objective reality in VE that allows viewers to have a subjective perception of being in the real. *Shenyou Dunhuang* is an online virtual heritage simulating

the Mogao Caves. The focus group participants responded to the cultural presence in the virtual heritage in realist terms:

> It is more realistic; it offers more detailed viewing. As a whole, it also creates a sense of immersion of being in Dunhuang. (Participant 2-1)
> It has restored the colour changes of hundreds or even thousands of years. I can feel the colour of this mural [as if it was painted] today, as well as what it looked like 500 years ago, or even 900 years ago during the Five Dynasties period. (Participant 2-3)

Whenever the participants described their experience of *Shenyou Dunhuang*, they compared their experience in the VE to their previous experience in the real world. Their comments reflect how realism is a subjective perception based on viewers' preconceived ideas. The participants who had been to the real site commented that 'it is similar to the real cave' (participant 2-3) and that 'it feels like what I experienced out there in the past' (participant 2-8). Moreover, participant 2-3 said he felt he was not there in the cave in the present day, rather he felt he had been taken back hundreds of years. In the design of the project, the illuminated section of the mural is the default setting that shows the mural's condition 500 years ago. Triggering the controller restores the mural to what it looked like 1,000 years ago when it was originally painted (Figure 6.1). The evidence is in line with cultural presence, which is the feeling of being in a particular place and time within the cultural context of the work. While realism helps generate presence in VEs, it may nonetheless

Figure 6.1. Image of the restored mural (left) and image of the default mural (right) in *Shenyou Dunhuang* (2018)

divert the viewer's attention towards the incongruities of the information instead of fostering the feeling of presence in a specific cultural context. In the following paragraphs, I analyse the focus group data to provide evidence for this argument.

Several examples demonstrate that participants paid attention to the perceived incongruities, for example, in terms of the resolution, colour difference and VE design, and compared these with their own previous experiences and perceptions:

> There are no problems with the technology, just some [issues with the] details. I will just mention a very simple finding. I found some lines on the [projected] walls to be curved [...] they are not straight. In the real world, how could the walls be curved? Just this little detail. (Participant 2-6)

Participant 2-8, who had learnt this about the cave from other sources previously, questioned the accuracy of the restored colours.

> The real cave is more than ten meters high. Even if [one] raises an electric torch to view, it is not clear [...] VR is clearer [...] However, [the creators] should consult some of the better experts in this area to restore authenticity. It is inaccurate. It represents the cave 500 years ago but restores the colour [of the murals] to 1,000 and 100 years ago when it was the period of the Five Dynasties in China. It is not very precise in this aspect. I think it has not been created by experts in cultural relics restoration or archaeology. (Participant 2-8)

In fact, the restoration aims to provide a more realistic sense of presence rather than prompting viewers to question its accuracy. Therefore, the affordance in VE becomes a paradox: the more realistic the VE is, the more viewers are willing to accept how real it is; however, when the VE is not as real as expected, viewers may feel less immersed in it. The following examples provide more evidence to prove this point.

Some participants who had been to Dunhuang found the experience in the VE below their expectations:

> Regarding visual experience, I felt that what I saw was pretty new, without the sense of antiquity in Dunhuang. There was a subtle sense of disparity from reality. (Participant 2-1)
> I have been to Dunhuang before, though I did not visit this particular cave. Regarding this cave, I felt that technologies had over-glorified it.

In reality, you can find a kind of trace of history in the cave, [in] which [the surface] is quite mottled. (Participant 2-3)

The authenticity of a VE depends on how affordances are able to meet viewers' expectations. According to the discussion with the focus group, regardless of whether the participants had visited the Mogao Caves, they brought their impression of the real cave to the VE. Even with the participants who had not been to the caves, they had some preconceived ideas based on their prior knowledge. When the affordances were not able to meet their expectations, the viewers felt that the VR was unimpressive. They had expected to experience authenticity before being immersed in the VE. However, the realist environment paradoxically prompted viewers to instead see details that they thought were not real enough. In addition, this VR allows users to view the details again and again, and to look into the dark interior of the cave, which means it allows for more capacity (than the real site) for viewers to question the incongruous information. The following is another example of how a participant paid more attention to the details when she realised the simulation was virtual:

Since I have seen the real one [i.e, the cave], I know very well that this is virtual. Then I also looked at its pixels and resolution. Then I tended to look at its technology and see how high the resolution was. I kept wanting to compare the differences. (Participant 2-3)

Erik Champion (2006) suggests that cultural learning is one of the significant functions of virtual heritage. Realism may be helpful to some extent but is not essential to the experience of virtual heritage or, more broadly, of VR arts. An increase in realism might paradoxically lead to a decrease in believability since participants use their 'recognition of reality' to detect incongruities (Wages et al., 2004). Moreover, due to the current limitations of VR technology, including the pixelation and resolution issues mentioned by participant 2-3, it is not possible to present every detail of the actual objects and spaces accurately as predicted by Benjamin (2008) to the point where there is no longer any difference between original and copy. As participant 2-6 said, the technology (VR) is not the problem, rather there are problems in the details. The participant found the walls were curved in the VE, which is not realistic in the real world. Even if this case study is one of the most authentic VR works of the Mogao Caves currently available, VR still cannot fully replicate all the details without them being recognised or called into question by viewers.

Illusionary Perceptions in the Virtual World

Realism is not the only way of fostering a sense of presence. Illusionistic VE provides an alternative way to make viewers feel their presence in a virtual world. VR allows for the creation of *fantastic* worlds, the very worlds we can never visit in reality (Wages et al., 2004, p. 223, emphasis in original). A virtual world is not a world mirroring the actual world, rather its users still can have the sense of being in a virtual space, described as *'presence without immersion'* by anthropologist Tom Boellstorff (2015, p. 112, emphasis in original). Online video games like *Second Life* and *The Sims* create platforms where users can communicate and engage with each other in virtual worlds. Even though more virtual worlds (such as *Rec Room*, a VR game) have included the rich experience of more realistic immersion, many of the most popular worlds have just used cartoonish graphics rather than being driven by a technological fantasy of realism (Boellstorff et al., 2012), which is to say realism is not the necessary condition of presence. As I have mentioned, *Boost Your Art Energy: 8-Minute Guided Session*, with its animation-style design, is a built-up virtual world that does not exist in the real world. Instead of considering it as a simulation of the actual world, the participants felt that they had entered a new and virtual world. For example:

The third room is particularly unreal, with a sense of unreality. It is completely different from the room Yuechen [participant 1-4] had chosen for the ancient Greek sculpture because that room actually had references to real art, realistic art. But my room was a completely unreal and animated room, so it was very different from the real experience. I felt that for me, the animation frame rate or the wearable technology didn't give me a strong sense of isolation. It didn't make me feel like it [the world] existed. When I entered that world, I forgot about the discomfort of wearing the headset or the unreality of the animation. Instead, such unreality gives you such a strong sense of contrast, or such a strong sense of illusion, that it brings a different kind of reality. (Participant 1-3)

This reminds me of Spielberg's movie *Ready Player One*. After putting on the headset, I entered another world. Although you are right next to me, I can't see you at all with my eyes, just virtual reality, so the immersion is great. (Participant 1-6)

When comparing the artwork *Boost Your Art Energy: 8-Minute Guided Session* with reality, participant 1-3 used terms such as animation, illusionary and unreal

to describe the VE she was immersed in, which is contrary to reality. While in this kind of alien environment, she felt 'this space is real in the virtual world'. In this artwork, the animation elements are significantly different from the look of the actual world. Nevertheless, participants regarded the virtual world of digital immersive art as a kind of reality. In other words, the viewers had a sense of presence in digital immersive art because they were willing to accept the 'reception contract' with the virtual world beyond their preconceptions.

The 'reception contract' with the virtual world is important in generating a presence in digital immersive art. As I have introduced, *Boost Your Art Energy: 8-Minute Guided Session* aims to trigger viewers' artistic creativity generated from their emotions in the context of popular or contemporary urban culture. As the participant reported,

> I feel modern and contemporary art explores the loneliness and isolation in urban life, as present in many such artworks. This work is presented in VR immersive art. It will make you think about emotions that are neglected in real life and will drag your emotions into this lonely and isolated situation, especially negative things. (Participant 1-1)

He added:

> The design of many scenes [exemplifies this], such as seeing a person dancing in a room and the suddenly a huge whale flies overhead in the air; also, for example, [seeing] many people sitting there meditating. Each object [featured in the work], coupled with a transparent presentation method, renders a lonely and very sad scene. To be honest, in the process of experiencing [the work], I felt really lonely. (Participant 1-1)

The participant was in a lonely and isolated place which evoked in him a pre-existing experience of other contemporary artworks. Some modern and contemporary artworks take loneliness as their theme to convey the isolation and alienation of urban society, such as Edward Hopper, the artist whose works evoke loneliness and disappointment in urban life (Peacock, 2017). Urban society has its specific cultural context, which was perceived by the participant from the isolated and spectacular VE. The participant linked his loneliness and feeling of isolation with the affordance in the VE, such as the single dancer and mediating people in the room. The work is not executed in a realist style but creates a spectacular world beyond the preconceptions of the normal world, such as the incongruous size of the whale flying in the room and the transparency of the objects seen in the VE. However,

these incongruities did not generate the participant's disbelief but instead generated a sense of being in the lonely urban life. Wolf (2013) calls the kind of imaginative experience that exists between the real and the *as-if-real* a 'quasi-experience'; it is one of the important conditions for producing aesthetic illusions, an ideal mental status when recipients are immersed in the artistic world. Digital immersive art can induce viewers to centre themselves within an imaginary world. When the viewer is perceptively in the imaginary world, cultural presence coinciding with a quasi-experience from the immersive narrative is generated.

Cultural Understanding in the 'reception contract'

Further to the use of the imagination, viewers use their rationality in relation to their cultural background or knowledge framework to understand the work of art (Wolf, 2013). Participant 1-1's feelings of loneliness or alienation in urban life and cognition about modern and contemporary art can be interpreted as the cultural capital that has helped him make sense of his experience in the virtual context. The significance of cultural capital is also evidenced in another example, the virtual work *At the Deepest Part of the Blossom* in *The Worlds of Splendors*. Apart from the immersive experience, presence in this work is generated through the interaction with the affordance of VE. For example, projected flowers appear under the viewers' feet as they walk by. In the focus group discussion, a participant thought of it as *bubu shenglian* (步步生莲), which is a Chinese idiom meaning a lotus blooming with every step of the way (Figure 6.2):

> When interacting with the artwork, I think the idea of *bubu shenglian* is good. There is a flower following in your step. I like it. But the butterflies on the wall are just average. (Participant 3-6)

Bubu shenglian originates from *Chuke Pai'an Jingqi* (初刻拍案惊奇) (1627), which is a collection of short stories from the Ming Dynasty. This idiom is used to describe a woman's graceful gait. When participant 3-6 walked by the interactive spot, her imagination about blooming flowers may have been triggered, creating the feeling of being in the illusionary sense of reflecting on this Chinese idiom. The triggers for identification depend on the viewer's understanding and knowledge since different people may have different understandings of *bubu shenglian*, and some might not even know this idiom.

At the Deepest Part of the Blossom is inspired by *Scroll Painting of Blossom* (百花图卷) from the Song Dynasty (960–1279). *At the Deepest Part of the Blossom* attempts to represent the mass of blossoms seen in the painting. Viewers experience the

Figure 6.2. Photo of participants engaging with *At the Deepest Part of the Blossom*

blossoming of the flowers through the eyes of a little bug. Some participants lack the knowledge to understand the context of being immersed in the flower bush like a little bug, so they cannot use their imagination to generate presence, as the title of the work states, 'at the deepest part of the blossom':

> I don't quite understand what a bug's perspective is, so I checked it with my mobile phone. The perspective of some insects is actually not the diamond shape shown in the exhibition. Those diamond-shaped mosaics are messy, and they are not from the perspective of little bugs. This makes me feel very unreal, and I don't feel [it is] like being in nature. (Participant 3-5)

In this example, the viewer's rationality plays a significant role in the sense of presence. As the participant reported, even though she found the relevant knowledge on her phone, she still could not connect a tiny bug's view with what she experienced in VE. She lost the sense of being there in the VE. Other participant discussions in Case Study 3 also demonstrate the significance of rationality in understanding or appraising the works:

> I think although this exhibition is immersive, I didn't particularly get the themes from beginning to end. I knew it wanted to promote the traditional Chinese paintings and so on. and let us know them better, but I don't think this exhibition has a theme of Chinese culture. It just wanted to promote traditional Chinese painting. (Participant 3-6)

If not for the guides at the beginning, we might not be able to understand it well. In the end, it will have this result: when we think of *The Worlds of Splendors*, our clearest memory is not the culture they want to reflect, but [we only remember that] we took a lot of beautiful photos there and how gorgeous and beautiful the exhibition is. I think if [the exhibition] doesn't emphasise the cultural aspect very well, they [the creators] may end up putting the cart before the horse. (Participant 3-3)

The artworks in *The Worlds of Splendors* are based on a specific cultural context, which is Chinese humanistic philosophy. As interviewee C-3, who works for this exhibition said, cultural understanding is required for viewers to be immersed in the cultural context. The elements used in the artworks are based on traditional Chinese fine arts that have already been built as a cultural framework in many viewers' minds. It is true that this exhibition, to some extent, evoked viewers' awareness of Chinese culture; as participant 3-6 mentioned, Case Study 3 'just wanted to promote traditional Chinese painting'. However, viewers can acquire such cultural awareness from other cultural products. As some participants mentioned, prior to experiencing the digital version of *Qianli Jiangshan* (千里江山), they had already viewed the authentic work, and it has appeared in many other cultural mediums such as TV programs and films. The participants may feel familiarity because proximity in the cultural context can provide a sense of presence, the particular feeling in digital immersive art, to viewers. However, cultural presence also needs their understanding of the cultural elements.

If cultural understanding is absent, a distance exists between the artworks and viewers. Theoretically speaking, the physical distance between VR and the viewer is dissolved in VR, thereby increasing the sense of immersion. However, digital immersive art communicates with viewers indirectly, depending on the cultural context or framework represented by the artwork. According to Benjamin (2008), distance is not only an attribute of the arts but also involves the subjective view of readers. When a viewer is at an art exhibition, his/her responses are guided by the artist's representation. At the same time, both representation and recipient are affected by the cultural context of creation and the cultural background of recipients (Wolf, 2013). The lack of cultural context and/or cultural understanding causes distance between the artwork and its viewers.

In order to illustrate the cultural context and aesthetic significance, the curator of *The Worlds of Splendors* provided didactic panels and audio guides for the artworks. When viewers are present in the act of viewing, the distance between the viewer and the artwork momentarily disappears, which is what many artists would like to achieve. However, if a viewer is unable to

understand the artwork because of a lack of awareness of its context, the viewer is at a distance (the opposite of presence). Didactic materials are used to raise the viewer's awareness of understanding the context of the art. However, once the presence of the cultural framework in digital immersive art is reliant on information presented in didactic panels, or based on the reputation and visibility of the cultural elements, as the participants reported, then the immersive technology itself becomes gadgetry for achieving a novel experience or spectacular background for taking photos, rather than a way of helping viewers understand the cultural meanings.

In summary, viewers have expectations and motivations for receiving an immersive cultural experience in VEs, which is not only met by the feeling of being there but also by the sense of being immersed in the cultural context, stories or histories. The 'reception contract' in terms of the illusions in the virtual world is negotiable, which does not mean that artists and viewers sit together to negotiate a work of art, but rather that a viewer is able to accept moments of disbelief in the virtual world. VE is the agent to communicate between the artists/designers and the viewers. To engender cultural presence, artists encode cultural meaning in their art to facilitate self-reflection; viewers perceive the immersive experience generated by VR and use their 'horizon of expectation' (i.e. knowledge and preconceived ideas; see Chapter 2) to decode the cultural context and make meanings.

Conclusion

Cultural presence is an illusion formed from the 'reception contract between' digital immersive art and viewers. As I have shown, cultural presence can be generated in a realist or fantastical way. To achieve a sense of cultural presence, viewers engage both their imagination, which is closely tied to their emotional response, and their understanding, which is rooted in their rationality. Through this interplay, viewers are able to bring themselves within a cultural framework that exists in a particular time, whether it be the past or the future.

The cultural presence of digital immersive art is not only about eliminating the sense of distance between art and viewers but also the viewers' use of their right minds to read the works. The cultural values of art, aura, authenticity and religion create distance in order to be read. In the previous chapter, I considered how curators aim to help audiences understand Chinese culture and convey art value through cultural products, but in this chapter, I extend the analysis to consider how cultural understanding also depends on viewers' cultural capital and their preconceived ideas. Some viewers project their

identity, admiration and respect from their existing notions when viewing the artefacts in VR and critiquing the cultural experience.

The concept of cultural presence in digital immersive art involves a dynamic interplay between the artwork and the viewers, necessitating both emotional and rational engagement. It also highlights the significance of viewers' cultural capital and preconceived ideas in shaping their interpretations and responses to the cultural elements presented in the immersive digital environment. In the next, I further step into the concept of cultural presence and explain how 'playfulness' plays a role in the reception of digital immersive art.

Chapter 7

PLAYFULNESS AS THE ILLUSIONARY EXPERIENCE OF CULTURAL PRESENCE

People's desire for playfulness is aroused by the use of advanced technology. Playfulness has played different roles across the ages. Cultural historian Johan Huizinga (1998) expands the concept of play into a more general picture, which includes the process of human evolution and cultural practice. He believes that playfulness is a fundamental function of human beings and their culture; in fact, it is its origin (Huizinga, 1998, as cited in Nielsen, 2009). However, playfulness seemed to weaken during the industrial epoch. Max Weber (1946) diagnoses the industrial age as one that is disenchanted with the world, where playfulness was separated from work, and people were not inclined to play anymore. More recently, some scholars suggest that the desire for playfulness seems to have returned, whereby *Homo sapiens* are once more *Homo ludens* (Jeon & Fishwick, 2017). With the affordance of digital technology, people use their smartphones for hunting monsters in their gardens (e.g. *Pokémon Go*, an AR mobile game) and children use controllers to paint in 3D space (e.g. Tilt Brush, a VR painting application). Playfulness seems to be an inseparable part of human beings. As Huizinga (1998, p. 3) notes, 'You can deny seriousness, but not play'.

In this chapter, I draw on the concept of *playfulness*[1] (play) to consider viewers' illusionary experience of digital immersive art and question the *authenticity* of digital immersive art through the ambivalence of viewers' perception of Chinese culture in terms of real artefacts and virtual works of art. In focus group discussions of the three case studies that I introduced in the previous chapter, viewers considered the VR experience to be game-like. Sometimes this game-like experience contradicts the perception of cultural presence.

1 In some references, 'play' shares the same meaning as 'playfulness'. This study uses 'playfulness' to distinguish itself from another meaning of 'play', that is, 'a dramatic work for the stage or to be broadcast'.

Playfulness, as an element of cultural practice, also has connections with illusion. Since the eighteenth century, playfulness has continually been defined by illusion (Scheuerl, 1997); 'being at play [...] means stepping into the imaginary sphere for a specific time without fully surrendering to it' (2009). The famous hypothesis by aesthetician Friedrich Schiller (2004) even goes so far as to propose that art originated from playfulness.

Playfulness as the Game-like Experience of VR

Playfulness in digital immersive art is a game-like experience, but it is not in itself a game. The distinction between playfulness and game is often not very clear since, in many languages, their meaning is the same, or when one term is derived from the other (Boellstorff, 2015). Huizinga (1998) defines three characteristics of playfulness. First, all playfulness is voluntary activity; second, playfulness is 'a stepping out of real life into a temporary sphere of activity with a disposition all of its own'; and third, playfulness is 'play[ed] out within certain limits of time and place' (Boellstorff, 2015, p. 23). Games share some of these features with playfulness. The rules of play are the core concept for game design, yet the significant characteristic of reward/goal-oriented motivation does not lie in play. Moreover, applying game design theories or elements to VR art does not necessarily lead to playfulness. As the researcher and game designer Stephen Guynup (2016) argues, the idea of teleportation, which has been learnt from game design, is often used as the default entry position for initiating works in virtual arts and virtual words, rather than generating playable experiences.

Game design theory is applied in many VR projects, for example, in virtual heritage. Erik Champion (2011) suggests adding tasks in virtual heritage through the affordance of virtual environment (VE). Reward and task finishing are critical elements in game design. However, virtual worlds and 3D art galleries are not created for playable and win/lose outcomes. Guynup (2016) proposes that some gaming tropes, such as game-like teleportation from one location or context to another without transportation or walking, are needed in a virtual gallery. The artworks in my case studies were designed to be 'game-like' through the application of game elements. For example, *Boost Your Art Energy: 8-Minute Guided Session* applies game-like teleportation and game user interface.

In the focus group discussion, many participants mentioned that they felt like they were playing a game. When I asked the participants what impressed them most in the experience, some of the answers were related to playing in the VE. As participant 1-7 of *Boost Your Art Energy*, which featured pink balls and animation designs, said, 'the clearest memory is playing with pink balls. Yes, I have been playing with pink balls.' Given the elements of

gaming and interaction used in virtual arts, it may not be surprising that viewers feel like they are playing in VEs. However, the focus group data demonstrates that playfulness exists in the reception of digital immersive art, which is coincidentally similar to the feelings when playing a game since the participants have a preconception of VR as an advanced digital technology that is often linked with games. As a flagship digital technology, VR is considered a future media for gaming. In the present day, many VR games are about high technologies, such as *Echo VR* (an online VR game), which allows global users to experience sports in a spacecraft (Graham, 2020). Moreover, some ideas in VR games are originally from science fiction novels or movies. The technological features of VR in the case study trigger the viewer's imagination for playing games. As participant 1-7 explained, the technological attributes reminded him that this is a game for playing since he related the aesthetic experience to his imagination about VR formed through science fiction:

> It has a kind of technological element, which gives us a sense of playability. It reminds me of the VR game in Liu Cixin's science fiction novel *The Three-body Problem*. When putting on clothes [in that fictitious VR game], players can feel the temperature, humidity, and strength. I think if that can be done [in the actual VR], the experience will be much better. (Participant 1-7)

The Three-body Problem (2014) is a science fiction novel by Liu Cixin. In the novel, the author describes a VR game, which allows users to play different roles in a metaverse. Metaverse is a hypothesised iteration of the internet, supporting persistent online 3D VEs.

Case Study 1 reminded another participant, 1-6, of the virtual world in the science fiction movie *Ready Player One*:

> I think of the sense [of immersion] in Spielberg's movie *Ready Player One*. After putting on the headset, I entered another world. Although you are by my side, my eyes can't see you at all. There is only virtual reality, so I feel very immersed. (Participant 1-6)

Ready Player One (2018) is a science fiction movie that uses the concept of the metaverse to describe a gaming universe in a VE. From the analysis of the two participants' discussion in the focus group, there is a spontaneous link between VR technology and gaming in viewers' imaginations. The focus group responses also explain why participants consider VR art as a form of entertainment rather than a cultural product when the game-like experiences

become dominant in the reception. The immersive art aroused the viewers' imagination about VR and reminded them of playing a game in VR.

Owing to the application of VR and game design elements, digital immersive art makes a viewer feel more like a 'sensational player' or a VR gamer rather than a reader or elucidator of an artwork. The cinema and media theorist Vivian Sobchack (1992) notes that sensation and intellection can emerge as perception. VR can arouse people's sensations when they experience VR content, for example, the feeling of nervousness and overreaction when users play VR shooting games (Bender & Sung, 2021). The technological affordance in VE largely evokes sensation in viewers, which allows viewers to centre themselves in a virtual world which they can view, become immersed in, and play with. However, as Sobchack (1992) has discussed, both sensation and intellection play roles in human perceptions. Presence is generated when the sensation of physical distance is dissolved, and viewers are still in their 'right minds' and able to 'read' a representation. In the following section, I investigate how critical viewers read playfulness in cultural presence.

The Magic Circle and Virtual Heritage

During the focus group discussion, it emerged that when the affordance of VR structures highly formal, integrated worldviews (i.e., cultural identity or religion), viewers tend to use their preconceptions to appraise the cultural value of the work. The technological affordance in VE thus allows the capacity of digital immersive art to build up the 'magic circle' of playfulness. In the magic circle, actual rules are replaced by the rules of playfulness (Huizinga, 1998). The magic circle (Huizinga, 1998, p. 13) emphasises the 'not serious' features of playfulness as well as the suspension of 'ordinary' life. In digital immersive art, the magic circle suspends real-world rules and reality, replacing them with artificial reality, since technological affordance not only isolates the real world but also generates new rules for a virtual world. Owing to the 'not serious' feature of playfulness, viewers in VE have the capacity to behave in ways that are against the norms and mores of the real world. This is evident in the focus group discussion based on *Boost Your Art Energy*. As participant 1-3 reported,

> I am very destructive in [the VR world], but there are many things in it that I cannot destroy. Even if this could be done, there would be no obvious effect, but I'd love to destroy everything, as I lose many of my moral constraints after entering that world.

The participant expressed her desire to destroy things in the virtual space because she felt that she had entered a virtual world where her behaviours would not impact the real world. According to Julian Dibbell's (1994) canonical

study, *A Rape in Cyberspace*, even behaviour like rape in virtual worlds may not be subjected to the rules or laws of the real world. Norms and mores are different in virtual worlds. Virtual worlds also have their own rules. The two kinds of virtual worlds referred to in Dibbell's study are structured differently, one is based on presence in VR achieved by isolating viewers out of the real world while the other is a multi-user chat kingdom (MUCK) or Multi-User Dungeon (MUD) based on text communication (Tasa & Görgülü, 2010). Both create new rules in their magic circles. At the same time, however, viewers use the norms and mores of the real world to judge the virtual world's affordances. Participant 1-3 considered her destructive behaviour as a loss of morals. As mentioned in Dibbell's *A Rape in Cyberspace*, rape was viewed by some users as misbehaviour or a criminal act, even though it happened in the virtual world. However, culture is a complex collective, which includes art, religion, customs, etc. Sometimes, in order to enhance the affordance of playfulness in VEs, the 'magic circle' may contradict the norms and mores of a specific culture, especially in relation to religious mores. The focus group data from *Shenyou Dunhuang* supports this argument.

As mentioned above, *Shenyou Dunhuang* is a virtual heritage project allowing users to see a digital restoration of the deteriorated murals and the ruined Buddhist statues in Cave No. 61 at the Mogao Caves. The city of Dunhuang is the heart of Buddhist cultural heritage in China. The Mogao Caves at Dunhuang are representative of Buddhist culture and art, and they are also a sacred place for Chinese Buddhism, which has religious meaning, cultural value and artistic mystique. Between the fourth and fourteenth centuries, the Mogao Caves, located on the Silk Road, were a Buddhist centre connecting South and East Asia. Based on the surviving art at Dunhuang, those who came to Mogao to visit, reside or govern, the region actively supported the local worship of Buddhism in different ways (Reed, 2016). Cave No. 61 was a hall cave sponsored by the military governor of the Gui-yi-jun regime, Cao Yuanzhong, and his wife as their family temple in the tenth century (Digital Dunhuang, n.d.). The VR in Case Study 2 is aimed not only at bringing the cultural value of Dunhuang to viewers but also triggered the participants' sense of being in a game:

It was more like gameplay at that moment. It felt like the god perspective, as you put it. It was more exciting and may satisfy some people's preferences. (Participant 2-6)

Even though I felt a little bit scared the first and second time when I tried to move, this created a sense of excitement, and then I deliberately flew up to the ceiling. (Participant 2-2)

Although its simulation was quite realistic, the feeling I had was just that I was using a technology, or I was playing a game. (Participant 2-3)

The affordance in VE, such as zooming into the details of murals and flying up to the ceiling, is not easily accomplished at the real-world Mogao Caves site. Inside the physical structure, it is difficult for participants to have a close-up view of the caisson ceiling or the murals in higher locations because of height restrictions. Although these are difficulties in the real world, they can be easily overcome by participants in the VE.

At the same time, however, playfulness caused some participants to feel disconcerted since this is contrary to the norms and mores of the Buddhism culture:

> Standing [in front of the Buddha statue] physically and looking up, you may feel how insignificant you are. However, you would not have such a feeling in VE. The virtual experience may desecrate the divine, in my view, as there were so many Buddhas displayed, and I was able to touch them and see them from different angles. I just felt it was not right. (Participant 2-5)
>
> Buddhist culture is rather special as it requires a sacred space. If you make it entertaining and make it fun, it is actually a bit disrespectful. (Participant 2-8)

At the real-world site of Mogao Caves, viewers maintain a certain physical distance from the Buddhist statues and murals; and this is coupled with the dim lighting in the space to engender the way viewers feel about the divine in Buddhism. In the virtual heritage, the immersive environments create the participants' sense of being in the hall cave at Mogao. The sense of presence in the virtual heritage accorded with the participants' respect towards the religious culture. However, the game-like features of the VR experience, such as allowing users to get close to or even touch the artefacts, decreased the overall cultural experience for some viewers.

The participants expressed various motivations for using VR, such as learning new knowledge or satisfying their curiosity. For instance:

> I may not need to visit Dunhuang myself in future. If I can see everything so clearly [in VR], why spend several hours travelling? Actually, I am not as religious or curious as you are. I think this VR is fine as I can see all the must-sees. (Participant 2-4)

This participant believed it was not necessary to view the real-world cultural heritage site after the virtual experience of *Shenyou Dunhuang* because, unlike other participants, she was only motivated to acquire visual knowledge, instead of learning about the religious aspect. Even though, as Stephen B.

Gilbert (2016), a researcher on HCI, notes, different VE users have different intentions or motivations, many of them may bring cultural and religious expectations to the virtual heritage. Playfulness can arguably reinforce the sense of presence in virtual heritage in relation to the viewers' sensation, but in terms of cultural presence, playfulness sometimes dissolves viewers' perception of the reverence for cultural significance (Zhao, 2021). Moreover, as I have discussed in the previous chapter, *Shenyou Dunhuang* aims to generate a sense of presence by using realism. However, playfulness in virtual heritage or digital immersive art should be used for fostering awareness of and respect towards a familiar or unfamiliar cultural context rather than making it feel like a game for viewers.

The Contradiction between Authenticity and Commercial Circumstance

Authenticity is not the same as realism which makes viewers feel a sense of reality through mirroring or simulation. Authenticity refers to the particular attribute of an original artefact; in the museum, experts in such matters test whether objects of art are what they appear to be or claim to be (Trilling, 2009). Authenticity in artworks has a particular value which cannot be produced by mechanical reproduction since the original artwork has a certain value called the 'aura'. The aura is an effect of an artwork being uniquely present in time and space (Benjamin, 1972). From this definition, the aura of art has two attributes: first, it only exists in its original form and cannot be transferred to the reproductions/copies; second, the 'aura' is impacted by where and when the work is presented.

Authenticity can be dissolved by commercialisation and digital simulation. It is historically contradicted by commercialisation. Since modernisation, commoditisation is said to destroy the authenticity of local cultural products, creating a surrogate or covert 'staged authenticity' (MacCannell, 1973). Staged authenticity refers to the fake or artificial authenticity in reproductions of the original artefact, such as imitations and counterfeits. Hence, museums and art institutions become, to some extent, guarantors of the authenticity of the artefact; as the philosopher Hilde Hein (2006, p. xix) has discussed, their 'anonymous and indirect validation enhances the aura of specific and fallible authorship'. However, digital immersive art is displayed in a hybrid circumstance where the art space/museum is integrated with retail, commodity and immersive spectacle, so the functions of digital immersive art have been regulated by commercialisation. Hence, I question how this integrated circumstance influences viewers' perception of the value of digital immersive art. Moreover, the authenticity of art is lost in digital copies. In the

digital age, digital arts are copied rather than reproduced since the original digital art is a data file that is in an invisible place and stored on a computer and then visualised as the image we see (Groys, 2008). In other words, the original artefact is first digitalised, then curated and exhibited, and finally received by viewers. Groys argues that curators/creators can potentially create new value through visualisation. Cultural presence is a form of new artistic value (as I have discussed in Chapter 2) by creating a cultural context for its viewers through digital immersive technology. Therefore, the second aim of this section is to compare how viewers interpret this (new) value of digital immersive art and the value of original artefacts.

According to my analysis of the focus group data, the convergence of exhibition and commercial environments is a factor that influences viewers' perceptions of the artistic and cultural value of digital immersive art. As I have discussed in Chapter 5, the collaboration of commercial and cultural spheres has resulted in exhibitions of digital immersive art in commercial spaces. Some of the exhibitions are not in conventional art spaces but rather in sites that are commingled with a commercial sensibility. For instance, *Boost Your Art Energy* was also exhibited in the K11 art space in Hong Kong. Commercialisation reduces the artistic and cultural experience of digital immersive art. This was reported by some of the participants:

> I feel that putting immersive art exhibitions in shopping malls is contradictory. Why did I go to see art exhibitions in museums and art galleries before this? Because they have a regimented effect on us. They're more real and more ritualistic. They have been gradually created in various ways so you could feel that sense of sanctity. But walking around in a shopping mall brings in a more playful mentality. (Participant 1-1)
>
> I feel more ritual in the museum. But in a shopping mall environment, I have a more playful mental status. (Participant 1-6)
>
> Our understanding of authentic art is still [tied to] the kind of traditional art, [in the form of] sculpture and painting. (Participant 1-6)

The viewing context of digital immersive art is an important reason why these viewers do not recognise the authenticity of this exhibition. *Boost Your Art Energy* creates a virtual space in VR HMD for its users, which is isolated from the outside environment. Even though the artwork is isolated in an art centre, the viewers are still aware of the surrounding commercial context of the shopping centre. Appreciating art via a VR headset within a retail environment is a very different experience for people who are used to appreciating art in museums and galleries. Traditional art forms such as

sculpture and painting are often exhibited in the 'white cube', which refers to a certain gallery aesthetic characterised by its square or oblong shape, white walls and a light source, usually from the ceiling (TATE, n.d.).

Some participants' perceptions of art are still fixed on traditional (non-technologically mediated) forms of art such as painting and sculpture, so they need arbiters to refine and exhibit the cultural and artistic value of digital art. Curators in art institutions play this role. The digitalisation of invisible data has eliminated the authenticity of digital art because of the reproducible nature of digital technology; however, curation allows the copy of digital art to be exhibited with the 'aura' of artistic value whereby curators can make choices and modify the performed images in a substantial way (Groys, 2008). At the same time, however, these curators also have to 'negotiate' with entrepreneurs despite their differing aims for distributing digital immersive art, as discussed in Chapter 5.

From the perspective of cultural consumption, the presence of commerce in an art museum has changed viewers' art appreciation from a form of admiration (i.e. a more ritualistic way) to a sense of entertainment and playfulness. This interpretation is corroborated in the focus group discussion of Case Study 1:

> By putting this kind of art exhibition in the mall, it becomes less artistic but more commercial. (Participant 1-6)
>
> Some people may specifically want to go to the art exhibition and stop by the mall to shop. Some people may just come to the mall to shop, and then be attracted by the art exhibition. When we were playing inside [the art centre], I found that this art exhibition attracted these consumers, especially children. A kid pulled his mother's hand to see what the people were doing. It's what draws the shoppers to the mall, and draws those like us who come to see the exhibition to come and spend money in the mall. (Participant 1-7)
>
> And we found it very irritating that if you buy a cup of bubble tea in the shopping mall, you can get two free tickets (arousing laughter among some other participants). (Participant 1-5)
>
> That's a business model. Don't laugh at them. It's for promotion. You can't laugh at them. (Participant 1-9)

In the commercial viewing circumstance, digital immersive art is used as a gimmick to attract more audiences. As participant 1-7 said and as Figure 7.1 shows, the art exhibition itself became a part of the business model in K11 to attract the people. Playfulness became the best way to attract visitors. As I have discussed, playfulness is a significant factor in the reception of digital

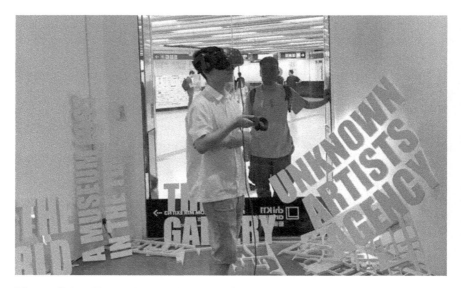

Figure 7.1. Photo of a participant and a passer-by attracted by the show window of the art exhibition

immersive art because of viewers' preconceptions about VR and games. Once the artistic or cultural value is absent in digital art, the immersive experience does not create the sense of experiencing cultures; instead, it becomes a game-like experience or entertainment while shopping. The value of digital immersive art becomes playfulness that inspires people's desire to play, rather than what Benjamin (2008) calls the 'aura' of the art.

Commercialisation also encourages a new way of art reception, which makes digital immersive art entertainment. As the participant 3-3 from *The Worlds of Splendors* said,

> Many art museums are now devoted to the field of immersive art. But I think many of them don't pay much attention to the humanistic core of the exhibition; they turn the immersive exhibition into a studio, just a place to take pictures. Young people like to *daka* [打卡, lit. trans. 'check in']. As I said, this form is more entertainment than culture. This is why these exhibitions have been criticised. Some people say that these exhibitions are just reproductions, or that they only use a form of light and shadow to represent the originals. In many cases, the artistic value of the original work is not felt.

As discussed in the previous chapter, *daka* is an internet buzzword in China that connotes going to a popular place or owning something special and

usually showing this off to others by posting photographs or videos on social media. As I have discussed, curators and entrepreneurs have accepted *daka* as a way of appreciating digital immersive art among younger audiences since *daka* is able to help attract more audiences and make more commercial profits. However, from the perspective of audiences, *daka* is regarded as entertainment rather than as a culture or art-related behaviour. Some audiences expect to be immersed in the cultural environment of digital immersive art, which contributes to comprehending, experiencing and admiring the value of art, but sometimes the arts are too commercialised and become a form of mass entertainment.

The Disparity between Viewers' Perception of the Original and Virtual Artefacts

In this section, I use *Shenyou Dunhuang* and *The Worlds of Splendors*, which represented high-profile artefacts of Chinese culture, to investigate the disparity between viewers' perceptions of the original and virtual artefact. According to my analysis of the focus group discussions, the question of authenticity makes viewers value VR works less than the original artefacts. If the VR work cannot provide the cultural experience they expect, viewers doubt whether digital immersive art actually delivers better experiences about Chinese culture than the original, non-virtual artefact, especially when the authenticity of the original artefact is irreplaceable to these viewers.

There are examples from the focus group discussion that demonstrate the significance of authenticity in relation to China's cultural artefacts. As one of the participants from *The Worlds of Splendors* said, viewing the original artefact is better than encountering it in immersive art exhibitions since the artefacts in museums keep their authenticity:

If it is to communicate Chinese culture, I might prefer traditional methods like art galleries and museums to this new form of immersive exhibitions. When I travel to any city, I always go to its museums and art galleries because this is the fastest and most direct way to understand the history and culture of that place. I look out for porcelain [artefacts] in the museum because it has a long history, but they will inevitably be damaged. Sometimes I will see obvious traces of restoration, not the original glaze of the original ceramics. I can clearly see that this piece has been filled up, or that this piece is part of the original. The museum restoration informs us about the porcelain as it was originally discovered: Which piece was kept? Which piece was defective? The museum can present us with the most essential and primitive culture. When I

look at the original work, I can see the variation in the brush strokes, understand the creative ideas, and even the traces of the modifications above, but I can't see these in the light show. (Participant 3-3)

The role of museums is to preserve the authenticity of the artefacts through collection and protection. To some extent, the conventional art space guarantees the authenticity and the aura of the artefact. For example, an expert who works in the museum may easily tell if the work is fake, so authenticity vanishes for him/her, but if no one advises viewers, they may consider the work to be authentic. According to participant 3-3, the 'defective' parts of the artefact kept by the museum have significant value for her to interpret the related cultural background. The anthropologist of tourism Erik Cohen (1988) argues that new cultural developments may also acquire the 'patina' of authenticity over time – a process designated as 'emergent authenticity'. The literal meaning of 'patina' is the shallow layer of deposit on a surface. But in the context of aesthetic experience, the patina of authenticity refers to how viewers can feel not only the perceived historical or heritage value but also the particular aesthetic of the fantasy of precipitation over time.

Cultural presence, as the new aesthetic value of digital immersive art, has the capacity to generate cultural experience as if from the real artefact. However, as I have discussed in Chapter 5, curators and entrepreneurs of digital immersive art have reasons, such as reputation and commercial profits, to use cultural elements which are familiar to the audiences to create cultural proximity. Cultural proximity contributes to cultural presence since presence can be generated from a cultural context familiar to the audience; however, cultural proximity is not the same as cultural presence. In order to generate a cultural presence for viewers, curators and creators need to understand the significance of the original artefact and exhibit its value ('aura') through digital technology. However, according to the focus group discussion, the loss of authenticity from the original artefacts causes the cultural experience in the VR works to be not as rich as the on-site experience. As a result, a disparity between the cultural experience of the VR work and the cultural presence expected by viewers is created. This is reflected in what some of the focus group participants in *Shenyou Dunhuang* said:

How do some replicas of artefacts evoke a cultural experience? They are not okay to me anyway. They don't make me empathise. I think the real cave just has a distinctive smell and it has a distinctive sound. It also transmits a special message to me. (Participant 2-9)

We can experience the sacredness of Buddhism in the real cave. The majesty of Buddhism is still stronger in the real site [than in *Shenyou Dunhuang*]. (Participant 2-8)

The reverence of being there and the sense of admiration are completely gone [in the virtual heritage]. It is definitely different from what I experienced on site. (Participant 2-6)

I personally think it would be better if it is positioned as a game. If it's just spreading a kind of culture, it's almost meaningless. Moreover, the sense of admiration and respect for being present is completely gone, which is really different from the experience of being on the spot. (Participant 2-6)

According to the participants' feedback, they do not have the same sense of the presence of actually being in the Mogao Caves due to the lack of authenticity in the VR work. Special features, such as the smell, sound and other intangible information about the actual Mogao Caves, are lost in the VR. Authenticity has its cult value (Benjamin, 2008), normally in relation to religious artefacts, which generates viewers' feelings of distance and admiration. The admiration and distance from the cult value of the original site are not afforded in the virtual heritage piece. Moreover, as participant 3-3 alluded to, the narrative of the content needs to be different in terms of how cultural presence is constructed and how audiences are invited to engage. If the contents of *Shenyou Dunhuang* were not about Chinese Buddhist culture, it could have been represented as a game and this would have encouraged a different level of engagement and even expectation from the viewers. In other words, the 'disparity' in the authenticity of the subject is also generated from how of the cultural content is represented.

There is a paradox of authenticity for virtual artefacts: even though people already know their experience is unreal before immersing themselves in the VE, they still bring their expectation of authenticity to the VE (Zhao, 2021). Researchers on consumer experience Ann H. Hansen and Lena Mossberg (2013) argue that end users prefer to look for reliable and unique cultural elements from the immersive experience rather than investigate whether the culture is fabricated. In some situations, their argument is true since recognising the unique cultural elements relies on a user's familiarity with the culture. However, when the cultural elements contain special values such as the 'aura', religious value, or heritage value, some viewers also project their preconceptions (i.e. understanding, admiration and respect for the original artefact) onto the virtual piece. Even though VR gives viewers a novel experience by eliminating the distance with artworks, the generating of cultural presence needs distance. Art, aura, authenticity and religious

value create distance. Distance allows viewers to be in their 'right minds' and 'read' a representation of art. Hence, if a viewer is considered a critical reader (as in the participants mentioned in this section), rather than a sensation-seeking 'player' of digital immersive art, whether they recognise the culture is fabricated or authentic is not reasonably insignificant.

Reasons for the Original Artefacts Mattering to Chinese Audiences

In this section, I investigate why audiences within China, the viewers belonging to the cultural context displayed/represented in the VR work, are concerned about the authenticity of the original artefacts. According to the focus group discussion, the viewers have high expectations of these immersive art exhibitions that represent traditional Chinese artefacts. There are two reasons for this. First, due to the objective reasons (i.e. long distance and limited accessibility), it is difficult for people to see or appreciate the original works. Second, the Chinese arts in question, such as Chinese cultural heritage, traditional paintings and Zhuangzi's philosophical thoughts, which are represented in the virtual works, have a high reputation in China in terms of aesthetic value as well as cultural or national identity. The two reasons will be discussed in detail in this section.

Some of the original artefacts are difficult for viewers to access in the real world. Mogao Cave No. 61, the original site for *Shenyou Dunhuang*, is isolated in the western part of China, and for heritage protection reasons, it is seldom opened to visitors. *A Thousand Miles of Rivers and Mountains* and *The Scroll Painting of Blossom*, which are both represented in *The Worlds of Splendors*, are stored at the museum, and opportunities for viewing them are limited. The difficult accessibility increases the viewers' enthusiasm and admiration for the original artefact. This is demonstrated in some of the participants' responses:

> I went to see the authentic exhibition of *Along the River During the Qingming Festival* (清明上河图) at the Palace Museum. Visitors had come from all over the country. We waited in a really long queue to view this exhibition. For the exhibition about Dong Qichang at the Shanghai Museum some time ago, many people also travelled from far away to see it. I feel that although this digital immersion exhibition has Chinese culture in it, it is unlikely that I would travel across cities to see this exhibition. (Participant 3-5)
>
> As she [participant 3-5] said just now, that kind of authentic exhibition is very popular. When I was an undergraduate, I viewed a few masterpieces at the Jiangsu Provincial Art Museum. The waiting line, at

that time, already reached the road outside. So, I think the influence of the original works would still be greater than that of the digital immersion exhibition because this kind of thing can be seen by everyone, but the original works are really hard to come by. (Participant 3-3)

These authentic works have very high value for Chinese audiences in terms of their significant status in Chinese culture. As previously mentioned, *Along the River During the Qingming Festival*, painted by the Song Dynasty painter Zhang Zeduan, captures the daily life of people and the landscape of the capital, Bianjing (present-day Kaifeng), during the Northern Song period. It is the most renowned Chinese painting and has been called 'China's Mona Lisa' (Bradsher, 2007). Dong Qichang was a Chinese painter, scholar, calligrapher and art theorist of the later period of the Ming Dynasty. In 2018, the Shanghai Museum curated *The Ferryman of Painting World: Dong Qichang's Painting and Calligraphy Art Exhibition*, which featured 154 of Dong's work borrowed from fifteen institutional collections, including the Shanghai Museum, the Palace Museum in Beijing, and the Metropolitan Museum of Art in New York.

In the focus group discussion, participants from both case studies (*Shenyou Dunhuang* and *The Worlds of Splendors*) believe that it is the cultural value which attracts them. The original artefacts empower the value of digital immersive art rather than vice versa.

In fact, this exhibition uses the proposition of Chinese elements to create content. The content of this exhibition is about the elements of Chinese culture. I don't know what kind of culture the immersive technology has in itself; I think immersive technology is just a means to put traditional culture in a way that is more accessible to young people nowadays, but the real cultural core of this exhibition is still in Chinese traditional culture. Following this logic, instead of using *Picture of The Ode of the River Goddess*, they can curate another immersive exhibition using another painting like *Along the River During the Qingming Festival* (清明上河图) as the topic of the exhibition next time. I think they just use Chinese culture as a topic. (Participant 3-4)

During my summer vacation last year, I went to see Picasso's immersive exhibition in Beijing. Before I went there, I heard that it was an exhibition with great public reviews. I went to see it with great expectations, but in the end, I felt disappointed. Because maybe it's still more form than content because many people actually go to these kinds of exhibitions to see Picasso or Van Gogh, but the best way to get closer to the artist is to see the authentic works. (Participant 3-2)

Additional examples from *Shenyou Dunhuang* show that some viewers think the value of original artefacts of Chinese culture is greater than VR works:

> I think Dunhuang is a place that everyone wants to visit. If there was nothing about Dunhuang in the VR project, I would not experience the VR. Because these [VR works] are related to famous cultural intellectual properties like the Forbidden City or Dunhuang, I want to experience them. (Participant 2-1)
>
> VR or digital technology can transform a very obscure or religious subject in a more accessible way and bring it into people's everyday lives. Additionally, I very much agree that culture is more important than this kind of technology because this project is about Dunhuang, which everyone is interested in viewing. (Participant 2-5)

The participants have favoured these cultural elements from their own cultural backgrounds. The media studies scholar Joseph Straubhaar (2014) believes that viewers tend to prefer media products from their own culture; this is called 'cultural proximity'. Cultural proximity can be seen as the cultural capital shared by audiences in the same region (Straubhaar, 2014). Language is a significant element of cultural proximity; cultural proximity is also composed of other cultural aspects like ethnic types, religion and values (Straubhaar, 2003). Appreciating or viewing cultural artefacts is a type of cultural capital that Chinese audiences should have, so these viewers would have the passion to gain knowledge or understand more about Chinese culture. They consider digital immersive art may be a good way to view and understand the culture. However, as participant 3-2 have said, 'the best way to get closer to the artist is to see the authentic works.'

When the cultural elements stay with strongly preconceived ideas, such as religion, cultural identity or even national identity, in the viewers' minds, the value of digital immersive art works is generated more from the cultural side (the original cultural value of the artefact) rather than what technology provides (the immersive experience). National identity means that people within the nation believe in the cohesive power of national culture (Fukuyama, 2018). Cultural heritage, traditional artefacts and ancient philosophical thoughts (i.e. Confucianism) are a significant part of Chinese national culture that fosters China's national identity. These are iconic elements that structure the imaginary of Chinese culture for the people of China. Just 'as the shared way of life unites the members of a community at the cultural level, the shared mode of conducting its collective affairs unites them at the political level' (Parekh, 1995, p. 259). As I have discussed in Chapter 1, China's government has used digital technology to rejuvenate its cultural power on a

national scale. Such a strategy is not only a form of soft power to demonstrate China's capability to the world but also a way to unite the Chinese citizens as a cohesive power within a polity. Although the dominant cultural grouping in China is Han Chinese, Chinese culture is not just a single ethnic composition. The Chinese government and many scholars (Dong et al., 2003; Keane et al., 2020; Wood, 2020) consider China as a civilisation, indicating something essential and permanent, enriched by multiple cultural groups. For instance, the aforementioned Dunhuang, a multi-ethnic city in western China, served as an important hub for economic and cultural changes along the ancient Silk Road. This is the historical background for the iconic Mogao Caves at Dunhuang. As indicated in the audience responses in *Shenyou Dunhuang*, Dunhuang continues to be considered an important symbol of Chinese culture. The Chinese government is currently launching policies and slogans to encourage its people to produce and consume cultural products in relation to China's 5,000-year civilisation in a digital way. In Chinese audiences' minds, these traditional cultural icons have arguably been a significant part of Chinese culture.

However, according to the analysis of the viewers' reactions, there is also some uncertainty amongst domestic Chinese audiences about whether these advanced digital technologies (VR/AR) are actually delivering better cultural experiences than non-virtual ones. In summary, there are three reasons supporting this argument. First, in the audiences' minds, the non-virtual pieces (the original artefacts) have authentic value. Second, some V/AR experiences are not as good as the audiences expected. Third, some implications caused by digitalisation, such as realism representation, commercialisation and game-like experience, may eliminate audiences' reception of cultural value.

Conclusion

This chapter has examined the factors that impact the generation of cultural presence in digital immersive art, including 'illusion' and 'playfulness'; and towards the end, I use the concept of 'authenticity', referring to viewers' existing expectations, to explore how cultural presence influences the viewer's perception.

Moreover, playfulness also plays a role in cultural presence. VR can enhance the viewers' feeling of being in a game-like experience. In the art reception of digital immersive art, viewers are active players. Game design theory and elements are applied in some digital immersive art projects, so it is to be expected that the viewers feel like they are playing a game. The technological features of VR trigger viewers' imagination that they are playing a game, despite the works not being designed as games. Such

playfulness sometimes contradicts some values of the cultural context. The 'not-serious' feature of play in VE may work against the norms and mores of a specific culture in the real world, especially when it relates to religious or ethnic culture. For instance, some participants considered *Shenyou Dunhuang* (2018), as blasphemy against the original artefacts that have significant cultural and religious values. In addition, the exhibition venue is another factor that influences the sense of cultural presence. For instance, the retail sector wants to use the newness of VR and art to change customers' perception of conventional shopping malls, so some digital immersive artworks are being exhibited there. However, viewers also consider that the art and cultural value is dissolved by the commercial circumstance of retail. Digital immersive art becomes considered as a type of game or entertainment that is encountered while shopping. Viewers have yet to completely accept digital immersive art as a form of art.

Chapter 8

DIGITAL IMMERSIVE ART AND THE PROBLEM OF CHINA'S SOFT POWER

Olympic Games, Expos and major festival events provide nations with a global platform for showcasing cultural achievements. At the Olympic Games closing ceremonies, it has become a convention for the next host nation to introduce itself with artistic displays, usually in the form of dance and performances that are representative of the host city. This tradition began at the 1976 Summer Olympic Games (IOC, 2009). At the 2008 Beijing Olympic Games opening ceremony, for instance, the renowned film director, Zhang Yimou, utilised advanced digital technology to draw attention to China's 5,000-year-old culture. The international news at the time reported a sudden rise in China's soft power. ARD (2008, as cited in Schneider, 2019, p. 110), Germany's main state TV channel, expressed surprise that the 2008 Beijing Olympics opening ceremony had not been 'a propaganda show'.

Soft power is a term coined by the US political scientist Joseph Nye (1990). In public diplomacy, 'the term usually describes a government's ability to influence foreign public opinion in its favour and to generate goodwill among the citizens of other countries for its foreign policy' (Schneider, 2019, p. 205). In contrast to military power, economic power, and technological power (i.e. hard power), soft power is related to ideology, foreign aid and culture. Essentially, it is a form of national branding that emphasises resources (Jullien, 2021; Pan, 2012; Sigley, 2015).

Today, many people hold the view that China is rejuvenating itself, changing the stereotype of a copycat nation (Made in China) and becoming an emergent technological power (Digital China). The origins of China's technological advance go back to the late 1980s when the four modernisations became part of statecraft. But technology was articulated most clearly in 2006 when the leadership announced that China would become an 'innovative nation' by 2020. In his summary report to the nation's Seventeenth National Congress in the following year, Hu Jintao, the former Chairman of the PRC, highlighted China's creative and innovative spirit and spoke positively about the role of digital technology in generating 'cultural confidence' (Xinhua, 2012). At the

time Hu delivered this address, mobile digital technology was rapidly coming centre stage in people's daily lives. Within a few years, the Chinese tech company Tencent would launch its popular messaging service WeChat, which functions as a social media platform and a means to connect Chinese people with their friends and families internationally (Sun & Yu, 2022).

In this chapter, I present two studies that reflect China's digital soft power. The first *Beijing 8-Minute Show* (2018), was a multimedia performance at the closing ceremony of the PyeongChang Winter Olympic Games. It was hailed by China's leadership as a great success, an example of China's technological development showcasing Chinese enterprises. The second study *Blueprints* (2020), was a multimedia installation exhibition in the UK by the Chinese artist Cao Fei. This second example provides a critical perspective on the impact of digital technology in contemporary society. In the chapter, I also consider the idea of Sino-futurism as a way to rethink China's embrace of digital technology.

When considering these two studies, *Beijing 8-Minute Show* and *Blueprints*, I examine the views of the creators, intermediators, and 'third-order' audience. The intermediators, called 'second-order' audiences by Schneider (2019), including media workers and critics who filter, rework and relay the event on the ground, create the mass media products, and provide semiotic signposts for the understanding of the event (Rauer, 2006). The 'third-order' audience consists of viewers and readers who experience the event through media, especially through digital relay technologies associated with the internet; they are not passive audiences since they experience the mediated events and interact with others on the internet (Schneider, 2019). Drawing on publicly available interviews, media reports, online comments and close reading of the art content in the case studies, I argue that digital technology in digital immersive art provides an opportunity to *re-present* the stereotypical Made in China image as Digital China, a global leader in technology, a place where bold innovation takes place.

Tell China's Stories 'well', in an Immersive Way

In the 30th collective study of the Political Bureau of the Communist Party of China (CPC) Central Committee, Xi Jinping (2021, as cited in Xinhua, 2021b) promoted the expression 'tell China's stories well'; this entailed a strategic mission to improve China's international communication capacity and spread Chinese culture globally. According to this strategy, the convergence of digital technology and cultural production would produce great benefits; it would enhance audiences' confidence in Chinese culture at home and China's soft power abroad (Li & Zhao, 2017).

What 'tell China's stories well' actually entails is open to interpretation, but for some Chinese artists, there is evidently a link to digital technology. For example, the original VR animation *Shennong: Taste of Illusion* (2018), developed by a Chinese VR team, Pinta Studio, tells an adventure story about a hero from ancient China. The VR animation has been nominated in many global film festivals, including the 75th Venice Film Festival – Venice VR in 2018 and Raindance Film Festival 2018 VR Competition – Best VR Experience (Pinta Studios, 2018). Furthermore, Chinese giant technological companies, such as Tencent, are using digital technology at mass events to 'tell stories' about Chinese culture. In 2017, Tencent cooperated with cultural heritage institutions like the Palace Museum and Dunhuang Academy to assert the feasibility of using digital technology to narrate Chinese cultural stories (Y. Zhao, 2018). The content of these stories highlights China's traditional culture, which accords with the strategy. However, Chinese artists often face questions of what stories about China's contemporary culture can be told, and how to tell these stories *well* to global audiences.

The Chinese government is carefully moulding China's image, particularly in the Global South and along the Belt and Road territories. Whereas cultural workers used to focus on the past (i.e. traditional culture, heritage, moral values), such as the emphasis on China's 5,000-year traditional culture at the opening ceremony of the Beijing 2008 Olympics, the emphasis has shifted to incorporate technology. The aim of Chinese governmental departments at the 2022 Beijing Winter Olympics was to highlight China's technological achievements. The Beijing Winter Olympics Organizing Committee put forward 'The Science and Technology Winter Olympics' (科技冬奥) as the theme of the Winter Olympics. Correspondingly, the committee from the Ministry of Science and Technology (MoST) instituted the leading group for the Science and Technology Winter Olympics (STWO). The first meeting was held in July 2020. The purpose was to implement the spirit of Xi Jinping's 'important instructions' on the preparations for the Beijing Winter Olympics and Paralympics, namely to have a deep understanding of the significance of scientific and technological innovation in supporting these preparations (Liu, 2020).

Beijing was the first city to host both the Summer and the Winter Olympics. It was a chance to think about the different images that China wants to present to the world. In an interview with Xinhua News Agency, Chang Yu, who worked on the STWO leading group, said:

[...] we want to present what people's lives will look like in the future and explore how the Olympic Games can benefit our people's lives, which is the aim for us to carry out the scientific and technological Winter Olympics work. (Chang, 2021, as cited in Ji et al., 2021)

According to Chang, the Beijing Winter Olympics Organizing Committee would show how China's technological achievement has changed the world and how Chinese technology benefits people's lives. This aim was demonstrated in the *Beijing 8-Minute Show* (2018). Zhang Yimou was the director of the 8-minute handover show for the 2004 Athens Olympics as well as the opening and closing ceremonies in Beijing in 2008 that used a mass of actors to display Chinese culture. In the *Beijing 8-Minute Show* (2004) in Athens, about 150 people participated in the performance (Xinhua, 2004). However, in the *Beijing 8-Minute Show* (2018), Zhang did not use a mass group of human actors. Instead, the show applied immersive technology performed by 24 roller-skating actors along with 24 AI robots (Beijing Winter Olympic Committee, 2018). Following the instructions of the Beijing Winter Olympics Organizing Committee, Zhang Yimou noted in a publicly available interview,

> This time there are not many performers [...] There will still be beautiful colours and unique Chinese culture that everyone hopes to see. But this time, there will be some new feelings, especially the performance that cooperates with artificial intelligence. (Zhang, 2018)

According to an official explanation, the significance of the *Beijing 8-Minute Show* in 2018 would tell the world the story of China in the 'new era'. The China Central Television (CCTV) commentators for the live-streamed video said,

> How to tell the story of China to the world in a new era and tell the story of the new China is the core essence of this performance. The feathers of the phoenix were drawn on the scene and gradually changed [...] which represents the meaning of auspiciousness in Chinese culture [...] In the ice screen, China's large aeroplanes and high-level astronomical telescopes appear as celestial eyes that have just been presented. All these are China's new contributions to the world's technology [...] On the ice screen, there are the smiling faces of children from all over the world [...] [represented as] olive branches and plum blossoms. (CCTV, 2018)

As exemplified in CCTV's explanation, China's technological achievements in the present day became the focus of the story, rather than only presenting conventional Chinese cultural motifs such as the panda and dragon. This show orchestrated the spectacular integration of cultural elements about winter sports, the Olympics, Chinese culture and digital technology (Figure 8.1). Aeroplanes were displayed on the transparent screen,

Figure 8.1. Snapshot of the footage: *Beijing 8-Minute Show* (2018)

visual elements depicting the phoenix were projected on the stage, and ice skaters wore flashing lights representing the Winter Olympics. The correlation between the aeroplanes and the phoenix is a trope about the convergence of China's high-technology achievement in the twenty-first century and Chinese traditional culture. Both visual elements imply the extraordinary ability to fly. The immersive experience and technological elements of the *Beijing 8-Minute Show* were highlighted by intermediators such as CCTV commentaries and China's state-owned international media. China's state-owned global website *Xinhua News Agency* enthused,

> Beijing's eight-minute show at the closing ceremony of the 2018 PyeongChang Winter Olympics will convey warm greetings from the 2022 hosts to the world in a high-tech way. (Ji & Wang, 2018)

China Global Television Network (CGTN, 2018) described the eight minutes as a 'handover show that incorporated many high-tech elements':

> Images were projected to the icy floor while dancers skated across it, creating a sense of augmented reality (AR). Unlike the closing ceremony of the Athens Olympics, which focused on displaying Chinese history using traditional elements such as red lanterns and jasmine, Beijing 8 Minutes in the PyeongChang Winter Olympic Games emphasised advanced technology. (CGTN, 2018)

The *Beijing 8-Minute Show* showcased Chinese technological enterprises. One of the digital technologies highlighted was the use of AR to project

immersive images on the stage. The immersive visual effects were provided by a technology company in Beijing, BlackBow. On its official website, BlackBow (2019) defines itself as dedicated to the cross-border of 'technology + art'. In the *Beijing 8-Minute Show*, BlackBow put up an immersive stage where a giant projection screen displayed digital images.

The 24 'ice screens' (冰屏) strengthened the immersive effect on stage. The research and development (R&D) and manufacturing of these transparent monitors were accomplished by YIPLED co., Ltd., a private enterprise based in Shenzhen. According to its official website, the transparent LED display features advanced side-emitting technology and smart controls, creating a unique aesthetic and immersive experience at the live event and on the performance stage (YIPLED, n.d.). Huang Qingsheng (2018, as cited in Ji et al., 2018) the leader of the ice screen R&D team, noted, 'our "ice screen" technology is at the world's leading level. This time we made a three-meter-long screen without a beam in the middle. Arguably, we should be recognised as the first team to achieve this technology in the world'.

In the show, the 24 ice screens were navigated by artificial intelligence (AI), allowing the screens to be assembled into different shapes and match the movements of the immersive images on the floor. These robotic systems were developed by Shenyang SIASUN Robot and Automation Company, a Chinese national robotics company. According to Zhang Lei (2018, as cited in Ji et al., 2018), head of the robotics research and development team, there were two significant technological breakthroughs: first, the robots' navigation is more accurate; and second, compared to commonly used industrial robots, these AI robots are more flexible, allowing for rotation and swinging movements, and matching movements with the actors.

The digital technologies heightened the immersion effect of the *Beijing 8-Minute Show*. As an immersive art, the transparent display gives theatre art a strong illusion of a distant individual's presence in the local environment (Fuchs et al., 2014). Such illusionary effect has been used in concert and performance stages by holographic projection, such as a hologram of Michael Jackson performing after his death at the 2014 Billboard Music Awards in Las Vegas mirroring his signature slick dance (Wete, 2014). *Beijing 8-Minute Show* accomplished the AR effect facilitated by the 24 transparent ice screens. With the help of a transparent screen, the displayed objects could be effectively integrated with that space and its occupants without giving away their own remote locations (Fuchs et al., 2014). Immersion is a mentally absorbing process of transformation from one state to another, which is characterised by a corresponding increase in emotional investment (Grau, 2003; Wolf, 2013).

The presence of these technological companies at the Olympics led to business opportunities. The event raised the profile of BlackBow, enhancing

its reputation and visibility in terms of staging immersive effects. After the 2018 Winter Olympics, BlackBow collaborated with the Chinese government on many such large-scale events, such as the light and fireworks show at the Shanghai Cooperation Organization (SCO) Summit and the 'Belt and Road' International Cooperation Summit Forum (BRF). As I have introduced in the previous chapters, BlackBow was a creative team for *The Worlds of Splendors* (2019). More recently, the work has become a cultural IP commercialised in partnership with retail brands. As demonstrated on its official website, the 'ice screen' by YIPLED Co., Ltd., was widely used for displaying cultural content in China's retail shop windows, TV shows, and trade fairs after the Winter Olympics (YIPLED, n.d.). Hence, these companies not only devoted their technological achievement to help benefit China's new image outside the nation but also stimulated China's domestic cultural market.

China's 'cultural and technological' Presence in a Foreign Discursive Environment

The displays of artefacts in Olympic ceremonies help communicate an image or reputation to audiences abroad. However, such interventions in a foreign discursive environment can be interpreted in a different way when viewed by foreign spectators (Schneider, 2019). Technology was part of both the opening and closing ceremonies for the 2018 PyeongChang Olympics. *Beijing 8-Minute Show* was seen together with Korea's technological performance (i.e. drone performances). Chinese state-owned media highlighted China's technological achievements of the day but some foreign media's (second-order audiences) attention focused on China's conventional cultural elements. For example, the British newspaper, *The Guardian*, summarised ten highlights from the PyeongChang Winter Olympics closing ceremony. *The Guardian* reported,

Beijing got to contribute its own section to the show – and it started with some astonishing lit-up see-through inline skating pandas. Top that. (Belam, 2018)

The National Public Radio (NPR), an American non-profit media, covered the PyeongChang Olympics Closing Ceremony and reported that

Beijing's section of the program includes some reminders that China has pandas. Whales are also repping China, it turns out. (Chappell, 2018)

According to these two excerpted media reports, the foreign media were fixated on typical Chinese cultural elements like the panda, but the

technological elements were absent. Much of the Western media overlooked the immersive digital technology in *Beijing 8-Minute Show*. Moreover, at the Olympics, media commentators are usually provided with script notes to refer to when describing what is happening in the program. There was little access to other televised broadcasters, however, due to arrangements with the Olympic committee. In a video of the closing ceremony found on the Olympics's official channel on YouTube,[1] I find few references to China's use of technology in the commentary; instead, only typical Chinese icons, such as the phoenix and panda, are mentioned.

In contrast to Western media reports, commentary from an Asian TV channel, Workpoint TV, focused more on Chinese power and technology. Workpoint TV is a nationwide television station owned by a Thai media company. As stated in their extended commentary,

> [...] This show uses 24 ice screens. The panda is the iconic mascot of China. The 24 ice screens represent the 24th winter Olympics. The show is a second to none. The performers and members of the creative team are mainly Asian. The LED screen technology is used to display the advanced technology of China. The digital images on the ground mean China's highway bridges. By the end of 2017, China has more than 800,000 highway bridges. In 2017, China had expressways longer than 130,000 km over the countries. This sense represents the phoenix. The show narrates the power of China. One of the prides for China is the ability to build aeroplanes. China's plane is competitive with Boeing and Airbus. China has the ability to send humans out to space and create space station. China is a solid competitor to Russia, USA, and EU countries. (WorkpointOfficial, 2018)

What the above commentary highlights about the *Beijing 8-Minute Show* (2018) largely corresponds with Chinese media reports. For instance, both media emphasise China's technological achievement in aerospace, transportation and LED screens. The Thai commentator interprets the cultural element, the phoenix, as the symbol for Chinese-created expressways, aeroplanes, and space stations demonstrating the pride and technological achievement of the PRC, which is in line with the CCTV commentary discussed earlier. The cultural element in both commentaries is not only expressed in terms of China's traditional image but also as a representation of Chinese power and pride in the contemporary era.

1 See https://www.youtube.com/watch?v=7rDxnPkLZMc (starting at 1.29.57), retrieved on 2 April 2022.

As a Thai TV station, Workpoint TV's positioning is aligned with Asian audiences; in this, it represents the voice from the East. Similar to China, many other nations in Asia have moved with state support or otherwise from a manufacturing-based economy to a digital economy. Some scholars (Noronha & D'Cruz, 2019, as cited in Athique & Baulch, 2019, p. 2) claim that South Korea and China are the major players in the manufacturing domain of the digital economy while India and the Philippines specialise as providers of digital labour. According to research conducted in 2006, developing countries such as China, South Korea, and some Southeast Asian countries have tried to borrow other developed countries' images or obscure their own country's image in their exporting strategies (Kim, 2006). Following China's accession to the World Trade Organization (WTO), there was a trend among domestic brands to name their products using transliterated English in an effort to improve their reputation. However, the game changed with its recognition of South Korea as a developed country by the United Nations. South Korea has a strong global presence because of its technological companies (e.g. Samsung) and the Korean wave (i.e. K-pop and K-dramas; Kim, 2021). In Asia, South Korea and Japan are not associated with cheap products and copies. Of course, as we have seen, China has high technology but the 'Made in China' label is still a problem associated with knockoffs (*shanzhai*) and lower quality, a stereotype which exists in the Western imaginary. China's rapid rise has not swiftly altered the entrenched image in the West.

Audiences tend to use agency to make their own meanings of media content (Van Dijck, 2009). The following discussion about the third-order audiences' comments on the video[2] of *Beijing 8-Minute Show* from Workpoint YouTube channel shows the disparity among audiences. As indicated from some of the comments below, we can see a disparity between China's attempt to rejuvenate its old image and the global audiences' imaginary of China:

Excerpt 1: user comments on the YouTube video titled 'SEE YOU IN BEIJING IN 2022 | Winter Olympic [sic] 2018'

It's a boring ceremony that doesn't look like China at all. (Along the Kaidou, comment, 2018)

It's true that it's boring, but isn't the Chinese knot, dragon, phoenix, etc., all representative of China? (Yuharuo, reply to Along the Kaidou, 2018)

2 See https://www.youtube.com/watch?v=I6JG5TCD9YI, retrieved on 17 January 2022.

I only knew about pandas (laughs). (Along the Kaidou, reply to Yuharuo, 2018)

I feel that it is appealing to China, which is changing with high tech. (Jeonghwa Byul, comment, 2018)

The comments consider the panda, Chinese knot, dragon and phoenix as the identifiable images of China. Technological elements are not mentioned in the comments. In fact, some comments explain that the reason that they do not like the *Beijing 8-Minute Show* is due to the lack of 'the portrayal of [Chinese] culture and authenticity'.

Excerpt 2: user comments on the YouTube video titled 'SEE YOU IN BEIJING IN 2022 | Winter Olympic [sic] 2018'

I didn't like this as much as the presentation in 2004 in Athens. I think Beijing saw Tokyo's presentation in the closing ceremony in Rio and thought they had to sell the notion that they are a technologically advanced nation, which everyone already knows. It misses the portrayal of culture and authenticity in this one. It didn't feel like China like in 2004. It felt more forced and artificial. (Green Hornet, comment, 2019)

China is quickly becoming one of the most technologically advanced nations on the planet. But I think the problem here is that they've not yet found a way to root their advancements into their deep culture and history (South Korea, I think, faces this issue too in some areas). Japan, on the other hand, has achieved this to a tee. Retro-futurism has long been a part of Japan's image since the early '70s. For decades Japan was recognized as a pinnacle of technological advancement. It's an image they've been able to cultivate deeply into their own culture. (Koroniria Ryder, reply to Green Hornet, 2019)

The issue here is whether or not global audiences accept technological elements as part of China's culture. The online comments such as these from international audiences demonstrate that technology is still being separated from Chinese culture. We can perhaps think of this as a static imaginary. As I have discussed in Chapter 2, the imaginary is a collective perception and different groups have different imaginaries. Some global audiences have not considered the identifiable technological elements as the modern cultural imaginary of China. Koroniria Ryder uses Japan as a comparison in the comment, noting that retro-futurism has long been a part of Japan's image since the early 1970s. Retro-futurism is a movement in the creative arts showing the influence of depictions of the future produced in an earlier era (Guffey & Lemay, 2014, p. 434). Indeed, the global audiences' cultural

imaginary of Japan is deeply related to modern technology due to the presence of cyberpunk and its genre derivatives in Japanese artworks and cultural products. Retro-futurism, for example, is connected with Japan's rapid economic and manufacturing development in the 1960s and 1970s.

The audiences' perceptions of China's culture are still, to some extent, reflected in the conventional view expressed around the time of the 2008 Beijing Olympics. The *Beijing 8-Minute Show* (2004) at the handover performance in the closing ceremony of the Athens Olympics presented Chinese elements like jasmine, red lanterns and kung fu. However, Zhang Yimou, the director, subsequently avoided this conventional iconography in the 2018 *Beijing 8-Minute Show*. The 2018 *Beijing 8-Minute Show* arguably presented a new image by highlighting technology, but not in a soft or orientalist way. Technological achievement, as a form of cultural presence, it seems, had yet to be accepted within the cultural imaginary of the audiences.

It is important to consider how Chinese audiences saw the show. As a few YouTube comments in Chinese demonstrated, Chinese people responded to *Beijing 8-Minute Show* with some pride:

Excerpt 3: user comments on the YouTube video titled 'SEE YOU IN BEIJING IN 2022 | Winter Olympic [sic] 2018'

I don't know why, but I spontaneously cry and get moved! The *8-minute Show* [2016] of Tokyo has a modern, cool, chic feel, but I still prefer *Beijing 8-minute Show* [2018]! Beautiful value is delivered from the warmly humanistic performance! Also, the creativity of *Beijing 8-Minute Show* is more unified and complete [than Tokyo's]. (Vicent Jack, commented, 2021)

Previously, I thought that Shiina Ringo's *Tokyo 8-Minute Show* [2016] could surpass Zhang Yimou's. Tokyo Olympics opening ceremony could even have become No. 1 in Asia, if Shiina Ringo had not resigned halfway through. So, *Lao Mouzi* [Zhang Yimou] is always *yyds* [永远的神, lit. trans. 'eternal god' which connotes people having god-like qualities]. (Zhang Lingfu, commented, 2021)

Even though these comments do not represent all Chinese people, nonetheless they reflect a new kind of collective imaginary of China that is in line with the 'Chinese Dream' of a resurgent China. The disparity within and outside China, thus, should be addressed as a significant factor in structuring China's image (its cultural presence) in the world. At the end of the *Beijing 8-Minute Show*, China's theme of the four 'new great inventions', high-speed rail, e-commerce, dockless shared bicycles, and mobile payments (Wu, 2019), was displayed on an on-site video. These four 'new great inventions' are a

reference to China's 'Four Great Inventions': namely papermaking, printing, the compass, and gunpowder, which have had a significant influence on modern Western civilisation and culture (Needham, 1954). Afterwards, celebratory accounts of these four new great inventions appeared in the Chinese media. As travellers to China attest, China is far more advanced in many areas of its economy than these foreigners are led to believe (Wu, 2019).

China's Presence via Digital Immersive Social Media

With the internet developing into a more immersive and multi-dimensional space, Robin Teigland and Dominic Power (Teigland & Power, 2013, p. 2) have proposed the concept of 'immersive internet' in which 'we can interact with others as well as with virtual and augmented spaces and sites, and even with artificial intelligence'. Such innovative ideas based on digital technology are adopted in digital immersive art not only as a network channel or social media (for distribution) but also as the means to provide users with an immersive experience. An increase in the number of users of VR devices (like Oculus Quest and HTC VIVE), illustrates the important role that digital immersive social media plays as a platform for art and culture (e.g. VRChat).

Not long after the Beijing Winter Olympics, the 2023 Asian Games, which were held in Hangzhou, made effective use of the digital immersive social media platform, PICO. In 2021, ByteDance, the parent company of *Douyin* (抖音, known as TikTok outside China), acquired PICO, a VR company, with the objective of establishing a live-streaming platform that caters to both VR and mobile users. PICO played a crucial role by providing VR livestreaming services for the entire event. The Hangzhou Asian Games also showcased immersive artistic performances representing Chinese culture to audiences. By creating personalised Avatars within the PICO VR platform, users were able to establish virtual identities and engage in various activities. They could visit a livestreaming virtual square showcasing different Asian Games events, watch and chat with fellow viewers, and use virtual light sticks and other props to cheer for the athletes (Figure 8.2). Furthermore, users had the opportunity to witness spectacular firework displays celebrating gold medal victories and capture moments with a virtual 'selfie stick', taking selfies alongside real-time footage of the games or other spectators in the square.

Todd Margolis (2014), a project scientist working on computer vision, believes that this form of media is not just an overlay of virtual objects but are stories that connect these objects to the people and places that give them meaning. In other words, using AR in conjunction with the internet platform provides a kind of social immersion that brings people together through their common interests. The storytelling across different internet platforms

Figure 8.2. An avatar standing on the Virtual square of Hangzhou Asian Games livestreaming

creates social immersion by unfolding elements of a fictional story to create an interactive narrative over time and space (Margolis, 2014). Hence, thrilled by the spectacle of the 2023 Asian Games, the on-site or online media viewers may let go of their spatial and temporal coordinates for a moment.

In contrast to China's global influence through popular platforms like TikTok and Douyin, PICO VR, has a relatively limited presence on the global stage. The influence of such immersive social media platforms is not only tied to the soft power associated with content and culture but also heavily relies on the market dominance of the devices themselves. In this regard, PICO VR's impact is less pronounced, as it faces challenges in terms of market share and device penetration.

At its global new product launch, PICO announced that it would be launched in 13 European countries, Japan and South Korea, and would also be launched in the Singapore and Malaysian markets later in 2022. According a report of IDC (2023), in 2021, the global shipments of VR headsets experienced a rapid growth from 6.7 million units to 11.23 million units, marking a year-on-year increase of 92.1%. However, one year later, the global shipments of VR headsets declined once again, falling below 10 million units.

China's number is 1.1 million units, accounting for approximately 10% of the global total in 2022. PICO faces strong competition from Meta's Oculus Quest and Apple's Vision Pro. Competition is manifest both in user experience and in market share, the number of global users.

This competition among market players illustrates the role of digital immersive art in showcasing national digital prowess. It goes beyond the realm of cultural and digital platforms; that is, it represents not only soft power but also hard power in terms of technology and industrial manufacturing. The competition between PICO, Oculus Quest and Vision Pro highlights technological advancements and manufacturing capabilities in the field of digital immersion. However, it is worth noting that the content offered on the western VR platforms is currently not accessible on PICO, and vice versa. The success of these platforms relies not only on content and user experience but also on the underlying technological infrastructure and hardware innovation.

As the global competition accelerates for the latest innovations in technology, attention is heavily focused on generative artificial intelligence (AGI) and the high-end computer chips needed to power the next generation of technologies. The capacity of large language models (LLM) systems to generate instant narratives opens a 'pandora's box' of AGI, raising a challenge for human creativity. Meanwhile, smaller start-ups like PICO have demonstrated that the power of storytelling remains critical and that there is a role for human generated content—and artists.

Playing with the Tropes of an Imagined China

Blueprints (2020) was a solo art exhibition by Chinese contemporary artist Cao Fei at the Serpentine Galleries, UK. Cao is a multimedia artist and filmmaker based in Beijing. *Blueprints* is based on Cao Fei's social research project which she had been working on for five years, examining the social history and urban transformation of Jiuxianqiao district in Beijing, where her studio is located. Artworks in *Blueprints* include *The Eternal Wave* (2020), *Nova* (2019), *Whose Utopia* (2006), *Asia One* (2018) and *La Town* (2014). Many digital technologies such as the internet, artificial intelligence (AI), augmented reality (AR), virtual reality (VR) and big data feature in Cao's artworks (Serpentine Gallery, 2020).

Unlike Zhang Yimou's *Beijing 8-Minute Show* which is officially endorsed by the Chinese government, *Blueprints* has been viewed favourably by global mainstream art critics. Cao provides an alternative way of invoking China's technological imaginary. With her reputation rising in the international art world, Cao has become an influential young Chinese artist on the global stage.

As her publicity blurb states, video, digital media, photography and internet art all play a role in this artist's engagement with an age of rapid technological development in China (Serpentine Gallery, 2020). *China Daily* adds, 'domestic and international media outlets have described Cao as an artist who depicts China's social shifts and individuals affected by the changes' (Deng, 2021). Philip Tinari (2021, as cited in Deng, 2021), an American curator and expert in Chinese contemporary art, proclaims 'Cao stands out as an example of a Chinese artist working in a global context'. Cao was ranked No. 10 on ArtReview's Power 100 List for 2023, making her the only Chinese artiest in the list. In addition to China, her works have been widely exhibited in the UK, USA, Germany and Brazil.

In *Blueprints*, Cao re-narrates science fiction stories about China's digital power as tropes to critique the alienated world influenced by advanced technology. As *The Times* comments, 'she is playing with the tropes of science fiction. But even as she evokes an unreal world, she wants to make works that stir real feelings' (Campbell-Johnston, 2020). This section and the following, thus, focus on how the artist reflects China's techno-cultural imaginary in the exhibition. In order to deeply understand the different approaches to telling China's story 'well', the last section presents a comparative analysis of these two case studies and links this to China's cultural presence in the world.

In the *Blueprint* exhibition, Cao uses the tropes of science fiction, cultural elements referencing the Sino-Soviet cooperation period, and the criticism of digital technology to represent a spectacular of an imagined China. *Blueprints* is based on Hong Xia (HX), research on China's modernism, which includes historical material, films, books, installations, and VR and AR works. Cao's research project, HX, draws from the history and the current state of the district of Jiuxianqiao. The project incorporates the context of the Sino–Soviet relationship into China's industrialisation. The vanishing Beijing neighbourhood was the birthplace of China's electronics industry in the 1950s. This is pointed out in a write-up in *The Times*:

> Over the past few years, Cao has plunged into some pretty arcane and complicated research, looking into the history of technology, of sci-fi cinema, of the local community, of the relationship between China and the Soviet Union. (Campbell-Johnston, 2020)

After 1949, when 'New China' was founded, rapid industrial development took place throughout the 1950s and 1960s. The development was fuelled with the assistance of communist allies. During this time, Jiuxianqiao changed from a rural area into a conglomerate of factory infrastructures.

According to an interview with Zhang Zhiyi, a retired employee of Factory No. 774 in Jiuxianqiao,

> Factory 738 and Factory 774 were built with assistance from the Union of Soviet Socialist Republics (USSR), and Factory 718 was built with the aid of the German Democratic Republic (GDR). They brought a team of staff to assist us, including technicians, workshop directors, and plant managers. (Tao, 2021)

Cao (2020, as cited in Campbell-Johnston, 2020) says the first computer in China was built there, developed from a blueprint that came from the Soviet Union, and this factory saw the birth of the Chinese computer age.

Many Chinese cultural elements representing the specific period (1950s–1960s) in China appear in *Blueprints*. For instance, the exhibition starts with a replica of the cinema atrium, which stems from the history of the Hongxia Theatre. This cinema, the Beijing Hongxia Theatre, opened in 1958 and closed in 2008. Its architecture and the name Hongxia (红霞, lit. trans. Red Dawn) are Soviet-inspired (Campbell-Johnston, 2020). These cultural elements not only relate to the Sino-Soviet relationship but to neighbourhood life and movies. As the review in *Dazed* magazine adds:

> Cao Fei has interviewed the residents surrounding the theatre, collecting memories and objects [...] You can see this in the opening gallery of *Blueprints*, which is transformed into the lobby of the theatre, complete with vintage cinema tickets, magazines, and filmed interviews peppered across the walls. (Yalcinkaya, 2020)

The lobby of the theatre, complete with vintage cinema tickets and magazines, features the aesthetics of the 1960s in China. Moreover, the VR piece *The Eternal Wave* (2020) shares the same name as a Chinese thriller. Viewers can see part of this thriller at the Hongxia Theatre in the VR piece. *The Eternal Wave* was originally released in 1958 and re-released in 2021 in mainland China. It is a film about the intelligence work of the CPC during China's wartime (1930s and 1940s). *The Liberation Daily*, owned by the CPC of Shanghai city, comments on the film as representing 'the pioneers of CPC fighting for the revolution' (Li, 2021).

Cao uses her science fiction style narrative and the facility of digital technology to connect the past, present, and future of China's story. For example, *The Eternal Wave* (2020) is Cao's first venture into VR. Cao works at the cutting edge of VR with Acute Art, and the artworks in *Blueprints* tell us how digital technology is ushering in a new opportunity. This work creates the

illusionary experience extracted from science fiction and the real world and is based on the artist's memory and research. Viewers can experience the VR piece through a VR HMD headset at the exhibition venue. The experience begins with the viewers standing in a simulated kitchen at Cao's studio in Beijing before leading viewers off into another virtual space. Moreover, viewers can interact with the virtual space, such as flipping the pages of a calendar, opening the door of a fridge, and handing a ticket to an usher. The work allows a first-person journey through the territory of *Nova* (an imaginary place of Cao's science-fiction film). Portals in the virtual kitchen transport viewers both to the Nova computer lab and to Hongxia Theatre, where the idealistic thriller *The Eternal Wave (1958)* is screening. *Nova* (2019) tells a story about an engineer who develops a computer in the lab at Jiuxianqiao and then sends his son to live inside the machine world. The son slips between past and future worlds in the fictional no man's land of an electronic city called Nova.

Understanding Sino-futurism as the Imaginary of Digital China

The credibility of Sino-futurism in Cao's works can be understood through an analysis of the reactions of the 'second-order audience', including media workers and critics who filter, rework and relay the exhibition on the ground. The idea of Sino-futurism was proposed by artist Lawrence Lek in his video essay *Sino-futurism (1839–2046 AD)* (2016). The work explores the parallels between portrayals of artificial intelligence and Chinese technological development, combining elements of science fiction, documentary melodrama, social realism, and Chinese cosmologies to delve into and critique the present-day dilemmas of China and the people of its diaspora. Lek (2016) explains that Sino-futurism is often mistaken for contemporary China, yet it is a science fiction that already exists. In other words, Sino-futurism uses the technological imaginary in science fiction as a trope for Chinese technological development today. Sino-futurism represents a new imaginary of China from Western observers.

Some scholars argue that Sino-futurism developed out of the kind of Orientalism that previously relegated China to a space of backwardness and barbarism (Niu, 2008) and which now connects it with a projected futurity (Conn, 2020). Moreover, Sino-futurism can be considered as a schism of retro-futurism. Retro-futurism is the remembering of science's anticipation from the past. As mentioned above, the Japanese artist Hajime Sorayama is the representative retro-futurist. Sorayama is best known for airbrush paintings and hyperreal illustrations and his depictions of robotised women

have elevated him to an internationally known artist (Kawecki, 2020). Retro-futurism is the genre derivative of cyberpunk. Cyberpunk has birthed a few genre derivatives of retro-futurist schisms such as steampunk and diesel-punk (McFarlane et al., 2020).

The renowned science fiction novelist William Gibson's (2001) first glimpse of Shibuya in Japan, all that towering, animated crawl of commercial information, reminded him of the city in *Blade Runner* (1982), a canonical cyberpunk film. For Gibson (2001), 'modern Japan simply was cyberpunk'. Cyberpunk becomes the critique of a future society based on the technological imaginary of modernised cities like Tokyo. More recently, with the rapid development of digital technology, Sino-futurism is becoming a technological imaginary in terms of its Orientalising impulse and appearance in contemporary artworks. Moreover, immersive digital technology generates the illusion through artworks to transfer viewers from the real word to the science fiction world, and from the past to the future. Sino-futurism, therefore, aided by the Western technological imaginary has become an art genre of digital immersive art on the global stage, as in the aforementioned VR artwork by Cao Fei, *The Eternal Wave* (2020), and Lawrence Lek's digital installations, *Ghostwriter* (2019) and *AIDOL* (2019).

By highlighting VR and AR in the exhibition, *Blueprints* received positive reviews from international media. As *The Guardian* says, her work 'is a perfect fit for a world adjusting to the COVID-19 pandemic' (Bakare, 2021). During the pandemic lockdowns, people were quarantined at home and public activities were suspended in most countries. The *Blueprints* exhibition had to negotiate the COVID-19 pandemic in early March of 2020. The VR installation, *The Eternal Wave*, at the exhibition was turned into an augmented reality work – accessible on any mobile phone – in collaboration with Acute Art, enabling audiences to experience it despite lockdown restrictions. The technology company Acute Art (2020) provides technological solutions for contemporary artists such as Kaws and Olafur Eliasson (whom I mentioned in Chapter 5) to digitalise their artworks or create digital works. Acute Art's founder Daniel Birnbaum (2020) says that 'we will need new ways to interact with art after the lockdown. I believe virtual reality is the answer'. Even though digital work loses its authenticity since the original work can be copied and then visualised (Groys, 2008), it can provide alternative accessibility during the pandemic.

VR and AR not only provide an alternative way for audiences to view but also serve to balance the political distance of Sino-futurism in art. Viewers can see art from a political view (Berger, 2008), and sometimes artists or curators intend to guide viewers in seeing in this way. In Cao's work, a special period of the Sino-Soviet relationship and even the name *Hongxia*

itself have deep political meaning, which inevitably leads the media and critics to see the work in a political way. The sinologist Linda Jaivin (2019) writes that the Asia-Pacific Triennial of Performing Art's 2017 performance in Melbourne of *The Red Detachment of Women*, a revolutionary opera from the Cultural Revolution, aroused the rage of protestors, many of whom had fled Chinese persecution. However, the use of technology (i.e. the novel experience and special effects), to some extent, distracts people away from the strong political meanings. As Rachel Campbell-Johnston (2020), *The Times* newspaper's chief art critic, comments on Cao's *The Eternal Wave* (2020), 'I, admittedly, am something of a VR neophyte. I was amazed by every dizzying, mind-boggling moment'. Audiences, thus, can be amused by the novelty of digital technology and, at the same time, stay at a political distance to look at the work.

The criticism of technology, in particular digital technology, allows Cao's work to be accepted by global audiences and Western mainstream media. *Blueprints* won the Deutsche Börse prize in 2021; the prescient intersection between technology, human emotion and state power won over the jury (Bakare, 2021). *The Guardian* commented on Cao Fei as the 'artist who explores the obsession with tech' (Bakare, 2021), which further validates the artist's ability to convey the consequences of technology on society through art. For instance, *Nova* (2019), Cao's sci-fi film, tells the tale of a Chinese computer scientist working on a secret project to transform people into digital entities. A failed experiment sees the man's son become lost in cyberspace; trapped as a digital ghost, he spends the film trying to reconnect with the real world. As *The Guardian* notes, *Nova* 'is a metaphor for blinkered adherence to ideology: a future the parent believes in so fervently they will commit their only child to purgatory' (Judah, 2020).

Cao's artworks in *Blueprints* are not only just about techno-utopianism in China but also point to universal values including the side-effects of the development of digital technology, such as the loss of privacy in cyberspace, the obsession with solutionism, and the human alienation caused by AI. To some extent, technology is a kind of literacy. There is something universal about digital technology, so the audiences could appreciate *Blueprints* because it has familiar icons like AI, VR, and robots mixed with a Sino-futurist imaginary. As Cao said in a publicly available interview,

Now, everywhere records your fingerprints [sic], your face, CCTV and since we perform to the database, what we are living is like a big brother influence of the camera. In one way, we are fascinated by the future and technology, but in another way, we contribute to the digital. (Cao, 2020b)

The influence of digital technology is not just specific to China but is a global problem. Samuel Greengard (2015, p. 32) gives a general view that thanks to ubiquitous digital technology, low-cost sensors, and easy-to-deploy microelectronics, it is possible to connect 'just about anything and everything to the internet'. Users give permission for installed apps to collect data. Under the surveillance of the internet, people receive recommendations to buy new products and services but are also caught up in concerns about privacy and security.

The criticism of digital technology is a more general imaginary that has been accepted by global audiences and critics unlike the Western imaginary of China's development. Therefore, Cao's works concerning the development of digital technology, especially its negative consequences, have resulted in gaining the global audiences' favour and, in turn, qualifying her as an international artist. As she said in an interview, 'In the past years, my work has been shown quite extensively in the West, and I received much feedback from that audience' (Bukuts, 2021). In addition, as a write-up about Cao's works from *Wallpaper*, an art and design magazine based in London, stated:

> Though many of Cao's works feature China as part of the mise-en-scène, 'they have a sense of universality [...] through the themes that she is dealing with, or the use of popular global culture and iconography' [...] 'it speaks to a likewise global audience. While she does take a particular interest in developments in China, due to how rapidly and profoundly economic change has taken hold there, perhaps the need to pigeonhole her as a Chinese artist is ambiguous.' (Wu, 2021)

The transformation of digital technology in the global economy and people's daily lives not only becomes a means for contemporary artists to reach out to new audiences, but also the technology itself becomes the theme of these artworks. With the representation of China as an emergent digital power eliciting attention, the development of digital technology in China is becoming spectacular in the art world. Sino-futurism provide an alternative techno-cultural imaginary of China to the world. As the scholar of science fiction Virginia L. Conn (2020) argues, Chinese authors are put in the position of responding to the concept of Sino-futurism and catering to Western assumptions in order to be legible on a global scale. Accordingly, these digital immersive art works tend to feature the universal value of technology and Sino-futurism imaginary in relation to China, thereby 'allowing' artists like Cao Fei to step on the global stage and bring China's cultural presence to global audiences.

The Comparison of Two Ways to Tell China's Stories 'well'

So far in this chapter, I have examined the two case studies of digital immersive art using digital technology to tell the stories about China's technological development. *Beijing 8-Minute Show* reveals China's new image by using a historical approach to highlight China's digital power, and reflects China's government-oriented imaginary in the twenty-first century, arguably a political imaginary. Cao Fei's *Blueprints* (2020) applies Sino-futurism to a pre-existing Western imaginary and references Digital China in the global art context. These two artists use different ways to tell China's story 'well'. In order to further investigate the approaches for using digital technology to engage China's cultural presence through digital immersive art, I want to summarise and compare the different approaches adopted in these two case studies.

In order to cultivate a positive image of China in the minds of global audiences, the AR technology in *Beijing 8-Minute Show* was used to stage a massive and splendid spectacular. A giant dragon was projected on the immersive stage (Figure 8.3). The giant immersive stage with projected images also validated the heroic image of China. As the CCTV (2018) commentators said in the video of the live-streamed show, the 'Chinese dragon is a symbol of Chinese power'. Furthermore, as I have noted above, the projected image of a giant phoenix, aeroplanes and advanced astronomical telescopes on the ice screens were interpreted as China's new contributions to the world's technology, that is, according to the CCTV commentators. Here, China has been presented in heroic terms for using its technological achievement to contribute to the world.

Figure 8.3. The projected image of the giant dragon in *Beijing 8-Minute Show* (2018)

In its domestic media, China is portrayed as heroic and unified. This also extends to its cultural products. For instance, in Liu Cixin's science fiction novel *The Three-body Problem* (2014), the hero is a Chinese man who uses the 'Sword of Damocles' to protect the planet from alien invasion. However, it needs to be acknowledged that American and other Western media have largely characterised China as a place of repression. Censorship is an integral part of the world that they depict (Conn, 2020). Interventions in a foreign discursive environment can be interpreted as hostile (i.e. bad China) when foreign media interpret them (Schneider, 2019). Rather than counteracting these biased narratives, Sino-futurism presents a critical approach for subverting cultural clichés (Lek, 2016). The technologised imaginary of China can be used to tell a cautionary tale where humanity's future is alienated by digital technology. In Cao's work, VR creates a playful approach to narrating Sino-futurism. The animated (cartoonish) images and the 'magic circle' in the virtual environment allow transformation across different timelines to create a playable time machine to actualise the tragic story in science fiction (Figure 8.4).

The two case studies represent different faces of China's digital technology, respectively, in a positive and critical way. In the government-oriented approach, at the end of the *Beijing 8-Minute Show*, Zhang Yimou displays a short video about how Chinese people's daily lives have been influenced by digital technology. In this short video, e-commerce is shown as one of China's four 'new great inventions', which was interpreted by the CCTV commentators as a contributor to convenience in Chinese people's lives. E-commerce is also represented in Cao Fei's digital media work, *Asia One* (2018) at the *Blueprints*

Figure 8.4. In Cao Fei's VR work, a science fiction character appears in Cao's kitchen

exhibition. *Asia One* is set in an e-commerce warehouse the size of a city, and its robot mechanisms are tended to by two voiceless loners that are unable to communicate. The work was shot at various sites, including the world's first fully automated sorting centre in the Jiangsu province of China. The work has been described in *The Guardian* as 'a surreal sci-fi rom-com that speaks to China's past and the global future'; and as the reviewer further comments,

> The warehouse's two human inhabitants, a young man and woman, have mindless jobs – one scanning, the other deskbound. Whether side by side or observing each other through technology, they are, of course, alienated. (Sherwin, 2020)

Shaped by and reliant on Western projections of Asia as the techne, Sino-futurism posits Chinese individuals (the labourers) themselves as resources exploited by original producers of cultural or technological capital (Conn, 2020). Cao's work features the labours' alienation from fast-developing e-commerce driven by capital. The criticism of digital technology through narrating the alienation along with the Sino-futurism imaginary becomes the core of Cao's work.

International artists like Cao Fei have employed a critical perspective to reflect on China's digital technologies and the role of digital technology in society. This is an alternative narrative to the official one, which is weighed down by governmental slogans. The side effects brought about by technological development and modernisation have become the 'gazed-upon' object for audiences abroad. The critical approach is *well* received in a Western context. Hence, in comparison to digital display of culture that exalt scientific and technological achievements under political influence, Chinese digital artworks that prioritise artistic autonomy and accentuate critical perspectives on technology garnered more global presence, at least within the realm of contemporary art.

Empowered by Sino-futurism, these artists' works are celebrated by global audiences. One approach has been to encourage artists to embrace cultural heritage and incorporate it into their works, thereby asserting a distinct Chinese identity within the realm of Sino-futurism. By drawing from traditional Chinese art forms, mythology and history, these artists create a unique fusion of the past and the future, challenging preconceived notions and offering alternative narratives. However, Sino-futurism is oriented by Western observers and also has its bias. The Western perception of China as an enigmatic and sometimes threatening entity has influenced the way Sino-futurism is interpreted and portrayed. Chinese officials have tried to dissolve this bias by increasing cultural confidence. I will explain this further in the next chapter.

Conclusion

Unlike Japan's teamLab's commercialised approach discussed in Chapter 5, the digital immersive art works discussed in this chapter are endorsed by the government, displayed in international mass events or supported by institutions for exhibiting art. *Beijing 8-Minute Show* displayed China's emerging technological leadership and showcases Chinese digital enterprises. By contrast, *Blueprints* took a critical approach by drawing attention to China's rise as a technological superpower.

Digital technology is not only a means to boost the economy, but it is also a strategy to enhance 'cultural power' (Keane & Chen, 2017). Digital technology is helping China stage spectaculars which, to some extent, are contributing to its presence on the global cultural stage. The administration's view on soft power is a significant driver in how official artists envisage spectaculars such as *Beijing 8-Minute Show*. Digital immersive technology is used to narrate a positive story about China's technological achievement, and it provides opportunities for China's digital technology companies to enhance their reputation. However, even though some global audiences have recognised China's fast-developing technology, they have not yet connected this technological presence as a new cultural imaginary about China. People within China generate a far different imaginary of their nation than one normally sees outside China or in Western media, where China's digital power is correlated to its political image.

Moreover, Sino-futurism representing a new technological imaginary about China offers an alternative possibility for 're-presenting China to the world'. In Cao's work, Sino-futurism empowers the art value of digital immersive art; it is used as a trope to criticise the rapid development of technology and allows artists like Cao Fei to step onto the global stage. At the same time, however, Sino-futurism does not counteract biased narratives in the Western imaginary. Nevertheless, this may be turned to digital immersive art's advantage. Sino-futurist digital immersive art, like Cao's work, uses the newness of immersive digital technology to augment the imaginary of Western audiences outside China; thus, these viewers can be engaged by the novelty and, meanwhile, stay at a political distance to see the work. In terms of the use of immersive digital technology in *Beijing 8-Minute Show*, its newness highlights an idea (about a heroic China's digital power), one that is contrary to the Western audiences' cultural imaginary.

Chapter 9

CHINESE MODERNISATION
AND THE FUTURIST ARTS

As I was writing this book, the 2022 Winter Olympic Games were being held in Beijing. At the event's opening ceremony, digital immersive technology displayed the majesty of Chinese culture, as had been the case at the closing ceremony of the previous event in Korea. China's English-language news service, *China Daily*, published a series of stories highlighting the achievements. One report was enthusiastic: 'with the use of many cutting-edge technologies such as 5G, machine vision and artificial intelligence (AI), the ceremony served as a visual feast with fantastic lighting and images' (Wu, 2022). However, rather than displaying achievements like the aeroplane and high-speed train presented in *Beijing 8-Minute Show* in 2018, the curators used digital technology to convey an image of a unified, romanticised and 'green' China. The digital immersive performance featured naturalistic elements, such as the 24 Solar Terms, Chinese landscape painting and snow. This blending of Chinese iconography was deliberately apolitical, suggesting a more mature use of digital immersive art. At the same time, however, subtle slogans were embedded in the ceremony, such as the 'Community of Shared Future' narrative, very familiar to people in China and parts of Asia, including Belt and Road (BRI) nations.

In addition, the official theme of the Games, 'Together for a Shared Future', was incorporated into the entire ceremony. The passing of the Chinese national flag was one of the main highlights covered by Chinese media. The flag was passed by hand by 100 Chinese people made up of all ethnic minorities in China, eventually making it to the hands of the flag-raisers. Another example was especially noteworthy: at the end of the ceremony, snowflake-shaped plates, each bearing a participating nation's name, interlocked to form a giant snowflake surrounding the Olympic flame. As *China Daily* wrote, the formation of the snowflake perfectly articulated the Chinese philosophy of 'harmony in diversity' and 'strength in unity' (Wu, 2022). The performance featuring the snowflake was reported in the Western media. *The Guardian* report included the snowflake performance as

one of the '11 key moments from Beijing 2022 opening ceremony'. It was described as follows: 'one sequence featured children dancing and singing across the arena, while the LED screens beneath them automatically tracked their footsteps, making stars appear at their feet as they performed and moved around' (Belam, 2022). However, in its report of key moments, *The Guardian* cited 'protests around the globe as the Games open'. China's non-humanitarian treatment towards ethnic minorities was featured as another one of the 'key moments from Beijing 2022 opening ceremony' (Belam, 2022). The coverage by *The Guardian* conflicts with the careful image of a unified China endorsed by the Chinese government. People might have been thrilled by the digital immersive display, but when media reports linked this achievement to political issues, there was evidently a sense of disillusionment among some viewers.

The success of the 2008 Olympics opening ceremony changed many people's minds about China and drew attention to Chinese culture. The use of technology was important in this regard. Beijing 2008 proved China's capability on the international stage. The performances and the use of technology helped to consolidate a new image of China. Digital immersive art came to be seen by the authorities as an opportunity for the nation to augment its soft power, a way to showcase technological power. In *Beijing 8-Minute Show* (2018), Zhang Yimou thus attempted to use digital technology to shift the viewing perspective away from politics and towards culture. Yet in the minds of Western audiences, China's technological achievements were not part of their image of China. In the minds of many in the West, China's digital power is part and parcel of the technocratic state, which reflects hard power.

As a showcase of national identity and a mass spectacle the Olympic Games are exceptional events. On the other hand, Chinese artists engaging with Sino-futurism do not reject the perception of China's digital power and solutionism. Digital immersive art works like Cao Fei's *Blueprints* (2020) highlighted China's cultural elements with political connotations while using the newness of immersive digital technology to provide a playful way to see the work. The use of technology (i.e. the novel experience and special effects), to some extent, distracts viewers from overt political meanings. These works have been widely accepted by the Western media. But Sino-futurism can also be biased. Digital immersive art may change the image of China as a manufacturer of low-quality mass products by featuring spectacular high technology in an imagined Digital China, but this art genre also contains a political perspective about China's superpower status.

In this book, I have investigated Digital China from two perspectives: the international, which accords with the standard definition of how soft power

is transmitted globally; and the domestic, which is about national identity whereby people within the nation are persuaded via digital technology to believe in the cohesive power of national culture. Chinese people evidently appreciate the abundance of Chinese traditional culture; meanwhile, artists' and curators' channel efforts into recreating and promoting Chinese culture in a digitalised way, and entrepreneurs are creating digital start-ups to change the old image of 'Made in China'. Collectively this contributes to a new imaginary that is being projected while reinforcing the idea of the 'Community of Shared Future', a political slogan that is only really properly understood within China. The merging of the triple imaginaries: 'Digital China' + 'Shared Future' + 'Chinese Dream', reinforces national and cultural identity in China, which is about bringing together all the components (i.e. ethnicities) into a big family and demonstrating to the world's media that China is unified.

As I have discussed in Chapter 5, such political slogans are highlighted in works inspired by ancient Chinese wisdom and represent China's vision of a just, secure, and prosperous world, one in which China sees itself as a builder of world peace and contributor to global development (X. Zhao, 2018). Even if the foreign/international audiences remain unpersuaded by digital immersive art, the domestic audiences have responded with pride. However, I should reiterate that it is equally significant to note that although domestic Chinese practitioners and audiences are proud of China's culture, nonetheless they are ambivalent about digital technology. Behind the immersive spectacles and technological developments, we see two sides of China. A digital superpower is rising but it has problems with its throwing off the old image associated with cheap products and copies. While culture is being rejuvenated by digitalisation, people have concerns about the implementation of digital technology.

Does Cultural Confidence Really Need a Justification from Outsiders?

The techno-cultural imaginary that I introduced at the beginning of the book is a hybrid model, a future vision of China that is yet to be realised. It influences how audiences read digital immersive art and how culture and technology are represented in people's minds. In 2023, I conducted a follow-up interview with Huang Jiasheng, the founder of Jes Studio and Configreality Space, at the Shanghai International Film Festival. He had brought his new work, a VR calligraphy gallery in which he cooperated with the artist Boyan to participate in the film festival. He said that his career in VR art suffered a significant setback during the COVID-19 lockdown. However, with the

emergence of the metaverse concept, he has secured a fresh round of venture capital. He expresses great joy in being able to showcase Chinese culture on the global stage and remains determined to pursue his VR dream despite the challenges he faces.

In the narrative of China's official discourse, cultural confidence is not only connected to the number of advanced digital technologies such as VR and AI but also complements grander concepts such as the metaverse and Chinese-style modernisation. The Chinese government maintains that Chinese-style modernisation must align with its own civilisation, culture and national conditions, and of course, political ideology (Zheng, 2023). Within the narratives of technological progress and national rejuvenation, culture assumes a central role. The emergence of the metaverse further strengthens the notion of Chinese-style modernisation. Following Facebook's rebranding as Meta in 2021, the concept of the metaverse has gained recognition in China as well. On 8 September 2023, the Ministry of Industry and Information Technology, the Ministry of Education, the Ministry of Culture and Tourism, the State-owned Assets Supervision and Administration Commission and the National Radio and Television Administration jointly issued the 'Three-Year Action Plan for the Innovation and Development of the Metaverse Industry (2023–2025)' (CNII, 2023), signifying the comprehensive elevation of the Metaverse Industry in China to become an important national strategy straddling the cultural and technological sectors. In this reset, many digital immersive art projects have appeared using the idea of metaverse.

On its 95th anniversary, the China Academy of Art unveiled the Meta-Art Academy (MAA),[1] China's first metaverse art school. The academy offers a hyper-immersive-themed course about art, an audio–visual sympathetic art theatre, and a mixed reality portal. As indicated in its promotional video, the primary objective of MAA is to promote Chinese culture in the digital age and explore the future of art. Moreover, digital immersive art is being employed for the ideological dissemination of the Communist Party of China (CPC), using the metaverse to effectively convey China's revolutionary narrative. In 2023, the Guangzhou Branch of the National Edition Museum of China has meticulously crafted various immersive and interactive exhibits featuring a historical trajectory utilising tapes, televisions, CD-ROMs and cultural elements from contemporary China. These exhibits not only evoke collective memories but also narrate the accomplishments achieved since the 18th National Congress of CPC.

1 See https://en.caa.edu.cn/news/1027.html, retrieved on 30 October 2023.

In the cultural sector, there are arguments about whether art is always instrumental or political. This book has not attempted to answer this question. However, it is important to see that the functions of art are regulated by commercial and political mechanisms and that politics and commercialisation can make art powerful. in the 1940s, China inherited the Soviet Union's theory of socialist realism that dictated that art should be 'pleasing to the masses' while, at the same time, educating and galvanising the masses. While we are in a post-socialist realism era now, the political authorities still have the memory of how art made China powerful in the past. In present-day China, digital technology is not only expected to engage with wider audiences but also is a way to deepen Chinese people's perception of Chinese culture. Immersion and distance are equally significant in this process. In China's creative industries, policy and commercialisation both regulate the production of digital immersive art. The creators of digital immersive art have created new cultural elements or recreated existing cultural elements, but they have also had to adapt to the commercialised nature of economic life in China. Art is often serving as the creative engine that drives much of the enterprise (Donald, 2006). In recent decades in China, art has become a business, and there are more roles to be played in the art world. Hence, policymakers, creators, curators and even entrepreneurs in China are seeking new ways to engage with Chinese audiences.

Compared to the digital immersive arts which are often considered as the instrument of political propaganda, artworks emphasising artistic autonomy have garnered more international acclaim, such as Cao Fei's *Blueprints* (2020), Lawrence Lek's video essay *Sino-futurism (1839–2046 AD)* (2016) and Lu Yang's video game *The Great Adventure of the Material World* (2019). Their immersive works, which blend Sino-futurism and Chinese culture have been widely circulated and exhibited within China. In 2022, Lek presented the solo exhibition *Post-sinofuturism 2065* at ZiWU on the Bund in Shanghai, while Cao held a solo exhibition *Staging the Era*, curated by the UCCA Centre for Contemporary Art in Beijing in 2021. The critical exploration of Sino-futurism prompts introspection in China regarding strategies for enhancing modernisation. Through this critical lens, Chinese artists and intellectuals actively reassess the interplay between traditional culture, futuristic elements and the direction of modernisation to seek a more sophisticated approach that harmonises technology and tradition.

People outside China may in fact criticise Chinese digital immersive art works that have lost their artistic autonomy and have become tools of political propaganda. These works truly illustrate the nuances of the techno-cultural imaginary that exists in China, the celebration of digital technology

with pride in Chinese culture, which coexists with disillusionment about technological solutionism. In 1980, the French philosopher and sociologist Jacques Ellul wrote:

> The universe we inhabit is becoming increasingly a dreamed universe since the society of the spectacle is changing gradually into the society of the dream. This is brought about by the diffusion of spectacles of all sorts which we ask the spectator to internalise, but also brought about by the maintained dream of a science which immerses us into a world as yet unknown and incomprehensible. (Ellul 2012, cited in Lee, 2017, p. 136)

In fact, the entrepreneur's metaverse dream and the Chinese people's dream of cultural confidence are also a dream universe, which is unknown.

On the level of politics the concept of the 'Chinese Dream' is underpinned by 'cultural confidence' and 'Chinese-style modernisation', reinforced as a techno-cultural imaginary by the Chinese domestic media. This collective political imaginary influences how Chinese audiences see digital immersive art. They are thus preconditioned to believe in the value of Chinese culture as it is represented in digital formats; especially when the artwork conveys highly formal, integrated worldviews, audiences use preconceptions to appraise the cultural significance of the work. Domestic audience members express admiration for Chinese culture. Some value Chinese culture over the trustworthiness of digital technology. Hence, Chinese audiences' perceptions of art facilitate critical views of digital technology.

Outside China, people also used their preconceived ideas to appraise the message in digital immersive art. The imaginaries of audiences outside the PRC are quite different from the imaginaries of those inside China. In *Unfabling the East*, Jürgen Osterhammel (2018, p. 10) notes, 'Did European observers ever really escape from a hall of self-reflecting mirrors? Did they not simply see what they wanted to see?' European and American sinologists and novelists have imagined their own China which has dictated the way the audiences outside China perceive it or its culture (Lee, 2018). In the context of 'Digital China', the Western media tends to correlate China's digital power with censorship and technocratic state (Keane et al., 2020). The Chinese government has attempted to use global cultural presence to change this negative image. China's technological achievements have yet to link with Chinese culture outside China. Hence, in some audience members' minds, the spectaculars of digital immersive technology may be construed as gimmicks reported by Chinese media or publicity designed by the Chinese government.

Through the comparison of the comments in Chapter 8, it appears that Chinese audiences haven't wavered in their cultural confidence despite the disparities in external perceptions. However, relying on this confidence isn't adequate to shift China's global perception. Technological optimism and cultural confidence jointly shape a virtual time capsule, which can be a space to preserve Chinese culture or nourishment for cultivating nationalism.

Chinese Futurist Art and Digital Asia

This book has brought together a comprehensive picture of China's digital immersive art, from its production to audiences' reception inside and outside China, and paves the way for further research in the field. It is important to see the complicated and ever-changing dynamics of producing, distributing and consuming digital immersive art. The diffusion of VR/AR in creative practice generates new forms of art; and the intervention of commercialisation makes new industrial forms, for instance, the immersive entertainment and retail museum mentioned in this project.

With more novel digital technologies (i.e. AI and blockchain) involved in the production of digital immersive art, more artforms and industrial forms are emerging. For example, the use of non-fungible tokens (NFTs) for the trade or collection of digital assets. NFT is a non-interchangeable unit of data stored on a blockchain, a form of digital ledger, that can be sold and traded (Dean, 2021). NFT changes the production and distribution process of digital immersive art. For instance, VRNFT,[2] a VR gallery with NFT support, allows its users to protect their digital assets, view artworks, and communicate with artists in a blockchain system. In 2021, Hong Kong hosted the first physical and virtual art fair, *Digital Art Fair Asia*, featuring a 360-degree immersive art experience and NFT digital art. Visitors can view the exhibition in Hong Kong or via VR goggles anywhere in the world. Moreover, some world-famous artists and art institutions have also engaged in NFT art. In 2021, the Japanese artist Hajime Sorayama unveiled his first limited edition NFT collection, *UNTITLED_SHARK ROBOT*, which is a collaboration between Hong Kong's K11 Musea and the art authentication platform Zhen. In China, Bigverse, a Chinese metaverse company, launched its NFT art platform NFTCN (NFT 中国) in 2021. As stated on its official website, Bigverse (2021) is committed to empowering the digital culture and art industries with technology, promoting Chinese culture, disseminating Chinese stories, and boosting the national strategy of cultural power. NFT art

2 See https://vr-nft.com/art/test-vr-nft-artwork-1/, retrieved on 15 February 2022.

is considered as the means of promoting Chinese culture not only domestically but also internationally. As the media has reported, the International Olympic Committee officially authorised *Bing Dwen Dwen* (冰墩墩), the 2022 Beijing Winter Olympics panda mascot, to be sold on an NFT platform (Shen, 2022). Hence, it is significant to see, in the future, how these new digital technologies are changing the dynamics of digital immersive art in the creative industries and contributing to China's cultural power.

Advanced by digital technology, futurist art becomes the future of art, since it involves the construction of people's future vision. Artists utilise digital technology to address their apprehensions regarding the future, while simultaneously, the fusion of technology and art crafts an optimistic vision of what lies ahead. Artificial intelligence has emerged as a valuable ally for artists, empowering even ordinary individuals to create art through platforms like Midjourney and DALL-E. In China, generative AI has found applications in the restoration of cultural heritage. However, it raises intriguing questions about the true essence of historical restoration. Can AI algorithms authentically resurrect the past, capturing its genuine form, or do these technological interventions inadvertently infuse historical representations with human biases and preferences? The duality of AI as a restorer of historical authenticity and a vehicle for sculpting perceptions invites contemplation on the ethical and philosophical implications of technology's role in shaping our understanding of the past.

In the past, traditional Chinese culture, predominantly through Confucianism, exerted influence in Asia by ingraining itself as a cultural concept, fostering enduring impacts across these nations. However, following the Industrial Revolution, the sway of Confucian values dwindled, giving way to a paradigm shift where science emerged as the ultimate solution to human predicaments. In the contemporary landscape, China endeavours to reshape its global image by leveraging technology and cultural influence. Yet, this ambition encounters a formidable obstacle stemming from preconceived notions that tie digital prowess to China's political identity. Even in Southeast Asia, there lingers apprehension regarding Chinese cultural offerings and online platforms due to their perceived association with technological solutionism and censorship prevalent in China. Concerns regarding practices like facial recognition, and the legacies of political figures like Mao and Xi Jinping further contribute to this suspicion (Keane et al., 2020).

Hence, more research about digital technology is needed to speak to global audiences and see the different perceptions among different groups, in particular, when a nation's international status is changing under digital transformation. Unlike the cultural images of South Korea (as featured in K-pop) and Japan (as featured in retro-futurism), recently imagined China

is becoming more explicitly related to the imaginary of digital power in the Western context via the immersive and spectacular performances endorsed by the government or through the Sino-futurism genre fostered by artists outside China. Digital immersive art is not exclusive to China, but China is an example to other countries that demonstrates some possibilities for using digital technology to deliver aesthetics, ideas and value through international art exhibitions and mass events. Asia, where China is located, is recognised as an emerging digital powerhouse in terms of its significant internet population and its diversity of cultures and geopolitics. Some scholars (Noronha & D'Cruz, 2019, as cited in Athique & Baulch, 2019) claim that South Korea and China are the major players in the manufacturing domain of digital Asia, while India and the Philippines are specialised providers of digital labour. With their development of hard power (e.g. infrastructure and finance) facilitated by digital technology, the latter countries may in the future face the same problems as China in terms of soft power.

The trajectory of their international images will be a critical focal point, prompting contemplation on whether leveraging digital technology could serve as a conduit for enhancing their global reputations. The unfolding narrative of these nations, wielding digital technology to fortify their positions, heralds a new chapter in the global arena. It prompts an essential inquiry into whether this technological advancement will indeed be the linchpin in their endeavours to reshape and augment their international identities. The book closes at this juncture, leaving the reader to ponder the unfolding stories of digital prowess and its profound implications on the global stage.

REFERENCES

Abbasi, M., Vassilopoulou, P., & Stergioulas, L. (2017). Technology roadmap for the creative industries. *Creative Industries Journal, 10*(1), 40–58. https://doi.org/10.1080/17510694.2016.1247627.

Acciaioli, G. (1985). Culture as art: From practice to spectacle in Indonesia. *Canberra Anthropology, 8*(1–2), 148–172. https://doi.org/10.1080/03149098509508575.

Acute Art. (2020). *Cao Fei's The Eternal Wave, Now in AR.* Retrieved 13 October from https://acuteart.com/cao-feis-the-eternal-wave-now-in-ar/.

Aguirre, A. C., & Davies, S. G. (2015). Imperfect strangers: Picturing place, family, and migrant identity on Facebook. *Discourse, Context & Media,* 7, 3–17. https://doi.org/10.1016/j.dcm.2014.12.001.

Aichner, T., & Jacob, F. (2015). Measuring the degree of corporate social media use. *International Journal of Market Research, 57*(2), 257–276. https://doi.org/10.2501%2FIJMR-2015-018.

Alexander, J. (2017). *VRChat is a Bizarre Phenomenon That Has Twitch, YouTube Obsessed.* Polygon. Retrieved 26 May 2021, from https://www.polygon.com/2017/12/22/16805452/vrchat-steam-vive-oculus-twitch-youtube.

Anderson, B. (2020). Imagined communities: Reflections on the origin and spread of nationalism. In Steven Seidman, Jeffrey C. Alexander, Steven Seidman, & Jeffrey C. Alexander (Eds.), *The New Social Theory Reader* (pp. 282–288). Routledge.

Artron. (2018). *'GAMEBOX: The Exhibition Immersive of Game Art' is coming to Shanghai to explore video games through the context of digital art* ('GAMEBOX沉浸式游戏艺术展' 即将登陆上海 通过数字艺术语境探讨电子游戏). Artron.Net. Retrieved 20 December from https://news.artron.net/20180817/n1017836_.html.

Athique, A., & Baulch, E. (2019). *Digital Transactions in Asia: Economic, Informational, and Social Exchanges.* Routledge.

Australian Society of Archivists. (2003). Australian Society of Archivists Annual Conference – GLAM. Retrieved 19 March 2021, from https://web.archive.org/web/20030801224434/http://www.archivists.org.au/events/conf2003/.

Bailenson, J. (2018). *Experience On Demand: What Virtual Reality Is, How It Works, and What It Can Do.* WW Norton & Company.

Bakare, L. (2021, September 10). Artist who explores obsession with tech wins Deutsche Börse prize. The Guardian. https://www.theguardian.com/artanddesign/2021/sep/09/artist-who-explores-obsession-with-tech-wins-deutsche-borse-prize.

Banis, D. (2017). The holodeck reloaded – Janet Murray talks VR, AR and why she's so good at predicting things. *Submarine Channel.* Retrieved 19 June 2018, from https://submarinechannel.com/holodeck-reloaded-janet-murray-talks-vr-ar-shes-good-predicting-things/.

Barbour, R., & Kitzinger, J. (1998). *Developing Focus Group Research: Politics, Theory and Practice*. Sage.

Baudrillard, J. (1988). *Jean Baudrillard: Selected Writings*. Stanford University Press.

Beijing Winter Olympic Committee. (2018). Explanation of 'Beijing 8-Minute' theatrical performance ('北京8分钟'文艺表演阐释). Beijing Organising Committee for the 2022 Olympic and Paralympic Winter Games. Retrieved 6 October 2021, from http://m.people.cn/n4/2018/0225/c121-10592943.html.

Belam, M. (2018, February 26). Winter Olympics closing ceremony: 10 highlights from PyeongChang. The Guardian. https://www.theguardian.com/sport/2018/feb/25/winter-olympics-closing-ceremony-10-highlights-from-pyeongchang.

Belam, M. (2022, February 20). Winter Olympics: 11 key moments from Beijing 2022 opening ceremony. https://www.theguardian.com/sport/2022/feb/04/beijing-2022-winter-olympics-opening-ceremony-11-key-moments.

Bender, S. (2019). Headset attentional synchrony: Tracking the gaze of viewers watching narrative virtual reality. *Media Practice and Education, 20*(3), 277–296. https://doi.org/10.1080/25741136.2018.1464743.

Bender, S. (2021). *Virtual Realities: Case Studies in Immersion and Phenomenology*. Springer Nature.

Bender, S. M., & Sung, B. (2021). Fright, attention, and joy while killing zombies in virtual reality: A psychophysiological analysis of VR user experience. *Psychology & Marketing, 38*(6), 937–947.

Benjamin, W. (1972). A short history of photography. *Screen, 13*(1), 5–26.

Benjamin, W. (2008). *The Work of Art in the Age of Mechanical Reproduction*. Penguin UK.

Bennett, T., Savage, M., Silva, E. B., Warde, A., Gayo-Cal, M., & Wright, D. (2009). *Culture, Class, Distinction*. Routledge.

Benzecry, C. E. (2014). An opera house for the 'Paris of South America': Pathways to the institutionalization of high culture. *Theory and Society, 43*(2), 169–196. https://link.springer.com/article/10.1007/s11186-014-9214-7.

Berger, J. (2008). *Ways of Seeing*. Penguin UK.

Bigverse. (2021). *About Bigverse (关于Bigverse)*. Retrieved 18 January 2022, from https://www.nftcn.com.cn/pc/#/index.

Biocca, F., & Levy, M. R. (2013). *Communication in the Age of Virtual Reality*. Routledge.

Birnbaum, D. (2020). *In the changed world after lockdown, we will need smarter new ways to interact with art. I believe virtual reality is the answer*. Artnet News. Retrieved 24 July from https://news.artnet.com/opinion/will-need-new-ways-interact-art-lockdown-believe-virtual-reality-answer-1839591.

Bismarck, B. V., DeBruyn, E., Groos, U., Hess, B., Wevers, U., & Heubach, F. W. (2004). *Ready to Shoot: Fernsehgalerie Gerry Schum-Videogalerie Schum*. Snoeck.

BlackBow. (2019). *About us: The introduction of BlackBow*. Retrieved 10 June from https://www.blackbow.cn/.

Bloor, M. (2001). *Focus Groups in Social Research*. Sage.

Boden, M. A. (1994). *Dimensions of Creativity*. MIT Press.

Boellstorff, T. (2015). *Coming of Age in Second Life: An Anthropologist Explores the Virtually Human*. Princeton University Press.

Boellstorff, T., Nardi, B., Pearce, C., & Taylor, T. L. (2012). *Ethnography and Virtual Worlds: A Handbook of Method*. Princeton University Press.

Böhme, H. (2014). *Fetishism and Culture*. De Gruyter.

Bradsher, K. (2007, July 3). 'China's Mona Lisa' Makes a Rare Appearance in Hong Kong. The New York Times. https://www.nytimes.com/2007/07/03/arts/design/03pain.html.

Bukuts, C. (2021, March 29). How Cao Fei predicted the future. *FRIEZE*. https://www.frieze.com/article/how-cao-fei-predicted-future.

Burke, G. (2006). Towards an immersive art pedagogy: Connecting creativity and practice. *Australian Art Education, 29*(2), 20–38. https://search.informit.org/doi/abs/10.3316/aeipt.162678.

Campbell-Johnston, R. (2020, March 7). Cao Fei interview—the top Chinese artist who defied the coronavirus to show in London. The Times. https://www.thetimes.co.uk/article/cao-fei-interview-the-top-chinese-artist-who-defied-the-coronavirus-to-show-in-london-psrf1828h.

Candy, L., & Ferguson, S. (2014). *Interactive Experience in the Digital Age: Evaluating New Art Practice*. Springer.

Cao, F. (2020a). *Blueprints* [immersive, site-specific installation]. Serpentine Gallery, London. https://www.serpentinegalleries.org/whats-on/cao-fei/.

Cao, F. (2020b). Cao Fei: Blueprints | Serpentine Exhibition. YouTube. https://www.youtube.com/watch?v=v9neyNVHE8A.

Carrozzino, M., & Bergamasco, M. (2010). Beyond virtual museums: Experiencing immersive virtual reality in real museums. *Journal of Cultural Heritage, 11*(4), 452–458. https://doi.org/10.1016/j.culher.2010.04.001.

Casarin, F., & Moretti, A. (2011). An international review of cultural consumption research. Department of Management, Università Ca' Foscari Venezia Working Paper, 12. https://doi.org/10.2139/ssrn.2037466.

Castoriadis, C. (1987). *The Imaginary Institution of Society*. MIT Press.

CCTV. (2018, February 26). 8 minutes in Beijing! See you in Beijing in 2022!. YouTube. https://www.youtube.com/watch?v=KRR154Kk-gE.

C Future Lab. (n.d.). *Future Starts Here*. Retrieved 9 November from https://mp.weixin.qq.com/s/rxLSpyziONXX3bXVPtLhNg.

CGTN. (2018, February 25). Hi-tech showcase as 'Beijing 8 Minutes' ends PyeongChang 2018. https://news.cgtn.com/news/346b444d35677a6333566d54/share_p.html.

CGTN. (2020, May 24). Come Together: The confidence power of Chinese culture renaissance. CGTN. https://news.cgtn.com/news/2020-05-24/Come-Together-The-confidence-power-of-Chinese-culture-renaissance-QJBuJRqdRm/index.html.

Champion, E. (2011). *Playing with the Past*. Springer.

Champion, E. M. (2006). *Evaluating cultural learning in virtual environments*. University of Melbourne. Melbourne.

Chang, Y.-Y., Potts, J., & Shih, H.-Y. (2021). The market for meaning: A new entrepreneurial approach to creative industries dynamics. *Journal of Cultural Economics, 45*, 491–511. https://doi.org/10.1007/s10824-021-09416-5.

Chappell, B. (2018, February 25). PyeongChang Olympics: Closing Ceremony Ends Biggest Winter Games Ever. National Public Radio (NPR). https://www.npr.org/sections/thetorch/2018/02/25/588634565/pyeongchang-olympics-closing-ceremony-ends-biggest-winter-games-ever#:~:text=Pyeongchang%20Olympics%3A%20Closing%20Ceremony%20Ends,Games%20Ever%20%3A%20The%20Torch%20%3A%20NPR&text=More%20Podcasts%20%26%20Shows-,Pyeongchang%20Olympics%3A%20Closing%20Ceremony%20Ends%20Biggest%20Winter%20Games%20Ever%20%3A%20The,they%20represented%20in%20South%20Korea.

Chen, C. C., Colapinto, C., & Luo, Q. (2012). The 2008 Beijing Olympics opening ceremony: Visual insights into China's soft power. *Visual Studies, 27*(2), 188–195. https://doi.org/10.1080/1472586X.2012.677252.

Chen, G., Chen, J., Deng, X. C. X., Deng, Y., Kurlantzick, J., Pang, Z., Wibowo, I., Zhang, L., Zhang, Y., & Zhao, S. (2009). *Soft Power: China's Emerging Strategy in International Politics*. Lexington Books.

Chen, R., & Sharma, A. (2021). Construction of complex environmental art design system based on 3D virtual simulation technology. *International Journal of System Assurance Engineering and Management*, 1–8. https://doi.org/10.1007/s13198-021-01104-z.

Cheney, C. (2019). *China's Digital Silk Road: Strategic technological competition and exporting political illiberalism*. Pacific Forum, Honolulu. https://pacforum.org/wp-content/uploads/2019/08/issuesinsights_Vol19-WP8FINAL.pdf.

China Media Group. (2021). *Tell the Chinese story well, spread the Chinese voice well* (讲好中国故事 传播好中国声音). QSTHEORY.CN. Retrieved 20 June from http://www.qstheory.cn/zhuanqu/2021-06/02/c_1127522386.htm.

Cho, J.-M., Kim, Y.-D., Jung, S. H., Shin, H., & Kim, T. (2017). 78–4: Screen door effect mitigation and its quantitative evaluation in VR display. SID Symposium Digest of Technical Papers, Oregon Convention Center, USA.

Chua, B. H. (2009). Being Chinese under official multiculturalism in Singapore. *Asian Ethnicity*, *10*(3), 239–250. https://doi.org/10.1080/14631360903189609.

Chuah, S. H.-W. (2018). Why and who will adopt extended reality technology? Literature review, synthesis, and future research agenda. Literature Review, Synthesis, and Future Research Agenda (13 December 2018).

CNII. (2023). Five departments including MIIT jointly issue 'Three-Year Action Plan for the Innovation and Development of the Metaverse Industry (2023–2025)' (工信部等五部门联合印发《元宇宙产业创新发展三年行动计划（2023—2025年）》). https://www.cnii.com.cn/tx/202309/t20230911_502452.html.

CNNIC. (2023). *The 52nd statistical report on China's Internet development* (第52次《中国互联网络发展状况统计报告》). Retrieved 11 December from https://cnnic.cn/n4/2023/0828/c199-10830.html.

Cohen, E. (1988). Authenticity and commoditization in tourism. *Annals of Tourism Research*, *15*(3), 371–386. https://doi.org/10.1016/0160-7383(88)90028-X.

Coleridge, S. T. (1950). *Biographia Literaria*. JM Dent.

Conn, V. L. (2020). Sinofuturism and Chinese science fiction: An introduction to the alternative sinofuturisms (中华未来主义) special issue. *Science Fiction Research Association (SFRA) Review*, 50, 2–3. https://sfrareview.org/2020/09/04/50-2-a0conn/.

Croteau, D., & Hoynes, W. (2013). *Media/Society: Industries, Images, and Audiences*. Sage.

Cruz-Neira, C., Sandin, D. J., & DeFanti, T. A. (1993). *Surround-screen projection-based virtual reality: The design and implementation of the CAVE*, the 20th annual conference on computer graphics and interactive techniques, California.

Curtin, M. (2007). *Playing to the World's Biggest Audience: The Globalization of Chinese Film and TV*. University of California Press.

Darley, A. (2002). *Visual Digital Culture: Surface Play and Spectacle in New Media Genres*. Routledge.

Davis, B. (2016, May 26). How teamLab's Post-Art Installations Cracked the Silicon Valley Code. ArtNet. https://news.artnet.com/market/teamlabs-silicon-valley-pace-show-504815#.WMtuM-zwZJR.twitter.

de Kloet, J., Fai Chow, Y., & Scheen, L. (2019). *Boredom, Shanzhai, and Digitisation in the Time of Creative China*. Amsterdam University Press.

De Saussure, F. (1960). *Course in General Linguistics*. Peter Owen Limited.

de Seta, G. (2020). Sinofuturism as inverse Orientalism: China's future and the denial of coevalness. *Science Fiction Research Association (SFRA) Review*, *50*(2–3), 86–94.

Dean, S. (2021, March 11). $69 million for digital art? The NFT craze, explained. Los Angeles Times. https://www.latimes.com/business/technology/story/2021-03-11/nft-explainer-crypto-trading-collectible.

Denegri-Knott, J., & Molesworth, M. (2010). Concepts and practices of digital virtual consumption. *Consumption, Markets and Culture, 13*(2), 109–132. https://doi.org/10.1080/10253860903562130.

Deng, Z. (2021, April 19). Focus on the ordinary. China Daily. https://www.chinadaily.com.cn/a/202104/19/WS607cc74aa31024ad0bab64fc_7.html.

DeSarthe. (2019). *WANG XIN*. Retrieved 19 May from https://www.desarthe.com/artist/wang-xin.

Dibbell, J. (1994). A rape in cyberspace or how an evil clown, a Haitian trickster spirit, two wizards, and a cast of dozens turned a database into a society. *Annual Survey of American Law*, 471. https://heinonline.org/HOL/Page?handle=hein.journals/annam1994&div=44&g_sent=1&casa_token=&collection=journals.

Digital Dunhuang. (n.d.). *Mogao Grottoes Cave 61*. Retrieved 13 November 2021, from https://www.e-dunhuang.com/cave/10.0001/0001.0001.0061.

Dissanayake, E. (2002). *What Is Art For?* University of Washington Press.

Dolfsma, W. (2004). *Institutional Economics and the Formation of Preferences: The Advent of Pop Music*. Edward Elgar Publishing.

Donald, M. (2006). Art and cognitive evolution. In Mark Turner (Ed.), *The Artful Mind: Cognitive Science and the Riddle of Human Creativity* (pp. 3–20). Oxford University Press.

Dong, W., Fuchen, H., Jun, L., Xiaowei, W., & Hongwei, L. (2003). On the Chinese civilization's cultural genes and its modern transmission (seminar) (中华文明的文化基因与现代传承 专题讨论). *Hebei Academic Journal, 23*(5), 130–147. https://kns.cnki.net/KCMS/detail/detail.aspx?dbcode=CJFD&filename=HEAR200305032.

Egbert, D. D. (1967). The idea of "Avant-garde" in art and politics. *The American Historical Review, 73*(2), 339–366. https://doi.org/10.1086/ahr/73.2.339.

Flach, J. M., & Holden, J. G. (1998). The reality of experience: Gibson's way. *Presence, 7*(1), 90–95. https://doi.org/10.1162/105474698565550.

Flew, T. (2016). Entertainment media, cultural power, and post-globalization: The case of China's international media expansion and the discourse of soft power. *Global Media and China, 1*(4), 278–294.

Freeman, J., & Avons, S. E. (2000). Focus group exploration of presence through advanced broadcast services. Human Vision and Electronic Imaging V, California.

Fuchs, C. (2014). *Digital Labour and Karl Marx*. Routledge.

Fuchs, H., State, A., & Bazin, J.-C. (2014). Immersive 3D telepresence. *Computer, 47*(7), 46–52. https://doi.org/10.1109/MC.2014.185.

Fukuyama, F. (2018). Why national identity matters. *Journal of Democracy, 29*(4), 5–15. https://muse.jhu.edu/article/705713.

Fung, K.-C., Aminian, N., Fu, X., & Tung, C. Y. (2018). Digital silk road, Silicon Valley and connectivity. *Journal of Chinese Economic and Business Studies, 16*(3), 313–336. https://doi.org/10.1080/14765284.2018.1491679.

George, L. M., & Peukert, C. (2019). Social networks and the demand for news. *Information Economics and Policy*, 49, 100833. https://doi.org/10.1016/j.infoecopol.2019.100833.

Gibson, J. J. (2014). *The Ecological Approach to Visual Perception: Classic edition*. Psychology Press.

Gibson, W. (2001, April 30). The Future Perfect. Time Magazine. http://content.time.com/time/subscriber/article/0,33009,1956774,00.html.

Gifford, R. (2007). *China Road: A Journey into the Future of a Rising Power*. Random House.

Gilbert, S. B. (2016). Perceived realism of virtual environments depends on authenticity. *PRESENCE: Teleoperators and Virtual Environments, 24*(4), 322–324. https://doi.org/10.1162/PRES_a_00276.

GLA. (n.d.). *The Worlds of Splendors* (瑰丽·犹在境). Retrieved 12 December from https://www.glartgr.com/the-worlds-of-splendors.

Gong, J. (2012). Re-imaging an ancient, emergent superpower: 2008 Beijing Olympic Games, public memory, and national identity. *Communication and Critical/Cultural Studies, 9*(2), 191–214. https://doi.org/10.1080/14791420.2012.676657.

Graham, P. (2020). Echo VR Has Officially Launched for Oculus Quest. Medium. Retrieved 25 June 2021, from https://medium.com/echo-games-blog/echo-vr-quest-launch-c67f506066cc.

Grau, O. (2003). *Virtual Art: From Illusion to Immersion.* MIT Press.

Greengard, S. (2015). *The Internet of Things.* MIT Press.

Grenfell, M., & Hardy, C. (2007). *Art Rules: Pierre Bourdieu and the Visual Arts.* Berg.

Groys, B. (2008). *Art Power* MIT Press.

Guffey, E., & Lemay, K. C. (2014). Retrofuturism and Steampunk. In R. Latham (Ed.), *The Oxford Handbook of Science Fiction* (pp. 434–446). Oxford University Press.

Guttentag, D. A. (2010). Virtual reality: Applications and implications for tourism. *Tourism Management, 31*(5), 637–651. https://doi.org/10.1016/j.tourman.2009.07.003.

Guynup, S. (2016). Virtual reality, game design, and virtual art galleries. In D. England, N. Bryan-Kinns, & T. Schiphorst (Eds.), *Curating the Digital: Space for Art and Interaction* (pp. 149–166). Springer.

Han, P.-H., Chen, Y.-S., Liu, I.-S., Jang, Y.-P., Tsai, L., Chang, A., & Hung, Y.-P. (2019). A compelling virtual tour of the Dunhuang Cave with an immersive head-mounted display. *IEEE Computer Graphics and Applications, 40*(1), 40–55. https://doi.org/10.1109/MCG.2019.2936753.

Hannigan, J. (2005). *Fantasy City: Pleasure and Profit in the Postmodern Metropolis.* Routledge.

Hansen, A. H., & Mossberg, L. (2013). Consumer immersion: A key to extraordinary experiences. In F. Sørensen & J. Sundbo (Eds.), *Handbook on the Experience Economy* (pp. 209–227). Edward Elgar Publishing.

Hartley, J. (2005). *Creative Industries.* Wiley-Blackwell.

Hartley, J. (2021). *Advanced Introduction to Creative Industries.* Edward Elgar Publishing. https://books.google.com.au/books?id=JbQTEAAAQBAJ.

Hartley, J. (2022). 'Pathetic earthlings! Who can save you now?' Science fiction, planetary crisis and the globalisation of Chinese culture. *Global Media and China, 7*(1), 3–23. https://doi.org/10.1177/20594364211067872.

Hartley, J., Burgess, J., & Bruns, A. (2015). *A Companion to New Media Dynamics.* Wiley-Blackwell.

Hartley, J., & Potts, J. (2014). *Cultural Science: A Natural History of Stories, Demes, Knowledge and Innovation.* Bloomsbury Publishing.

Hassan, R. (2020). Digitality, virtual reality and the 'empathy machine'. *Digital Journalism, 8*(2), 195–212. https://doi.org/10.1080/21670811.2018.1517604.

Heeter, C. (1992). Being there: The subjective experience of presence. *Presence: Teleoperators & Virtual Environments, 1*(2), 262–271. https://doi.org/10.1162/pres.1992.1.2.262.

Heidegger, M. (1962). *Being and Time* (J. Macquarrie & E. Robinson, Trans.). SCM Press.

Hein, H. (2006). *Public Art: Thinking Museums Differently.* Rowman Altamira.

Höllerer, T., & Feiner, S. (2004). Mobile augmented reality. In A. Hammad & H. A. Karimi (Eds.), *Telegeoinformatics: Location-based Computing and Services* (pp. 187–216). CRC Press.

Holm, D. (1991). *Art and Ideology in Revolutionary China* (Vol. 1). Oxford University Press.

Howkins, J. (2002). *The Creative Economy: How People Make Money from Ideas.* Penguin UK.

Hu, J. (2007). *Hu Jintao's report at the 17th National Congress of the Communist Party of China* (胡锦涛在党的十七大上的报告). Central Government of PRC. Retrieved 30 May from http://www.gov.cn/jrzg/2007-12/28/content_845741.htm.

Hui, D. (2019). Bamboo forest: Exploring the aesthetics of augmented reality. In D. Hui (Ed.), *AR Awakening: X-Realities of Hong Kong Layering* (pp. 12–21). MCCM Creations.

Huizinga, J. (1998). *Homo ludens: A Study of the Play-Element in Culture* (Reprint of the edition 1949. ed.). Routledge.

Hutter, M. (2015). *The Rise of the Joyful Economy: Artistic Invention and Economic Growth from Brunelleschi to Murakami.* Routledge.

Hwaya, K. (2019, March 27). Augmented reality dragon wows baseball fans on opening day. Korea.net. https://www.korea.net/NewsFocus/Sci-Tech/view?articleId=169492.

ICOMOS. (2008). The ICOMOS charter for the interpretation and presentation of cultural heritage sites. *International Journal of Cultural Property, 15*(14), 377–383. https://doi.org/10.1017/S0940739108080417.

IDC. (2023). *In 2022, China's all-in-one VR machines will break the 1 million unit annual shipment mark for the first time* (2022年全年中国VR一体机首破年出货量100万台大关). Retrieved 15 April from https://www.idc.com/getdoc.jsp?containerId=prCHC50448523.

Illuthion. (2018). *White paper for China's immersive industry development 2018.* Retrieved 18 March from http://illuthion.com/talks/2020-illuthion-immersive-industry-whitepaper/.

Inoko, T. (2019, May 13). *The exhibition that the whole world sees: How teamLab breaks the boundaries* (全世界都看的展 teamLab 如何打破边界) [Interview]. *Southern Weekly.* https://mp.weixin.qq.com/s/uldRRAlS2mbh9o1X4dtjsw.

IOC. (2009). The Modern Olympic Games https://stillmed.olympic.org/media/Document%20Library/OlympicOrg/Documents/Document-Set-Teachers-The-Main-Olympic-Topics/The-Modern-Olympic-Games.pdf#pages=5.

iResearch. (2018). Report for the offline entertainment consumption of China's new generation 2018 (2018 年中国新生代线下娱乐消费升级研究报告) https://www.iresearch.com.cn/Detail/report?id=3251&isfree=0.

Iser, W. (1980). *The Act of Reading: A Theory of Aesthetic Response.* Johns Hopkins University Press.

ISPR. (2000). *The Concept of Presence: Explication Statement.* Retrieved 10 August 2020, from https://ispr.info/.

Jackson, W. A. (2009). *Economics, Culture and Social Theory.* Edward Elgar Publishing.

Jaivin, L. (2019). Red detachment: Is Chinese culture beyond reach? *Australian Foreign Affairs, 5,* 29–54. https://search.informit.org/doi/abs/10.3316/informit.216166804382965.

Jasanoff, S. (2015). Future imperfect: Science, technology, and the imaginations of modernity. In S. Jasanoff & S.-H. Kim (Eds.), *Dreamscapes of Modernity: Sociotechnical Imaginaries and the Fabrication of Power* (pp. 1–33). University of Chicago Press.

Jasanoff, S., & Kim, S.-H. (2009). Containing the atom: Sociotechnical imaginaries and nuclear power in the United States and South Korea. *Minerva, 47*(2), 119–146.

Jauss, H. R., & Benzinger, E. (1970). Literary history as a challenge to literary theory. *New Literary History, 2*(1), 7–37. https://doi.org/10.2307/468585.

Jenkins, H. (2004). The cultural logic of media convergence. *International Journal of Cultural Studies, 7*(1), 33–43. https://doi.org/10.1177%2F1367877904040603.

Jeon, M. P., & Fishwick, P. (2017). Special issue on arts, aesthetics, and performance in telepresence: Guest editors' introduction: *Homo ludens* in virtual environments. *PRESENCE: Teleoperators and Virtual Environments, 26*(2), iii–vii. https://doi.org/10.1162/PRES_e_00295.

Ji, Y., Wang, J., & Kai, Z. (2018, February 18). How to create Panda Messenger, "Ice Screen" and Robot Dance Steps? Chinese wisdom lights up "Beijing 8 minutes" (熊猫信使、"冰屏"和机器人舞步如何打造? 中国智慧点亮"北京8分钟"). *Xinhua News.* https://baijiahao.baidu.com/s?id=1593392223341912948&wfr=spider&for=pc.

Ji, Y., Wang, M., & Wang, Y. (2021, March 4). Winter Olympics, a new era of intelligence- How will the technological Winter Olympics change our lives? (冬奥, 智能新时代——科技冬奥将如何改变我们的生活?). Xinhua News. http://www.gov.cn/xinwen/2021-03/04/content_5590256.htm?_zbs_baidu_bk.

Ji, Y., & Wang, Z. (2018, February 24). "Beijing 8 Minutes" integrates artificial intelligence and interacts with Chinese people through the Internet "北京8分钟"融入人工智能通过互联网与国人互动. Xinhua News. http://www.xinhuanet.com/world/2018-02/24/c_1122447467.htm.

Jin, Y., & Ziye. (2023). *Dialogue between Chinese Culture and artificial intelligence* (《文化中国》与人工智能的对话). Retrieved 30 June 2023, from https://mp.weixin.qq.com/s/QyAnvaR2cCeZWTQD4-9WyQ.

Jonas, H. (1973). *Organismus und Freiheit: Ansitze zu einer philosophischen Biologie* Vandenhoeck & Ruprecht.

Jones, K. B. (2007). The transformation of the digital museum. In K. B. Jones & P. F. Marty (Eds.), *Museum Informatics: People, Information, and Technology in Museums* (pp. 9–25). Taylor & Francis.

JOYNVISCOM. (2018, January 5). Lost in play: Find the lost one hour of life (戏游: 寻找生命中丢失的一小时). *WeChat Official Accounts.* https://mp.weixin.qq.com/s/KS9RJ_lcyDSv8Vlhv_crQg?.

Judah, H. (2020, March 5). Cao Fei: Blueprints review – would you trade love for progress? *The Guardian.* https://www.theguardian.com/artanddesign/2020/mar/04/cao-fei-blueprints-review-would-you-trade-love-for-progress.

Jullien, F. (2021). *There Is No Such Thing as Cultural Identity* (P. Rodriguez, Trans.). Wiley.

Jung, J., Yu, J., Seo, Y., & Ko, E. (2021). Consumer experiences of virtual reality: Insights from VR luxury brand fashion shows. *Journal of Business Research, 130,* 517–524. https://doi.org/10.1016/j.jbusres.2019.10.038.

Jung, T., Dieck, T., Claudia, M., Lee, H., & Chung, N. (2016). Effects of virtual reality and augmented reality on visitor experiences in museum. In U. Gretzel, R. Law, & M. Fuchs (Eds.), *Information and Communication Technologies in Tourism 2016* (pp. 621–635). Springer.

K11 Art Foundation. (n.d.). *Vision and mission.* Retrieved 14 November from https://www.k11artfoundation.org/en/about.

Kang, L. (2012). Searching for a new cultural identity: China's soft power and media culture today. *Journal of Contemporary China, 21*(78), 915–931. https://doi.org/10.1080/10670564.2012.701032.

Kawecki, J. (2020, April 1). Inside the erotic sci-fi grotto of Hajime Sorayama. Highsnobiety. https://www.highsnobiety.com/p/hajime-sorayama-interview/.

Keane, M. (2015). *The Chinese Television Industry.* Bloomsbury Publishing.

Keane, M. (2016). The ten thousand things, the Chinese dream and the creative cultural industries. In M. Keane (Ed.), *Handbook of Cultural and Creative Industries in China* (pp. 27–42). Edward Elgar Publishing.

Keane, M., & Chen, Y. (2017). Digital China: From cultural presence to innovative nation. *Asiascape: Digital Asia, 4*(1–2), 52–75. https://brill.com/view/journals/dias/4/1-2/article-p52_5.xml.

Keane, M., & Yu, H. (2020). TikTok tries to distance itself from Beijing, but will it be enough to avoid the global blacklist? *The Conversation* https://theconversation.com/tiktok-tries-to-distance-itself-from-beijing-but-will-it-be-enough-to-avoid-the-global-blacklist-143247?fbclid=IwAR0pNldjYt6BSnDKZ_axjGI7SerygGIOh1L4l_AJDOcBSqGFYWxToUunkoQ.

Keane, M., Yu, H., Zhao, E. J., & Leong, S. (2020). *China's Digital Presence in the Asia-Pacific: Culture, Technology and Platforms*. Anthem Press.

Keane, M., & Zhao, E. J. (2014). The reform of the cultural system: Culture, creativity and innovation in China. In H.-K. Lee & L. Lim (Eds.), *Cultural Policies in East Asia: Dynamics between the State, Arts and Creative Industries* (pp. 155–173). Palgrave Macmillan. https://doi.org/10.1057/9781137327772_10.

Kellner, D. (2003). *Media Culture: Cultural Studies, Identity and Politics between the Modern and the Post-modern*. Routledge.

Kellner, D. (2011). Cultural studies, multiculturalism, and media culture. In G. Dines & J. M. Humez (Eds.), *Gender, Race, and Class in Media: A Critical Reader* (Vol. 3, pp. 7–18). Sage.

Kim, E.-S. (2018). Sociotechnical imaginaries and the globalization of converging technology policy: Technological developmentalism in South Korea. *Science as Culture, 27*(2), 175–197.

Kim, H. K., Park, J., Choi, Y., & Choe, M. (2018). Virtual reality sickness questionnaire (VRSQ): Motion sickness measurement index in a virtual reality environment. *Applied Ergonomics, 69*, 66–73. https://doi.org/10.1016/j.apergo.2017.12.016.

Kim, Y. (2006). Do South Korean companies need to obscure their country-of-origin image? A case of Samsung. *Corporate Communications: An International Journal, 11*(2), 126–137. https://doi.org/10.1108/13563280610661660.

Kim, Y. (2021). *The Soft Power of the Korean Wave: Parasite, BTS and Drama*. Routledge.

King, G. (2005). *The Spectacle of the Real: From Hollywood to Reality TV and Beyond*. Intellect Books.

Kitzinger, J. (1994). The methodology of focus groups: The importance of interaction between research participants. *Sociology of Health & Illness, 16*(1), 103–121. https://doi.org/10.1111/1467-9566.ep11347023.

Knight, C. K. (2011). *Public Art: Theory, Practice and Populism*. John Wiley & Sons.

Kuo, M., & Wolfson, J. (2017). Jordan Wolfson. *Artforum International, 56*(3), 202–203.

Lash, S., & Lury, C. (2007). *Global Culture Industry: The Mediation of Things*. Polity Press.

Law, L. (1993). *Spectacular Times: Images and Everyday Life*. Internet Archive. https://archive.org/details/SpectacularTimesImagespdf.

Lazaridou, K., Vrana, V., & Paschaloudis, D. (2017). Museums+ Instagram. In V. Katsoni, A. Upadhya, & A. Stratigea (Eds.), *Tourism, Culture and Heritage in a Smart Economy* (pp. 73–84). Springer.

Lee, G. (2017). *Fooling the World or Fooling Itself: China's Spectacular-Oneiric Society: An Intervention from a Critical Chinese Studies Perspective*. In Proceedings of the XV East Asia Net Research Workshop (ed Brombral D), Venezia: Edizioni Ca'Foscari.

Lee, G. (2018). *China Imagined: From European Fantasy to Spectacular Power*. Oxford University Press.

Lee, K.-f. (2019). *AI Superpowers: China, Silicon Valley, and the New World Order*. Harper Business.

Lefebvre, H. (1991). *Critique of Everyday Life: Foundations for a Sociology of the Everyday* (Vol. 2). Verso.

Lek, L. (2016). Sinofuturism (1839–2046 AD). Center for Art and Media Karlsruhe. Retrieved 2 December 2021, from https://zkm.de/en/sinofuturism-1839-2046-ad.

Li, C. (2021, October 10). Deciphering The Eternal Wave (解密"永不消逝的电波"). *Jiefang Daily* (解放日报). http://sh.xinhuanet.com/2021-10/10/c_1310235555.htm.

Li, F., & Zhao, X. (2017). Digital creative industries and the promotion of state cultural soft power: Strategies and pathways (数字创意产业与国家文化软实力提升路径研究). *Journal of Guangxi University for Nationalities, 39*(6), 2–7. http://sustech.caswiz.com/handle/2SGJ60CL/57183.

Li, K. (2015). *We still have to do the traditional MADE IN CHINA, but the core of Made in China 2025 should be Chinese equipment* (传统的"MADE IN CHINA"我们还要做, 但"中国制造2025"的核心, 应该是主打"中国装备"). Retrieved 1 October 2021, from http://www.gov.cn/zhuanti/2016-05/16/content_5073774.htm.

Li, K. (2016). 2016 Report on Government Work (2016年中国政府报告). http://www.gov.cn/guowuyuan/2016-03/17/content_5054901.htm.

Li, S. (2022, November 10). Strengthen the spiritual power to realize the great rejuvenation of the Chinese people (conscientiously study, publicize and implement the spirit of the 20th National Congress of the Communist Party of China) 增强实现中华民族伟大复兴的精神力量（认真学习宣传贯彻党的二十大精神）. People"s Daily. http://paper.people.com.cn/rmrb/html/2022-11/10/nw.D110000renmrb_20221110_1-06.htm?utm_source=substack&utm_medium=email.

Li, W. (2009). *Creative Industries are Changing China* (创意改变中国). Xinhua Press.

Lim, S. S., & Soriano, C. R. R. (2016). *Asian Perspectives on Digital Culture: Emerging Phenomena, Enduring Concepts*. Routledge.

Liu, C. (2014). *The Three-Body Problem* (K. Liu, Trans.). Tor Books.

Liu, Y. (2020, June 30). The first meeting of the Leading Group for the Science and Technology Winter Olympics was held (科技冬奥领导小组第一次会议召开). Science and Technology Daily. http://digitalpaper.stdaily.com/http_www.kjrb.com/kjrb/html/2020-07/02/content_447902.htm?div=-1.

Livingstone, S., Van Couvering, E., & Thumin, N. (2008). Converging traditions of research on media and information literacies. In C. Lankshear, M. Knobel, J. Coiro, & D. J. Leu (Eds.), *Handbook of Research on New Literacies* (pp. 103–132). Taylor & Francis.

Lombard, M., & Ditton, T. (1997). At the heart of it all: The concept of presence. *Journal of Computer-Mediated Communication, 3*(2). https://doi.org/10.1111/j.1083-6101.1997.tb00072.x.

MacCannell, D. (1973). Staged authenticity: Arrangements of social space in tourist settings. *American Journal of Sociology, 79*(3), 589–603. https://doi.org/10.1086/225585.

Margolis, T. (2014). Immersive art in augmented reality. In V. Geroimenko (Ed.), *Augmented Reality Art* (pp. 149–159). Springer.

Mayer, R. (2013). *Serial Fu Manchu: The Chinese Supervillain and the Spread of Yellow Peril Ideology*. Temple University Press.

McFarlane, A., Schmeink, L., & Murphy, G. (2020). *The Routledge Companion to Cyberpunk Culture*. Routledge.

McLuhan, M. (1964). The medium is the message. In *Understanding Media: The Extensions of Man* (pp. 23–35). Signet.

McNeil, M., Arribas-Ayllon, M., Haran, J., Mackenzie, A., & Tutton, R. (2016). Conceptualizing imaginaries of science, technology, and society. In U. Felt, R. Fouché, C. A. Miller, & L. Smith-Doerr (Eds.), *The Handbook of Science and Technology Studies* (pp. 435–463). MIT Press.

Messham-Muir, K. (2018). The BADFAITH machine: The phantom point of view in VR. *Artlink, 38*(4), 12–19. https://search.informit.org/doi/abs/10.3316/informit. 022607498952783.

Milk, C. (2015). How Virtual Reality can Create the Ultimate Empathy Machine. TED Presentation. Retrieved 10 April from https://www.ted.com/talks/chris_milk_how_virtual_reality_can_create_the_ultimate_empathy_machine.

Minsky, M. (1980). Telepresence. *OMNI Magazine, 38*(4). https://philpapers.org/rec/MINT.

Mitchell, W. J., Inouye, A. S., & Blumenthal, M. S. (2003). *Beyond Productivity: Information Technology, Innovation, and Creativity*. National Academies Press.

Mokyr, J. (2011). *The Enlightened Economy: Britain and the Industrial Revolution, 1700–1850*. Penguin UK.

Molesworth, M., & Denegri-Knott, J. (2007). Digital play and the actualization of the consumer imagination. *Games and Culture, 2*(2), 114–133. https://doi.org/10.1177/1555412006298209.

Morley, D., & Robins, K. (2002). *Spaces of Identity: Global Media, Electronic Landscapes and Cultural Boundaries*. Routledge.

Mosco, V. (2009). *The Political Economy of Communication* (2 ed.). SAGE Publications. https://doi.org/10.4135/9781446279946.

Needham, J. (1954). *Science and Civilisation in China: Volume 1* (Vol. 5). Cambridge University Press.

Negroponte, N. (1995). *Being Digital*. Alfred A. Knopf.

Nielsen, C. (2009). Play. In H. R. S. L. Embree (Ed.), *Handbook of Phenomenological Aesthetics* (pp. 265–268). Springer.

Niu, G. A. (2008). Techno-orientalism, nanotechnology, posthumans, and post-posthumans in Neal Stephenson's and Linda Nagata's science fiction. *Melus, 33*(4), 73–96. https://www.jstor.org/stable/20343508.

Nye, J. (2004). *Soft Power: The Means to Success in World Politics*. PublicAffairs.

Nye, J., & Kim, Y. (2019). Soft power and the Korean Wave. In Y. Kim (Ed.), *South Korean Popular Culture and North Korea* (pp. 41–53). Routledge.

Nye, J. S. (1990). Soft power. *Foreign Policy* (80), 153–171. https://doi.org/10.2307/1148580.

Osterhammel, J. (2018). *Unfabling the East*. Princeton University Press.

Pan, C. (2012). *Knowledge, Desire and Power in Global Politics: Western Representations of China's Rise*. Edward Elgar Publishing.

Parekh, B. (1995). The concept of national identity. *Journal of Ethnic and Migration Studies, 21*(2), 255–268. https://doi.org/10.1080/1369183X.1995.9976489.

Paul, C. (2003). *Digital Art*. Thames & Hudson.

Paul, C. (2008). Digital art/public art: Governance and agency in the networked commons. In C. Sommerer, L. C. Jain, & L. Mignonneau (Eds.), *The Art and Science of Interface and Interaction Design* (pp. 163–185). Springer.

Peacock, J. (2017). Edward Hopper: The artist who evoked urban loneliness and disappointment with beautiful clarity. The Conversation. https://theconversation.

com/edward-hopper-the-artist-who-evoked-urban-loneliness-and-disappointment-with-beautiful-clarity-77636.

Penny, S., Smith, J., Sengers, P., Bernhardt, A., & Schulte, J. (2001). Traces: Embodied immersive interaction with semi-autonomous avatars. *Convergence, 7*(2), 47–65. https://doi.org/10.1177%2F135485650100700205.

Peterson, R. A., & Anand, N. (2004). The production of culture perspective. *Annual Review of Sociology, 30*, 311–334. https://doi.org/10.1146/annurev.soc.30.012703.110557.

Pett, E. (2021). *Experiencing Cinema: Participatory Film Cultures, Immersive Media and the Experience Economy.* Bloomsbury Publishing.

PIKAPIKA. (2019, March 24). Immersive Digital Exhibition: From zero to the 'Red Sea' in two years, who can become China's teamLab (沉浸式数字展：两年内从零到红海，谁能成为中国的teamLab). *Entertainment Capital* (娱乐资本论). https://mp.weixin.qq.com/s/Q-HkrvDlllD4qvvad0kuIw.

Pinta Studios. (2018). Shennong: Taste of Illusion (Original VR Animation). 75th Venice Film Festival – Venice VR, Venice. https://store.steampowered.com/app/907970/Shennong_Taste_of_Illusion/.

Plummer, K. (2001). *Documents of Life 2: An Invitation to a Critical Humanism* (Vol. 2). Sage.

Potts, J., Cunningham, S., Hartley, J., & Ormerod, P. (2008). Social network markets: A new definition of the creative industries. *Journal of Cultural Economics, 32*(3), 167–185. https://doi.org/10.1007/s10824-008-9066-y.

Pow, C.-P., & Kong, L. (2007). Marketing the Chinese dream home: Gated communities and representations of the good life in (post-) socialist Shanghai. *Urban Geography, 28*(2), 129–159. https://doi.org/10.2747/0272-3638.28.2.129.

Pujol-Tost, L. (2018). Cultural presence in virtual archaeology: An exploratory analysis of factors. *PRESENCE: Teleoperators and Virtual Environments, 26*(03), 247–263. https://doi.org/10.1162/pres_a_00296.

Pujol-Tost, L., & Champion, E. M. (2007). A critical examination of presence applied to cultural heritage. The 10th annual international workshop on presence, Barcelona.

Pusey, J. R. (1983). *China and Charles Darwin.* Harvard University Asia Center.

PwC. (2019). Global Entertainment & Media Outlook 2019–2023 https://www.pwc.com/outlook.

Rauer, V. (2006). Symbols in action: Willy Brandt's kneefall at the Warsaw Memorial. In B. Giesen, J. L. Mast, & J. C. Alexander (Eds.), *Social Performance: Symbolic Action, Cultural Pragmatics, and Ritual* (pp. 257–282). Cambridge University Press.

Reed, M. (2016). The Mogao Caves as Cultural Embassies. Harvard Divinity Bulletin Retrieved 10 November 2021, from https://bulletin.hds.harvard.edu/the-mogao-caves-as-cultural-embassies/.

Repnikova, M. (2022). *Chinese Soft Power.* Cambridge University Press.

RET. (2019). Joyful Colors: A Research on the Application of IP in Chinese Shopping Malls (悦动的色彩——中国购物中心IP应用研究). https://www.ret.cn/report/2172.html.

Rifkin, J. (2009). *The Empathic Civilization: The Race to Global Consciousness in a World in Crisis.* Penguin.

Ritzer, G. (2005). *Enchanting a Disenchanted World: Revolutionizing the Means of Consumption* (2nd ed.). Pine Forge Press.

Riva, G., & Mantovani, G. (2000). The need for a socio-cultural perspective in the implementation of virtual environments. *Virtual Reality, 5*(1), 32–38. https://doi.org/10.1007/BF01418974.

Riva, G., Waterworth, J., & Murray, D. (2014). *Interacting with Presence: HCI and the Sense of Presence in Computer-mediated Environments*. De Gruyter Open Poland. https://doi.org/10.2478/9783110409697.

Rössel, J., Schenk, P., & Weingartner, S. (2017). Cultural consumption. In J. Rössel, P. Schenk, & S. Weingartner (Eds.), *Emerging Trends in the Social and Behavioral Sciences* (November 8 ed., pp. 1–14). Wiley. https://doi.org/10.1002/9781118900772.etrds0432.

Roussou, M. (2007). The components of engagement in virtual heritage environments. In Y. Kalay, T. Kvan, & J. Affleck (Eds.), *New Heritage* (pp. 241–257). Routledge.

Rubin, P. (2018). *Future Presence: How Virtual Reality is Changing Human Connection, Intimacy, and the Limits of Ordinary Life*. HarperCollins.

Ryan, M.-L. (2015). *Narrative as Virtual Reality 2: Revisiting Immersion and Interactivity in Literature and Electronic Media*. Johns Hopkins University Press.

Said, E. W. (1978). *Orientalism*. Routledge & Kegan Paul.

Sautman, B., & Hairong, Y. (2009). African perspectives on China–Africa links. *The China Quarterly, 199*, 728–759. https://doi.org/10.1017/S030574100999018X.

Scheuerl, H. (1997). *Das Spiel*. Beltz.

Schiller, F., & Snell, R. (2004). *On the Aesthetic Education of Man*. Courier Corporation.

Schneider, F. (2019). *Staging China: The Politics of Mass Spectacle*. Leiden University Press.

Schuemie, M. J., Van Der Straaten, P., Krijn, M., & Van Der Mast, C. A. (2001). Research on presence in virtual reality: A survey. *CyberPsychology & Behavior, 4*(2), 183–201. https://doi.org/10.1089/109493101300117884.

Seale, C. (2004). *Social Research Methods: A reader*. Routledge.

Serpentine Gallery. (2020). *Cao Fei: Blueprints*. Retrieved 20 November from https://www.serpentinegalleries.org/whats-on/cao-fei/.

Shambaugh, D. (2013). *China Goes Global: The Partial Power* (Vol. 409). Oxford University Press.

Shambaugh, D. (2015). China's soft-power push: The search for respect. *Foreign Affairs, 94*(4), 99–107. https://www.jstor.org/stable/24483821.

Shambaugh, D. (2020). *China and the World*. Oxford University Press. https://doi.org/10.1093/oso/9780190062316.001.0001.

Shan, S.-l. (2014, September 1). Chinese cultural policy and the cultural industries. *City, Culture and Society, 5*(3), 115–121. https://doi.org/10.1016/j.ccs.2014.07.004.

Shen, H. (2018). Building a digital silk road? Situating the internet in China's belt and road initiative. *International Journal of Communication, 12*, 19. https://ijoc.org/index.php/ijoc/article/view/8405.

Sherwin, S. (2020, 31 July). Cao Fei's Asia One: Human behaviour. *The Guardian*. https://www.theguardian.com/artanddesign/2020/jul/31/cao-fei-asia-one.

Shen, X. (2022, February 11). Beijing's beloved Olympics panda mascot has its own NFTs, but they are unavailable in China. South China Morning Post. https://www.scmp.com/tech/tech-trends/article/3166727/beijings-beloved-olympics-panda-mascot-has-its-own-nfts-they-are?module=perpetual_scroll_0&pgtype=article&campaign=3166727.

Shi, Y. (2018, December 15). The Palace Museum's annual number of visitors exceeded 17 million for the first time (故宫博物院年接待观众数量首次突破1700万). Xinhuan News.http://www.gov.cn/xinwen/2018-12/15/content_5349117.htm.

Sigley, G. (2015, December 1). Tea and China's rise: Tea, nationalism and culture in the 21st century. *International Communication of Chinese Culture, 2*(3), 319–341. https://doi.org/10.1007/s40636-015-0037-7.

Siu, L., & Chun, C. (2020). Yellow peril and techno-orientalism in the time of COVID-19: Racialized contagion, scientific espionage, and techno-economic warfare. *Journal of Asian American Studies, 23*(3), 421–440. https://muse.jhu.edu/article/772573.

Slater, M. (2004). How colorful was your day? Why questionnaires cannot assess presence in virtual environments. *Presence: Teleoperators & Virtual Environments, 13*(4), 484–493. https://doi.org/10.1162/1054746041944849.

Sobchack, V. (1992). *The Address of the Eye: A Phenomenology of Film Experience.* Princeton University Press.

State Council. (2016). 13th Five-Year National Development Plan of Strategic Emerging Industries ("十三五" 国家战略性新兴产业发展规划). Central Government of PRC. http://www.gov.cn/zhengce/content/2016-12/19/content_5150090.htm.

State Council. (2019). Opinions on Further Inspiring the Potential of Culture and Tourism Consumption (国务院办公厅关于进一步激发文化和旅游消费潜力的意见). Central Government of PRC. http://www.gov.cn/zhengce/content/2019-08/23/content_5423809.htm.

Stephenson, N. (1992). *Snow Crash.* Bantam Books.

Steuer, J. (1992). Defining virtual reality: Dimensions determining telepresence. *Journal of Communication, 42*(4), 73–93. https://doi.org/10.1111/j.1460-2466.1992.tb00812.x.

Stogner, M. B. (2011). The immersive cultural museum experience–creating context and story with new media technology. *International Journal of the Inclusive Museum, 3*(3), 117–130. https://doi.org/10.18848/1835-2014/CGP/v03i03/44339.

Stone, R., & Ojika, T. (2000). Virtual heritage: What next? *IEEE Multimedia, 7*(2), 73–74. https://doi.org/10.1109/93.848434.

Straubhaar, J. (2003). Culture, language and social class in the globalization of television. In A. Goonasekera, G. Wang, & J. Servaes (Eds.), *The New Communications Landscape: Demystifying Media Globalization* (pp. 218–244). Routledge.

Straubhaar, J. (2014). Choosing national TV: Cultural capital, language, and cultural proximity in Brazil. In M. G. Elasmar (Ed.), *The Impact of International Television: A Paradigm Shift* (pp. 77–110). Routledge.

Sun, W. (2002). *Leaving China: Media, Migration, and Transnational Imagination.* Rowman & Littlefield Publishers.

Sun, W. (2020). I shoot so I exist, we daka so the old cities exist – short video: Practice of popular video in cyber city (我拍故我在 我们打卡故城市在——短视频: 赛博城市的大众影像实践). *Chinese Journal of Journalism & Communication, 42.* https://doi.org/10.13495/j.cnki.cjjc.2020.06.001.

Sun, W., & Yu, H. (2022). *WeChat and the Chinese Diaspora: Digital Transnationalism in the Era of China's Rise.* Routledge.

Sun, X. (2018, February 26). At Games' end, Beijing takes baton. China Daily. http://www.chinadaily.com.cn/a/201802/26/WS5a9355b5a3106e7dcc13dfc7.html.

Takahashi, D. (2021). *Social gaming platform Rec Room raises $100M at $1.25B valuation.* Venturebeat. Retrieved 26 May from https://venturebeat.com/2021/03/23/social-gaming-platform-rec-room-raises-100m-at-1-25b-valuation/.

Tao, W. (2021, June 26). In Hongxia Theatre, there is the youth of workers (红霞影剧院里, 有工人的青春). Workers' Daily (工人日报). http://www.workercn.cn/34059/202106/26/210626061959541.shtml.

Tasa, U. B., & Görgülü, T. (2010). Meta-art: Art of the 3-D user-created virtual worlds. *Digital Creativity, 21*(2), 100–111.

TATE. (n.d.). *White cube*. Retrieved 5 May 2020, from https://www.tate.org.uk/art-terms/w/white-cube?cv=1&session-id=d5948c8c32854c418ec6142261643bb5.

Taylor, C. (2003). *Modern Social Imaginaries*. Duke University Press.

teamLab. (2017). *teamLab: Dance! Art Exhibition, Learn & Play! Future Park*. Retrieved 7 January from https://www.teamlab.art/e/shenzhen/.

Teigland, R., & Power, D. (2013). *The Immersive Internet: Reflections on the Entangling of the Virtual with Society, Politics and the Economy*. Springer.

Throsby, D. (2008). Modelling the cultural industries. *International Journal of Cultural Policy, 14*(3), 217–232. https://doi.org/10.1080/10286630802281772.

Trilling, L. (2009). *Sincerity and Authenticity*. Harvard University Press.

UNESCO. (1987). World heritage list Mogao Caves. United Nations Educational, Scientific and Cultural Organization (UNESCO). Retrieved 16 April 2021, from https://whc.unesco.org/en/list/440/.

Van Dijck, J. (2009). Users like you? Theorizing agency in user-generated content. *Media, Culture & Society, 31*(1), 41–58.

Venkatesh, A., & Meamber, L. A. (2006). Arts and aesthetics: Marketing and cultural production. *Marketing Theory, 6*(1), 11–39. https://doi.org/10.1177%2F1470593106061261.

Vukadin, A., Wongkitrungrueng, A., & Assarut, N. (2018). When art meets mall: Impact on shopper responses. *Journal of Product & Brand Management, 27*(3), 277–293. https://doi.org/10.1108/JPBM-01-2017-1406.

Vukovich, D. (2013). *China and Orientalism: Western Knowledge Production and the PRC*. Routledge.

Wages, R., Grünvogel, S. M., & Grützmacher, B. (2004). How realistic is realism? Considerations on the aesthetics of computer games. International Conference on Entertainment Computing, Eindhoven, The Netherlands.

Wang, F. (1988). Marxist literary criticism in China. In L. Grossberg & C. Nelson (Eds.), *Marxism and the Interpretation of Culture* (pp. 715–722). Springer.

Wang, H. (1995). The fate of "Mr. Science" in China: The concept of science and its application in modern Chinese thought. *Positions: Asia Critique, 3*(1), 1–68. https://doi.org/10.1215/10679847-3-1-1.

Wang, J. (2016). The makers are coming! China's long tail revolution. In M. Keane (Ed.), *Handbook of Cultural and Creative Industries in China* (pp. 43–63). Edward Elgar Publishing.

Wang, X. (2019). *Maybe It's Time to Refresh the Art World A Little Bit* [Digital installations]. Hong Kong. https://www.desarthe.com/artist/wang-xin.html.

Wang, Y. (2008). Public diplomacy and the rise of Chinese soft power. *The ANNALS of the American Academy of Political and Social Science, 616*(1), 257–273.

Wang, Y. (2023). *The Cultural Soft Power in Contemporary Chinese Story*(中国故事的文化软实力). Jiangsu People's Publication (江苏人民出版社).

Wang, Z. (2014). The Chinese dream: Concept and context. *Journal of Chinese Political Science, 19*(1), 1–13. https://doi.org/10.1007/s11366-013-9272-0.

Weber, M. (1946). Science as a Vocation. In A. I. Tauber (Ed.), *Science and the Quest for Reality* (pp. 382–394). Springer.

Weilenmann, A., Hillman, T., & Jungselius, B. (2013). Instagram at the museum: Communicating the museum experience through social photo sharing. Proceedings of the SIGCHI conference on human factors in computing systems, Paris.

Wen, W. (2017). Making in China: Is maker culture changing China's creative landscape? *International Journal of Cultural Studies, 20*(4), 343–360. https://doi.org/10.1177%2F1367877917705154.

Wete, B. (2014). *The 10 Best & 'WTF?!?' Moments of the 2014 Billboard Music Awards.* Retrieved 2 February from https://www.billboard.com/lists/10-best-wtf-moments-2014-billboard-music-awards/hologram-michael-jackson-returns-to-the-throne-2/.

Wilkinson, S., & Silverman, D. (2004). Focus Group Research. In D. Silverman (Ed.), *Qualitative Research: Theory, Method and Practice* (pp. 177–199). SAGE Publications.

Winter, T. (2016). One belt, one road, one heritage: Cultural diplomacy and the Silk Road. *The Diplomat, 29*, 1–5. https://thediplomat.com/2016/03/one-belt-one-road-one-heritage-cultural-diplomacy-and-the-silk-road/.

Winter, T. (2019). *Geocultural Power.* University of Chicago Press.

Witmer, B. G., & Singer, M. J. (1998). Measuring presence in virtual environments: A presence questionnaire. *Presence, 7*(3), 225–240. https://doi.org/10.1162/105474698565686.

Wolf, W. (2013). Aesthetic Illusion. In W. Wolf, W. Bernhart, & A. Mahler (Eds.), *Immersion and Distance: Aesthetic Illusion in Literature and Other Media* (pp. 1–63). Brill. https://brill.com/view/book/9789401209243/B9789401209243-s002.xml.

Wood, D. (1991). *On Paul Ricoeur: Narrative and Interpretation.* Routledge.

Wood, M. (2020). *The Story of China: A Portrait of a Civilisation and Its People.* Simon and Schuster.

Workpoint Official. (2018, February 25). SEE YOU IN BEIJING IN 2022 | Winter Olympic 2018, YouTube. https://www.youtube.com/watch?v=I6JG5TCD9YI.

Wu, D. (2021, October 10). Cao Fei's dystopian fantasies fuse art and technology. *Wallpaper.* https://www.wallpaper.com/art/cao-fei-dystopian-artworks-interview-2021.

Wu, H. (2019). The significance of 'New Four Inventions' in the history of thought ("新四大发明"的思想史意义). *People's Tribune* (人民论坛), *7*(3), 73–75. http://www.rmlt.com.cn/2019/0311/541570.shtml.

Wu, X. (2022, February 7). More than just an opening ceremony at this Winter Olympics. China Daily. http://www.chinadaily.com.cn/a/202202/07/WS62007709a310cdd39bc8501d.html.

Xinhua. (2004, August 30). Eight-minute performance stunning Athens, Beijing China stunning the world (八分钟演出惊艳雅典中国北京倾倒全世界). Sina Sports. http://sports.sina.com.cn/s/2004-08-30/0438353562s.shtml.

Xinhua. (2012, November 8). Hu Jintao made a report to the conference on behalf of the 17th Central Committee of the Communist Party of China (胡锦涛代表中共第十七届中央委员会向大会作报告). China Daily. http://www.chinadaily.com.cn/dfpd/2012-11/08/content_15894434.htm.

Xinhua. (2020, April 6). Live broadcast of Forbidden City tour racks up millions of views. Xinhua News. http://www.xinhuanet.com/english/2020-04/06/c_138951092.htm.

Xinhua. (2021a, March 13). The 14th Five-Year Plan for National Economic and Social Development of the People's Republic of China and Outline of the Vision for 2035 (中华人民共和国国民经济和社会发展第十四个五年规划和2035年远景目标纲要). *Xinhua News.* http://www.gov.cn/xinwen/2021-03/13/content_5592681.htm.

Xinhua. (2021b, June 1). Xi Jinping presided over the 30th collective study and speech of the Political Bureau of the CPC Central Committee (习近平主持中共中央政治局第三十次集体学习并讲话). Xinhua News. http://www.gov.cn/xinwen/2021-06/01/content_5614684.htm.

Xu, F. (2005). *Chinese Artistic Spirit* (中国艺术精神). East China Normal University Press.

Xu, J., & Yu, H. (2022). Regulating and governing China's internet and digital media in the Xi Jinping era. *Media International Australia, 185*(1), 3–8.

Yalcinkaya, G. (2020, March 10). Artist Cao Fei uses Soviet sci-fi to explode time and space as we know it. DAZE. https://www.dazeddigital.com/art-photography/article/48301/1/artist-cao-fei-blueprints-soviet-sci-fi-to-explode-time-and-space-as-we-know-it.

Yamamura, M. (2015). *Yayoi Kusama: Inventing the Singular.* MIT Press.

Yang, F. (2015). *Faked in China: Nation Branding, Counterfeit Culture, and Globalization.* Indiana University Press.

YIPLED. (n.d.). *YIPLED* (壹品光电). Retrieved 13 November from https://www.yipled.cn/.

Zhang, Y. (2018). *Zhang Yimou reveals the behind-the-scenes story of Beijing 8 Minutes* (张艺谋揭秘北京八分钟) [Interview]. Beijing Organising Committee for the 2022 Olympic and Paralympic Winter Games. https://tv.cctv.cn/2018/01/29/VIDEsIW4Nz2aAWHo4wInPR2X180129.shtml.

Zhao, X. (2018). In pursuit of a community of shared future: China's global activism in perspective. *China Quarterly of International Strategic Studies, 4*(1), 23–37. https://doi.org/10.1142/S2377740018500082.

Zhao, X. (2021). Playfulness, realism and authenticity in cultural presence: A case study of virtual heritage players. *Body, Space & Technology, 20*(1), 106–115. https://doi.org/10.16995/bst.352.

Zhao, X., & Keane, M. (2023). Sino-futurism and alternative imaginaries of Digital China. *Media International Australia.* https://doi.org/10.1177/1329878X231215108.

Zhao, Y. (2018, March 9). Technology + Culture Boosts the Construction of Digital Culture China ("科技+文化"助推建设数字文化中国). Guangming Daily (光明日报). https://culture.gmw.cn/2018-03/09/content_27936161.htm.

Zhdanov, A. A. (1950). *Essays on Literature, Philosophy, and Music.* International Publishers.

Zheng, Y. (2023). *Zheng Yongnian: Political parties and modernisation* (郑永年: 政党与现代化). Retrieved 26 August 2023, from https://www.qiia.org/en/node/1078.

Zhu, Y., Edney, K., & Rosen, S. (2019). *Soft Power with Chinese Characteristics: China's Campaign for Hearts and Minds.* Routledge.

Zhu, Y., & Rosen, S. (2010). *Art, Politics, and Commerce in Chinese Cinema* (Vol. 1). Hong Kong University Press.

INDEX

Milton Keynes UK
Ingram Content Group UK Ltd.
UKHW031838030924
447682UK00002B/12